RIVER BOOKS
sponsored by
the River Systems Institute
at Texas State University,
Andrew Sansom, General Editor

Richard M. Donovan

10-1-06

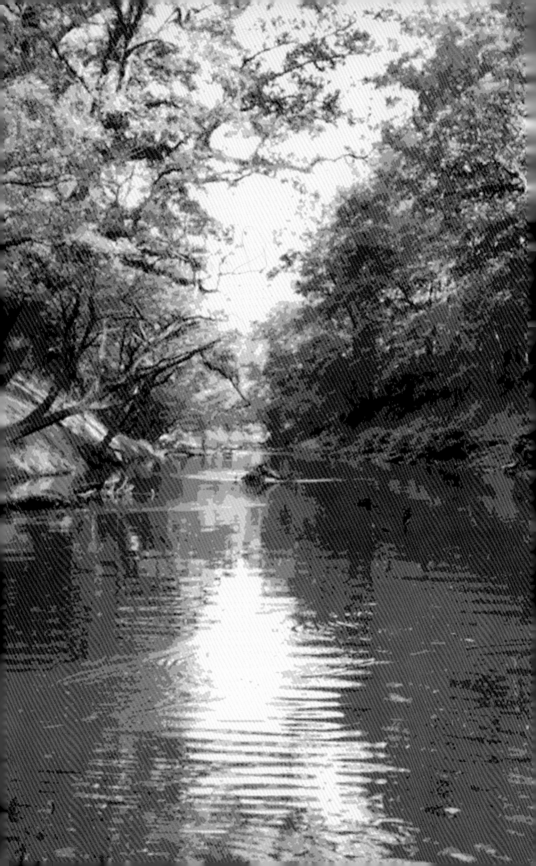

Paddling the Wild Neches

Richard M. Donovan

TEXAS A&M UNIVERSITY PRESS COLLEGE STATION

The paper used in this book meets the minimum requirements
of the American National Standard for Permanence
of Paper for Printed Library Materials, Z39.48–1984.
Binding materials have been chosen for durability.

A generous grant from the TLL Temple Foundation
helped make this book possible.

Images in the frontmatter are based on photographs by
Randy Courtney (frontis), Mark Bush (p. viii, xii), and
Gina Donovan (p. x).

LIBRARY OF CONGRESS
CATALOGING-IN-PUBLICATION DATA

Donovan, Richard M., 1936–
 Paddling the wild Neches / Richard M. Donovan.— 1st ed.
 p. cm.—(River books)
 Includes bibliographical references and index.
 ISBN 1-58544-496-0 (paper [flex bound] : alk. paper)
 1. Donovan, Richard M., 1936—Travel—Texas—Neches River. 2. Canoes
and canoeing—Texas—Neches River. 3. Neches River (Tex.)—Description
and travel. 4. Neches River Valley (Tex.)—Description and travel.
5. Neches River Region (Tex.)—Social life and customs. 6. Neches River
Region (Tex.)—History, Local. I. Title. II. River books (Series)
F392.N35D66 2005
917.64'150464–dc22 2005025897

For my wife Bonnie
and my daughter Gina

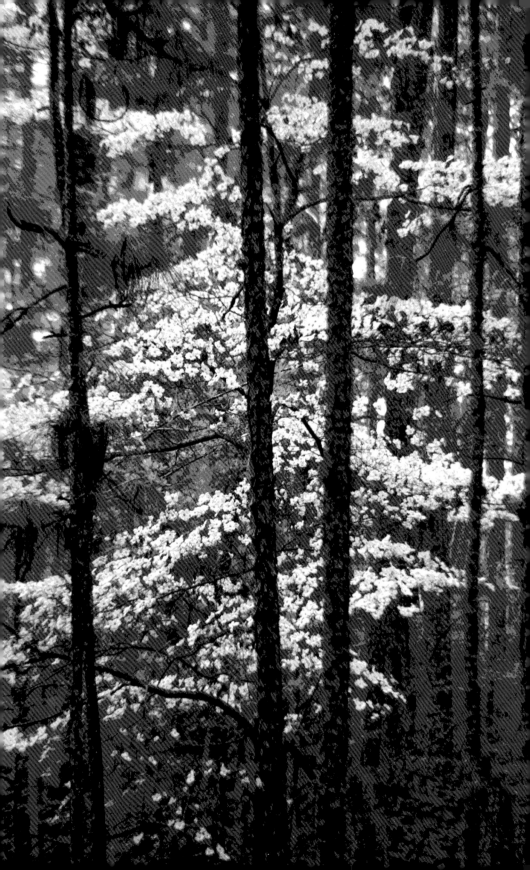

Canoes are unobtrusive;

they don't storm the natural world

or ride over it, but drift upon it

as part of its own silence.

—John Graves, *Goodbye to a River*

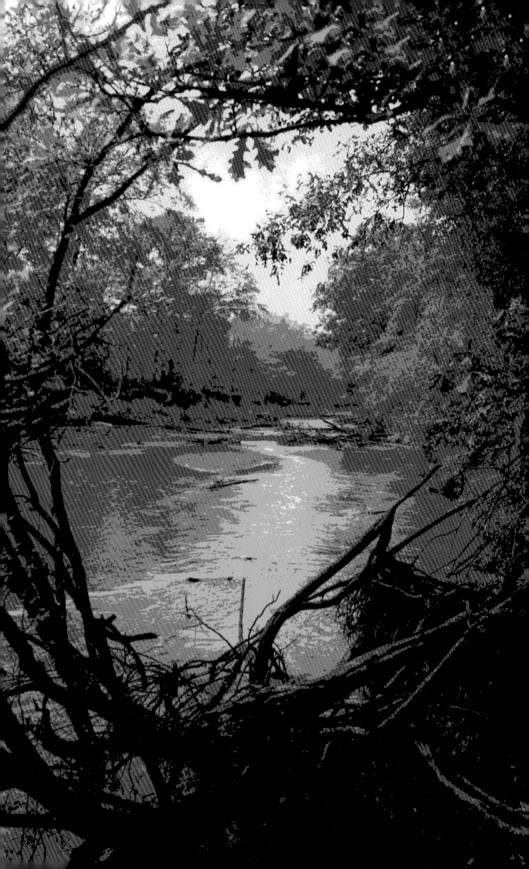

Contents

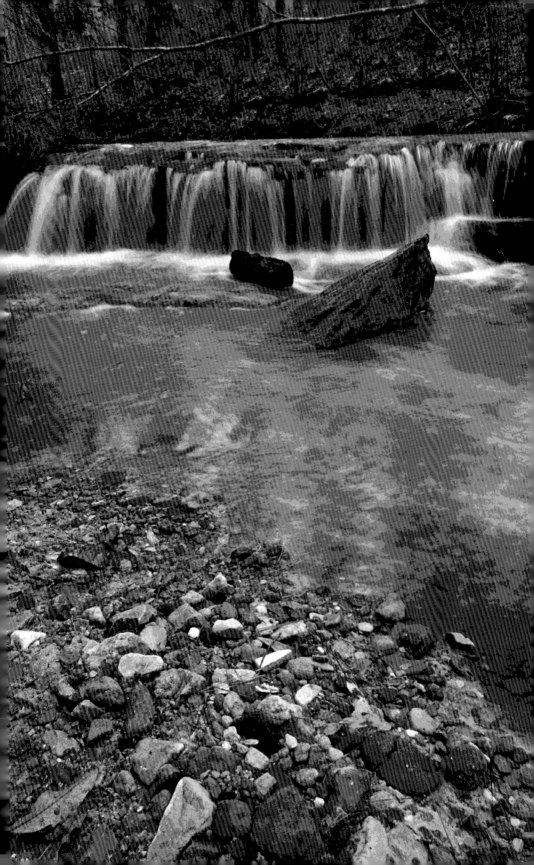

Foreword

There is no river like the Neches. The confluence of natural history and lore is richer in its bottomlands than perhaps any other place in Texas. Richard Donovan has captured the mixture well in this delightful account of his solo odyssey down some of that river's most beautiful and mysterious reaches.

In *Paddling the Wild Neches*, Donovan makes an impassioned plea for continued protection of a river that conservationists have been struggling to save since the 1930s. A businessman and longtime employee of the timber industry, Donovan makes it clear where he stands on the need for additional protection but gives deserved credit to industry leaders such as Arthur Temple, without whom the river and its riparian woodlands might already have been destroyed.

More than anything else, I know you will find in Donovan's words, as I did, the alluring tale of one man's adventure down a river that offers rich history and tradition, along with exceptional beauty, around every bend. If his writing does not make you want to float the river, nothing will. If it does not make you want to help save the Neches and Texas' other remaining wild rivers, I will be surprised.

Thanks to Richard Donovan, I am going to float the Neches again as soon as I can.

—Andrew Sansom

Acknowledgments

To acknowledge all of those to whom I am indebted would be an impossible task, and the risk of omission would be ever present. Still, there are those I simply must thank.

First, my sincere thanks to my superb editor Shannon Davies for her patience and nourishing support. Dr. Pete Gunter receives my humble gratitude for the positive review and helpful suggestions he provided for the manuscript's final edit. Thad Sitton's encouragement and advice in the very early stages of this effort were essential. I also offer special thanks to my daughter Gina. Her fondness for the 1999 river journal initiated the process that led to this book being written. Janice Bezanson with the Texas Committee on Natural Resources receives my praise for the many valuable contributions she made.

Deep appreciation goes to David Bezanson, Natural Area Preservation Association; Brandt Mannchen, Houston Sierra Club; Jonathan Gerland and Louis Landers, the History Center; David Hancock, Angelina and Neches River Authority; Howard Cox, professor at Angelina College; Cindy McMullen, Kurth Memorial Library; and to Rose Ann Largent, Adrian Van Dellen, Roland Boykin Long, and Constance Whiston. Thanks are also extended to those who joined and paddled with me along segments of the 2001 Neches River Canoe Expedition. Their participation was a special treat.

Finally, I must acknowledge my wonderful wife Bonnie for her invaluable support. Without her, nothing would have been done. *Paddling the Wild Neches* is as much a product of her efforts as of mine. In this attempt, as in everything I have ever done, she has been more than an equal partner. It was her quick fingers that transferred my scrawl to the printed page and her keen mind that corrected so many mistakes I made.

I am pleased to note that the Conservation Fund, head-quartered in Virginia, has already protected thirty-three thousand acres of forested wildlife habitat along the Neches River corridor. Through its East Texas Forestland Initiative, the organization's Texas office is working to extend the conservation corridor down the Neches River from Lake Palestine. Royalties from this book are being donated to the Conservation Fund.

Introduction

I grew up in a time and place where the trotline, trapline, shotgun, and skinning knife were still considered essential tools of life for many in the rural Neches River country of the 1940s and '50s. The quest for fin, fur, feather, hide, and claw was not so much for trophy or sport as it was for meat and supplementary income. Air-conditioning was unavailable, and electric lighting in most homes consisted of a single incandescent bulb dangling from the ceiling in the center of each room. Teams of horses and mules hitched to wagons and stockmen mounted on fast foxtrotting horses were still common on the dirt streets of my hometown. Dogs, aggressive cur dogs, accompanied these men almost everywhere they went. It has been called a simpler way of life. It was not. The issues and problems of that time were just very different.

Most of the folks in our small world had never heard the word *ecology*, and few guessed that the world as we knew it would ever change. They were wrong. It changed. It did not happen all at once, but in fits and starts over a period of forty or fifty years, the last remaining thread of frontier life died.

During my teens in the 1950s, those who loved to hunt, fish, and enjoy wild places sought out the big cathedral hardwood forests along the Angelina and Neches rivers. Stringers of hardwoods growing alongside streams that emptied into the two rivers were also prized for wild game. I roamed these woods with a pump shotgun and a .22 caliber semi-automatic rifle I had won selling magazine subscriptions for our Zavalla Chapter of Future Farmers of America. My friends and I fished the rivers by tossing throw lines baited with crawfish and perch from the riverbanks or from a homemade boat if one was available to borrow.

We could not have described what an environmentalist was, but we did notice what was happening to the streams and forests

around us. My first real feeling of unease for the natural world I knew came during the early 1950s when the effluent from the big paper mill at Lufkin began turning the Angelina River a putrid black every summer. During the hot, dry low-water months, the river's natural khaki-colored waters were overwhelmed by thousands of gallons of black broth discharged into it by the mill. The word we heard was that this stuff the mill was pumping into the river was harmless. No one I knew dreamed of questioning the mill's right to alter the characteristics of the river, and many naively believed that business and industry would never consider releasing anything harmful into the water or air. Still, most of us who did not live right along the Angelina River would switch our fishing lines to the Neches until winter rains flushed out the Angelina and diluted the blackness. We didn't know whether the black process water from the mill was a health hazard or not, but we couldn't help thinking that the stories of big fish kills upriver, closer to the mill's discharge, indicated something was wrong.

By the time I received a bachelor of business administration degree from Stephen F. Austin State University in 1962 and accepted a job in Waco, other alterations to the rivers and the surrounding woods were providing a preview of things to come. The Neches River had already been dammed at Town Bluff in 1952 to form the 13,700-acre B. A. Steinhagen Lake. Ten years later and twenty-five miles upriver, trees were being pushed down and concrete was being poured for the huge Sam Rayburn Dam and Reservoir on the Angelina River. This Goliath was to be roughly nine times the size of the Steinhagen reservoir.

The forests were being changed, too. Clear-cutting, the practice of removing all the trees, merchantable and nonmerchantable, from the logging site, and its attendant practice of replanting the logged site with pine seedlings, had become common. In just a few short years, loblolly pine saplings were marching shoulder to shoulder and heel to toe across tens of thousands of acres of rolling hills and flatlands.

When my wife Bonnie and I moved to Waco, my ties to the Neches and its woodlands were severed. With the cares of a job,

raising a family, and some serious health problems, it would be almost forty years before I would again seek out the river. Even after we returned to Diboll and Lufkin and started a real estate company, the wild places along the wooded river remained memories only, memories in which my friends and I were forever young.

I never thought of myself as an environmentalist until people began to call me one. I still have trouble with the "radical environmentalist" label. It doesn't offend me; it just doesn't fit. Radicals, to me, do radical things, such as poison the water and air, eradicate hardwoods, and destroy wildlife habitat.

It was Pete Gunter's 1993 book *The Big Thicket: An Ecological Reevaluation* that first sparked my activism. Gunter's account of the struggle to establish the Big Thicket National Preserve illustrates the extent to which we humans are willing to exploit the earth and its finite resources. Few quotes outside the Holy Bible ever stirred me quite like the statement by Archer Fullingim, the well-known eccentric editor of the *Kountze News*, speaking of logging in the Big Thicket, as quoted by Bob Armstrong in his foreword to Gunter's book: *"Look up and listen. In here you can hear the Holy Ghost, and they're cutting it down, Boy! If we don't do something, it'll all be gone."*

I decided then and there that real environmental change had to begin with us—you and me. We can't wait for our leaders. We don't have time. These days we worry about growing terrorist activities, but other problems that could sicken and kill whole generations of our children and grandchildren are environmental ones—water degradation, topsoil loss, air pollution, and climate change. Some of today's youth may feel they have inherited problems too great to do anything about. They have not. All it takes is getting involved.

By 1995 I was semi-retired and began to seek out old hunting and fishing sites, only to find that many were no longer available. Fences had sprung up everywhere, and the countless old wagon roads that had led to the river for generations lay out of reach behind the "Posted" signs of hunting clubs. In some places the

towering trees were gone, replaced with neat rows of planted pines. Years earlier I had surrendered the visceral urges to hunt or bait a hook, but I still longed to revisit places I once thought "our own."

Our public lands, the national forests, are suffering, too. Clear-cutting and "Timber Stand Improvement" practices, a euphemism for killing hardwood trees, are transforming large areas of our public lands into pine farms. I was thankful to find parts of the Neches bottomlands intact and more awesome than I remembered. Many huge two-hundred-year-old and older pines have been killed by the southern pine beetle, but the hardwoods are thriving. And the old dead pines are not "going to waste," as some people say. These decaying trees remain a food cache for birds, insects, and other wild creatures until the last powder of the rotting stumps melts, returning their rich nutrients to the earth.

It is the national forests on the creeks and slopes that concern me. The hardwoods that grow along the upland creeks and rainwater branches are under attack. They are being destroyed to make room for pines. Some in the U.S. Forest Service still think of the national forests as timber-growing mechanisms for pine production. Today a growing segment of Americans wants the Forest Service to focus on taking care of the things that make the lands they manage so special: naturalness, clean water, abundant wildlife, recreation, and land use choices for future generations.

Caught up in forest preservation issues, I was totally unprepared for the December 14, 1998, headline and big full-color illustration on the front page of the *Lufkin Daily News*. "Neches River Basin" was the headline, and a brightly colored map depicted the Neches River as a string of lakes from Lake Palestine in the north to B. A. Steinhagen Lake in the south, with the proposed Rockland and Fastrill reservoirs bulging in between. There has been talk of building a giant dam across the Neches at Rockland, Texas, since Congress authorized the project in the River and Harbors Act in 1945. Since that date, several attempts to build the dam and reservoir have surfaced, but lacking eco-

nomic justification, they failed to get government approval and financing. Strong opposition by homeowners, landowners, timber companies, environmental organizations, and farmers and ranchers finally led to the deauthorization of the project in 1988.

The *Lufkin Daily News* article described the probable division of the river's water between the Upper Neches River Municipal Water Authority (UNRMWA) in the upper reaches and the Lower Neches Valley Authority (LNVA) to the south.

These water people are divvying up my river, I thought, the river of my youth, where I strung trotlines and throw lines, along the banks of which I crept with gun and dog, and where I fed countless mosquitoes. They were laying claim to our river, yours and mine, the people's river, a river rich in history and tradition.

The most alarming news in the article was that the Rockland Dam and Reservoir Project had been resurrected. Conservationists work hard to protect Texas' hardwood forests, rivers, and streams by preserving ten acres of hardwoods here, a puddle of wetlands there, and another twenty acres somewhere else. The giant Rockland Dam alone, in one fell swoop, would inundate 126,000 acres of some of the finest and last remaining bottomland hardwoods in Texas. How, I asked myself, can those who supposedly represent us and are charged with looking out for our best interests not see the social, economic, historical, and ecological richness of this wild, watery corridor of life? Don't they understand what would be lost if the dams were built?

Several polls and studies show that a large percentage of the people of Texas are more than a little concerned with the continued degradation of our environment. Texans are particularly worried about exploitation of the state's land, water, and wildlife resources. *Protecting the Wide Open Spaces of Texas,* a publication of Sierra Club's Lone Star Chapter, relates: "Out of the fifty states, Texas ranks number one in the amount of open space lost to development. . . . According to a recent U.S. Department of Agriculture study Texas lost 893,500 acres from 1992 to 1997 at a rate of 178,700 acres per year." In July of 2004, Gary Cartwright wrote in *Texas Parks and Wildlife* magazine: "Every two minutes

another acre of Texas farmland or open space becomes a subdivision, or mall or road." More than 4,400 miles of Texas' rivers, over one-third of those monitored, are so polluted that they do not meet federal standards set for recreation and other uses. As Texas continues to grow in population, it is likely that leapfrogging developments will devour more land, and growing industries will consume and pollute still more streams. In addition to the plans to construct new dams across the Neches River at Fastrill and Rockland, a proposal to increase the height of Dam B (B. A. Steinhagen Lake) by as much as seven or twelve feet is also on the drawing board. If the height of the dam were raised, Martin Dies Jr. State Park, Forks of the River (at the confluence of the Angelina and Neches rivers), and the Angelina/Neches Rivers Wildlife Management Area would all be destroyed.

Another illuminating report, by the National Wildlife Federation, illustrates just how badly state water planning officials are out of sync with the vast majority of Texas voters. According to the survey, 93 percent of all Texas voters say it is important for Texas to provide adequate protection for rivers, bays, and wildlife in all water plans. Ninety-one percent believe water projects should be proven cost-effective before qualifying for state funding, and voters prefer that cities adopt water conservation measures as opposed to building new dams and water pipelines. Yet our regional water planning groups seem to concentrate on doing just this—constructing dams and pipelines.

I saw two of Texas' finest rivers, the Angelina and the Attoyac, disappear when the Sam Rayburn Reservoir was built in the 1960s. The reservoir, as it was presented, seemed like a good idea in the region at the time. There would be jobs. People would get rich. Concrete and steel, whether in dams, highways, or parking lots, were seen as inherently good. Opposing them was like refusing to salute the flag—just plain un-American. The local newspaper, some powerful timber interests, and the unfortunate people who owned land that stood in the way of "progress" did oppose construction of the dam. Anyone who has seen the huge reservoir can see that they lost. In the spring of 1965, the gates

were closed on the newly constructed Sam Rayburn Dam, blocking the Angelina River's flow toward the Neches. On that date, the Angelina and Attoyac rivers for all practical purposes ceased to exist.

As the promoters had said, there were jobs. They lasted for seven or eight years, but no one I know got rich. A few individuals probably did, but they did not live here. Some undeniable benefits did accrue from erasing so much prime wildlife habitat: Sam Rayburn Reservoir offers excellent opportunities for fishing, duck hunting, and all sorts of water sports. Many consider the lake among the finest bass fishing lakes in the United States. Other game fish, such as catfish and crappie, also are found here in great numbers. However, this recreation came not only at a high economic and environmental cost but also at a huge human cost. The lives of many families who lost their land, homes, ancestral cemeteries, farms, and ranches were shattered. Many of their descendants, to the third generation, are still bitter today. Thirty-five years after he and his wife were forced to move and accept less than their land was worth, one gentle old man, J. T. McGilberry, a family friend, would break into tears if he attempted to talk about his and his forebears' farm.

I pushed aside the thought of Rockland Dam for the moment but never completely forgot it. Then, continuing my process of self-education on forest issues, I began reading the U.S. Forest Service's 1996 *Final Environmental Impact Statement for National Forests and Grasslands in Texas*. It took all the discipline I could muster to lift and get through this almost seven-pound tome. After wading through page after page of material about timber harvest and management, road construction, prescribed fire, and other more favorable topics, I reached Appendix E, "Wild and Scenic River." I continued to read with only mild curiosity until the sentence: "The potential exists for designation of the Neches River as a segment of the Wild and Scenic River System of Waterways." My excitement soared as I learned that in 1982 the National Park Service had identified the Neches from the north end of B. A. Steinhagen Lake upstream to Lake Palestine as

having "outstandingly remarkable scenic, recreational, fish and wildlife values." The Park Service described the Neches as "one of the most scenic waterways in East Texas."

Highly trained scientific people had studied the river and had deemed it extraordinary and worth preserving. They had confirmed what I inherently knew.

The Forest Service plan defined the qualifications and procedure necessary for obtaining "Scenic River" status and described the attributes that validated the nomination of the Neches River for this honor.

The Wild and Scenic Rivers Act states that "certain selected rivers of the Nation which, with their immediate environments, possess outstandingly remarkable scenic, recreational, geologic, fish and wildlife, historic, cultural, or other similar values (including ecological values), shall be preserved in free-flowing condition, and they and their immediate environments shall be protected for the benefit and enjoyment of present and future generations."

I laid the big manual down almost reverently. Providence had placed the solution before me: the Neches River, between Lakes Palestine and B. A. Steinhagen, is eligible for a Scenic River designation under the Wild and Scenic Rivers Act. The Neches can be preserved in its almost pristine state through this act. Future generations of Americans can have a window into Texas' early frontier.

What is a Scenic River? It is a river segment "free of impoundments, with shorelines or watersheds still largely undeveloped, but accessible by roads." The National Park Service in Washington, D.C., states in its brochure *National Wild and Scenic Rivers System:* "The principal effect of the Wild and Scenic Rivers Act is to preclude the construction of dams and other water resources projects, which would adversely affect the free-flowing nature of the river and its natural and cultural values."

Will this Scenic designation force local people off their land? Will recreationists and hunters have access to my private property if the river is designated? Will the federal government enact zoning restrictions on my property? The answer to these three ques-

tions is a definite no. Will it curb Neches River landowner activities, such as timber harvesting? The answer is maybe, depending upon the landowner's current land management practices.

The *Interagency Wild and Scenic Rivers Reference Guide: A Compendium of Questions and Answers Relating to Wild and Scenic Rivers* (January 1999) speaks to these questions as follows:

(1) "It is not the government's role or desire to interfere with, or regulate activities on, private lands in order to meet the intent of the [Wild and Scenic] Act" (pp. 60–61).

(2) "Wild and Scenic Rivers are not 'river parks,' a term used to suggest public ownership of land given over to recreational pursuits" (p. 5). Private property rights will remain steadfast and will be enforceable to the fullest extent of the law.

(3) "Under the Act, the federal government has no authority to regulate or zone private lands" (p. 37). Zoning on private lands is solely the jurisdiction of state and local authorities.

(4) Designation of the Neches River "is not likely to alter timber harvesting or logging practices beyond existing limitations" (p. 39). Currently, all activities must comply with the requirements of state law and the federal Clean Water Act. Many environmentally conscious local timber producers will experience little inconvenience, if any, because they already voluntarily comply with the Sustainable Forestry Initiative, which encourages "streamside management zones" to protect water quality, limit soil erosion, and enhance wildlife productivity. The Scenic designation seeks to protect and enhance these same characteristics and would protect the river that is such an important part of the area's entire ecosystem.

Designating the Neches a Scenic River is a three-step process. First, a study bill must be passed by Congress, allowing the National Park Service access to previously appropriated funds to

complete a study of the Neches River's outstanding values—its aesthetic, scenic, historic, archaeological, and scientific features and free-flowing state. Second, a three- to four-year study of the Neches River must be performed; and third, Congress must pass another bill actually designating the river.

During the designation process, a committee of Neches River landowners, members of local and state governments, and the general public will be assembled to participate in developing the plan by which the Neches River will be managed. The National Park Service will aid the committee by offering guidance and technical assistance.

Ultimately, designation of the Neches as a Scenic River would allow landowners to keep their property as dry land to enjoy, rather than having it condemned and submerged under twenty-five to fifty feet of water. It would place the Neches beyond the grasp of people wanting to dam it up and pump it dry!

If we could give the people of our state a sense of the Neches River as I know it, I thought, they would insist it be preserved for future generations of humans and wildlife alike. The question was: How could a small group of volunteers endear this river to Texans? How could we distribute compelling information to the general public? These thoughts and questions puzzled me for days before the idea came to me. If we were to develop and promote a 235-mile canoe trip between Lakes Palestine and B. A. Steinhagen, we could showcase the river's natural beauty; explain the vibrant bottomland hardwood habitat system so crucial to wildlife production; describe the importance of the river's freshwater inflows into the Big Thicket National Preserve and the Sabine Lake estuary, where many marine life species reproduce; and we could reveal the water developers' plans to inundate hundreds of thousands of acres of private property and bottomland hardwood habitat and place them underwater forever.

Would our efforts arouse public interest in rescuing this unique river? I was hopeful they would.

Our grown daughter Gina and I, a few years earlier, had canoed the Neches from State Highway 7 to State Highway 94,

a distance of about eighteen miles. Later we floated and paddled from Highway 94 to the boat ramp at U.S. Highway 59, approximately twenty-four miles. Except for these two trips, I had not paddled a canoe or boat any appreciable distance for forty years. Now I was thinking about paddling 235 miles—was it possible for me, at age sixty-five, to meet the physical challenges? If it would get our message out, I would make the attempt.

What was our message? To save a river, of course, but how could that be made compelling? To achieve any degree of success, it would be imperative to articulate a sense of this outstanding river. At least two generations of Texans have grown up knowing only the sketchiest of details about rivers. Rivers are much more than ditches filled with flowing water; they are links to our past and our hope for a healthy and environmentally diverse future.

We would tell about the Neches and the people who have walked its banks, fished its waters, and harvested its bounty. We would tell about the animals that come to the river to drink and about the birds, big and small, that wade along the water's edge seeking bugs, reptiles, and small fish for food. We would give people a mental picture of eagles sitting on broken treetop snags and help them hear the sounds of night. We would share the rewards of silence and solitude and of becoming an unobtrusive part of the world around us. The Neches would tell our message for us if we would only listen and watch.

In September, 1999, we presented the idea of the proposed Neches River Canoe Expedition to the local media, the *Lufkin Daily News, Jacksonville Daily Progress,* and KTRE-TV Lufkin-Nacogdoches. They thought the adventure was newsworthy, and a simple media plan was developed.

Buoyed by the endorsements, I began preparations for the river trip. It would be necessary to start from scratch. I owned nothing in the way of camping supplies. There was a canoe; Gina and I had purchased the seventeen-foot aluminum Grumman in 1997. For most of the time since then, the canoe had been turned upside down behind our garage. I also had two

wooden paddles; one came from a discount store and the other had been around so long that I had forgotten about it.

As I began to assemble the items necessary to make the trip enjoyable yet frugal in weight and space, I learned that it is not an easy task to fit one's life into a seventeen-foot canoe. The final pared-down list included a life vest, water container, two paddles, stove, cooking utensils, tent, sleeping bag, mattress pad, flashlight, insect repellent, towels, soap, and a small limb saw. The saw would be needed to cut a path through tree-falls blocking the way down the river.

The one-person tent was an easy decision. It was small and light and had two zippered door panels with insect screening to allow ventilation. I chose a seven-gallon plastic water container and a big, tough plastic box to serve as a combination food/gear box. My camp stove would be a Coleman propane canister with one small burner screwed onto the top.

I kept the menu simple. Breakfasts would be mostly sweet rolls and coffee. Lunches and evening meals would consist of canned sausages, pork and beans, rice, noodles, summer sausage, flour tortillas, Nutri-Grain and granola bars, and instant hot chocolate.

Bonnie was apprehensive about my safety and wanted me to take along a cell phone for emergencies. She was disappointed to learn that a phone signal would be almost nonexistent in most of the remote Neches country. I was not too concerned; the many hours of my youth spent fishing, hunting, and camping gave me confidence that I should be able to deal with most of the problems that might arise.

At the meeting with the press, it was agreed that I would keep a journal of daily experiences and give segments to Bonnie at selected highway crossings along the route. This journal would record the mundane and the spectacular, the ugly and the beautiful. I would make a special effort to describe the creatures that swam in the river and walked along the water's edge as well as the birds that flew in the air above. Bonnie would type the notes and e-mail the installments to the newspapers and TV station.

This narrative, *Paddling the Wild Neches*, is a compilation of those terse, often hastily recorded 1999 journal entries, excerpts from written and oral historical accounts by people whose lives were shaped by the Neches environment, and anecdotes of personal experiences along the river.

Writing a book about my experiences on the Neches River was the farthest thing from my mind until I received a call from Constance Whiston with the Texas Parks and Wildlife Department in Austin. Gina was serving on that agency's Texas Rivers Conservation Advisory Board and had bound several copies of my 1999 river journal for their May 19, 2000, board meeting. Providence moved one of those copies into Constance's hands. After reading the notes, she contacted me and suggested that the material might be made into an interesting book. I graciously thanked her, but I did nothing. After several months, Constance not only joined Gina in encouraging me to write but also initiated my first contact with the publisher in January, 2001. Still, I made no serious effort until several friends insisted that this book be written. I am grateful to all those who pressed me to do this. They are right: the story of the river needs to be told.

The Neches River and Its People

TO UNDERSTAND ANY REGION, its physical geography, and its people, one must first understand where they came from, or the forces that forged them into their present form and culture. The natural components of rainfall, sunlight, elevation, and soils along the Neches corridor combine to produce some of the most varied conditions and luxuriant biodiversity found anywhere. These conditions and the plant and animal life they foster have drawn men and women here for thousands of years. People and the forces of nature have interacted, sometimes with great tumult, to write the history of the river.

The Neches River originates at an elevation of 545 feet in northeast Texas, east of Colfax in Van Zandt County. The springs come out of the ground as a cool trickle about six inches wide. As the water flows down the sandy hillside, it is joined by numerous other seeps and springs. By the time it reaches the bottom of the hill, the water has become a respectable spring-fed creek. From its origins on the sandy hillside, the Neches flows some 416 crooked miles through the very heart of Texas' forestlands to its mouth at Sabine Lake and the Gulf of Mexico. In the river's watershed can be found some of the most diverse hardwood forests remaining in Texas. These great hardwood forests are being cleared at an ever-increasing rate, but their early abundance helped sustain generations of both Native Americans and early European settlers.

The Indian population in the Neches Valley reached its peak sometime after the arrival of the Caddos in about A.D. 780. It is estimated there were thousands of Caddos hunting and farming the Neches Valley in 1542, when the tattered remnants of Hernando de Soto's expedition staggered into East Texas, looking for a route to Mexico. The first Spaniards were greeted with the word *tejas*, meaning friend, and they concluded this was what the

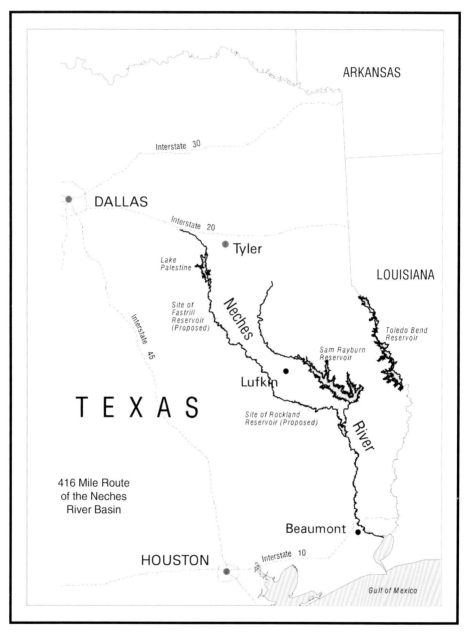

MAP 1. *Course of the Neches River. From its source near Interstate 20, this historical stream flows through the forested region of Texas before emptying its silt-rich waters into Sabine Lake Estuary and the Gulf of Mexico. (Courtesy Natural Area Preservation Association)*

natives called themselves. Thereafter the land east of the Trinity River was known as Tejas, later evolving into Texas.

The first European settlement in the province of Tejas, the Spanish Mission San Francisco de los Tejas, was built in 1690 near the mouth of San Pedro Creek, where it empties into the Neches River not far from Weches.

The Spanish gave the Neches its name as they did most of the other rivers and streams in the state. They took the name from the Caddo Tejas Indians, who called it Nachawi, their name for the bois d'arc trees (French for "wood of the bow"; Texans pronounce it "bodark") that grew along its banks. The Caddos used wood split from these trees to make their excellent hunting bows. It was also highly prized by other Indian tribes, and the Caddos used it effectively in their bartering.

The Spanish made several efforts to establish a permanent colony among the Neches Caddos, but all attempts failed. Then in 1779, Antonio Gil Y'Barbo led back to the area that is now Nacogdoches a group of settlers who had fled the region three years earlier, and they reestablished a settlement that today lays claim to being the oldest town in Texas.

Twenty years after the successful founding of Nacogdoches, tribes of other Native American nations began drifting into and settling in the Caddo lands. These new immigrant tribes included Choctaw, Kickapoo, Shawnee, and Cherokee. Of these newcomers, the Cherokee composed the overwhelming majority. These Indians lived here in relative peace for about thirty-five years, until Mirabeau B. Lamar was elected the second president of the Republic of Texas. One of Lamar's first priorities as president was to purge all Indians from the "settled areas" of the young nation to make way for new Anglo settlers.

Lamar and the Texans permitted one tribe of Native Americans, the Alabama-Coushatta, to remain in the new republic. These peaceable Indians were originally two tribes. Like the Cherokees, Shawnees, and similar tribes, they had been pushed from their native lands by the westward advance of the whites. They crossed into and out of Texas several times but by 1836

had established themselves at a site they called Ta Ku La, or Peach Tree, in Tyler County. The Alabama-Coushattas fed and cared for many Texas families fleeing the advancing armies of Mexican General Santa Anna. Following the Texans' victory at San Jacinto, large numbers of Anglos settled at Peach Tree and gradually changed it from an Indian village to a prosperous frontier town. Finally, pressure from the whites forced Chief Colabe Sylestine to move his people away from Ta Ku La, deeper into the inhospitable Big Thicket region.

Early Anglo pioneers discovered a veritable paradise in the giant Texas forests. They found the Neches waterway populated with all kinds of ducks and fish and the forests teeming with wildlife. Numerous scouts wrote about existing on daily kills of deer and turkey. The river's bottomlands contained a great variety of trees, shrubs, vines, and cane. Since these trees and plants produced fruits and nuts in different seasons of the year, food and cover were available to wildlife all year long. A prodigious autumn mast (acorns, hickory nuts, and beech nuts) fell from thirteen species of oaks, seven species of hickories, beeches, gums, and other nut-bearing trees that grew from the river's edge into the hardwood-pine mix of the hills and slopes.

The availability of food, den trees, and nesting sites supported a wide variety of birds and animals. As recently as the early 1900s, black bears, wolves, and cougars could be found in the bottomlands. These symbols of wildness passed into history with the logging of ancient forests, destruction of large blocks of habitat, and overhunting.

The first Anglo settlers appeared along the river even before Stephen F. Austin founded his colony on the Brazos River in the early 1820s. They carefully sought out the hills and ridges, or highlands, along the outside edges of bottomlands to build their cabins. They incorrectly believed that the "fevers"—the disease we know as malaria—lurked in the mists and vapors that rose from the dark-watered sloughs, swamps, and oxbow lakes. They had the right association: swamps equaled fevers. They had no

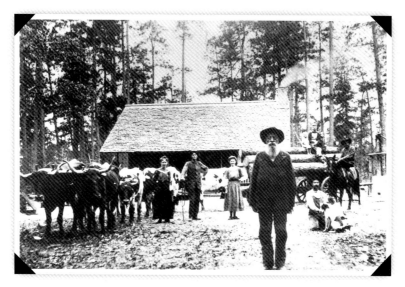

Rural family scene: this photograph taken about 1906 shows the Mott family home in the Old Concord community east of Zavalla. The "eight up" or four pairs of oxen are hitched to a log wagon loaded with pine logs. Pictured left to right are Cordelia Sanders Marshall, Ancil Hopson (bull puncher), Ruthie Mott, Hiram Mott, and Silas Mott with dogs. On logs are Evelyn Mott, Sam Sanders, and Gladys Sanders. Bill Sanders sits on the horse with one leg crooked around the saddle horn. A moderate south wind pushes smoke away from the chimney. Note the hand-split shingles on the roof and the long-handled ox whip in the puncher's right hand. The long handle allowed the driver to reach above the animals and apply the "cracker" to the backs of oxen that were not performing. It was also used as a prod to "punch" the animals. (Museum of East Texas, Lufkin)

way of knowing the mosquitoes that thrived in the swamps and sloughs were transporting the malaria parasite.

These first settlers often were "running from something" and quietly disappeared into the forest wilderness. They brought with them a way of life that endured almost unchanged in rural East Texas until the 1960s. Thad Sitton's excellent book *Backwoodsmen:*

Stockmen and Hunters along a Big Thicket River Valley defines this way of life as a hunter-gatherer, farmer-stockman society. Of these pursuits, farming was allocated the least time and effort. Corn, beans, squash, melons, and sweet potatoes—the same foods the Indians raised—were planted. The settlers cared little for owning the land; they used it as a "commons," much as the Indians had done.

Free range for livestock and unlimited hunting and fishing were the keys to the settlers' survival. Stockmen turned their hogs and cattle loose in the river bottoms, where the animals thrived on switch cane and the abundant mast that fell from hardwoods growing in the rich, seasonally flooded land. The settlers practiced a southern, forest-adapted tradition of stock raising that was vastly different from that found farther west. The plaited rawhide stock whip with its buckskin "cracker" tip was an essential tool for working cattle in thick woods. The stockman used the horse for travel and to keep him away from his dangerous livestock. When an animal needed to be caught and held for castration, marking, or "doctoring," the stockman turned not to his horse and rope but to his dogs.

Trying to drive wild cattle and hogs on horseback as the western cowboy did was impossible through the woods, sloughs, and thickets. It was only with the help of the versatile stock dogs that the livestock could be located, bunched, and moved, sometimes miles, through tangled vines and thickets into pens for "working" or selling.

In the 1940s and '50s, when I was a boy growing up in Angelina County, the brothers Hubbard and Wes Pouland and Mr. Boy Dykes had more semiferal hogs and cattle than just about anyone I knew. The Pouland brothers' animals populated miles of the Angelina River around Old Concord (now under the waters of Sam Rayburn Reservoir), and Boy Dykes's livestock ranged in the Best Bend of the Neches River (smack in the footprint of the proposed Rockland Dam site). Almost all stockmen had dogs, but these men were known for having some of the best. They

realized that well-trained dogs were as valuable as any possession they owned. They simply could not exist without them.

The Neches and its surrounding lands remained essentially a wilderness until the late nineteenth century and the coming of the lumber mills that wiped out Texas' virgin forests. These big mills are too numerous to mention by name, but most resembled the mill located in the ghost town of Old Aldridge. The skeletal remains of this once-thriving sawmill can be seen today a few hundred yards from the Neches River in Angelina National Forest, near Boykin Springs Campground.

World War II, and the decade following, presented additional demands on the river's bottomlands. America and Mexico were building railroads and needed crossties. "Peckerwood" mills sprang up all along the Neches, and a large majority of the remaining hardwoods were sawn into crossties. These small mills earned the name *peckerwood* from the woodpecker: like the bird,

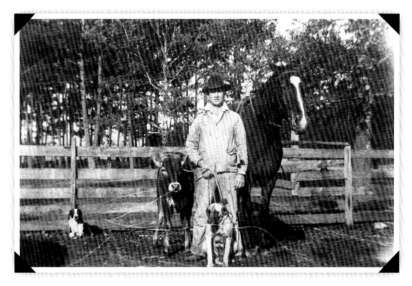

A pet calf stands beside Avy Joe Havard and his cur stock dog, Smokey, before he mounts his horse to check his stock in the Neches bottom, 1937. The jacket and pants Havard is wearing were made from sugar sacks by his wife Pearl. (Pearl Havard, Diboll)

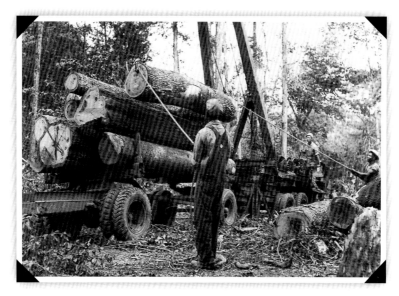

Loading hardwood logs: by the 1960s mechanized equipment had made it much easier to log hardwoods from the bottomlands. (Texas Forestry Museum, Lufkin)

the operations flitted from site to site, leaving only a pile of sawdust to mark their passing. After logging an area until the timber was exhausted, the loggers quickly moved to another location and began cutting again. They also removed the last remnants of the great Neches bald cypress trees that early Spanish explorers had described in awe.

Nothing on earth is infinite, and after at least one hundred years of exploitation by "civilized" man, the Neches country was almost exhausted, its seemingly endless bounty essentially used up. Fortunately change was in the air, not planned or orderly change but change born of inescapable forces brought about by different life circumstances.

Launching the Expedition

The face of the water, in time, became a wonderful book . . . delivering its most cherished secrets as clearly as if it uttered them with a voice. And it was not a book to be read once and thrown aside for it had a new story to tell every day.

—Mark Twain, *Life on the Mississippi*

Saturday, October 2, 1999

It is still dark when I roll out of bed and begin stowing the last pieces of gear into the pickup. The days of planning are over. Reality begins today! I had hoped it would rain to raise the water level of the Neches, but no such luck. There are a lot of unanswered questions. Will the river channel be so clogged with tree-falls that it will be impossible to canoe? If I complete the journey, will it arouse public interest in the river's plight? Will that interest translate into public action? Are today's Texans really concerned about preserving wild places for foxes, raccoons, bobcats, white-tailed deer, turkeys, ducks, and songbirds? Or have our passions been so consumed by neon, concrete, and tinsel that we simply view extermination of wildlife as one more cost of a consumer society? Maybe I'll find out.

Bonnie surveys my packing efforts. She lifts the life vest from the bed of the truck, where it is sure to blow out, and tucks it safely behind the seat. With the canoe trailer securely fastened behind the truck, we are ready. A stop for breakfast at Mike's IHOP and forty-five minutes later, we are northbound toward the intersection of U.S. Highway 175 and the Neches River.

At 8:40 A.M. we turn west from Jacksonville onto U.S. Highway 175 and proceed to Cuney, where we turn right on a narrow

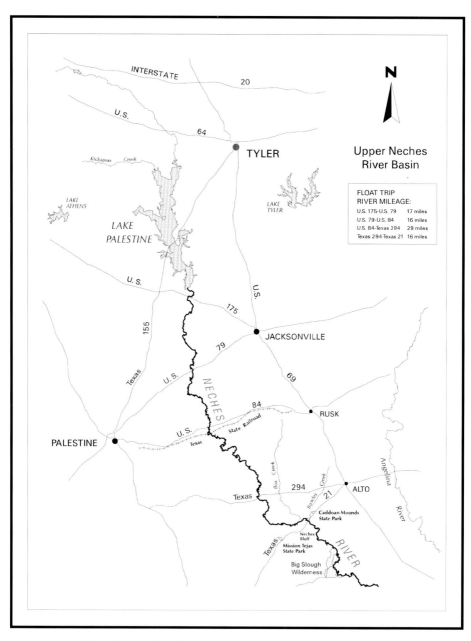

MAP 2. *Upper Neches River from Lake Palestine to State Highway 21.*
(Courtesy Natural Area Preservation Association)

dirt road that leads down beside the bridge to the river. James Ray, a Jacksonville advocate for protection of the Neches, Jay Graham, reporter for the *Jacksonville Daily Progress*, and Ed Furman of Palestine, president of East Texas River Runners, are waiting. Zach Maxwell, reporter for the *Lufkin Daily News*, arrives moments later.

Bonnie and Ed help me lift the canoe from the trailer into the water while Zach and Jay check out the river. Furman advises us that the water is extremely low and there will be numerous tree-falls before reaching U.S. Highway 79, and still more farther south, before crossing under Highway 84. He has little advice for what lies beyond that point. It matters little now. It's hard to imagine enough trees in the river to make me quit. This canoe trip is intended to highlight the wonders of the Neches and begin the initiative to have it protected under the National Wild and Scenic Rivers Act.

We load the seventeen-foot Grumman with the seven-gallon plastic water container, paddles, limb saw, and the big plastic box that holds the tent, sleeping bag, food, and other supplies. Zach and Jay have a couple of final questions: "What kind of food are you taking, and where will you sleep?" Ed Furman insists I take a paddle he has fetched from his truck. It is a queer-looking instrument. The blade is bent at close to a 17-degree angle to the handle, and it doesn't look very durable. His offer is so generous that I feel compelled to accept, but I resolve to keep the paddle safely under the seat.

I step into the canoe and push away from the bank, excited about what lies ahead on this long-anticipated adventure.

The river's cargo of nutrient-rich silt lies deposited behind Lake Palestine Dam, leaving the water almost clear with a slight greenish hue. The current is surprisingly strong despite the below-normal rainfall for the season. Immediately beyond the bridge, the Cherokee County side greets me with a sloping, wooded bank that drops off abruptly at the river channel. The four- or five-foot face of this drop-off is colored in dark shades from cocoa to ebony. There are places where slabs or chunks of

the face have broken off, revealing bright orange earth beneath the black exterior crust. The blackness is probably a result of the oxidation process of naturally occurring iron particles in the soil.

Rivulets of water are streaming and dripping into the river, constantly refreshing the emerald moss and soft green ferns that drape over the bank's upper edge.

Four fallen trees block the river within the first thirty minutes. I bend low and squeeze under two of them but have to drag the canoe over the others. My learning curve experiences a sharp upward spike at the last tree-fall crossing. As I carefully reenter the canoe after pulling it over the log, the fractious craft skitters sideways, dumping me into four feet of water. My weight shoves one gunwale under, and the plastic bailing cup is floating in at least six inches of water. It is a simple matter to pull the canoe to shore and bail the water, but my pride takes longer to recover.

Numerous ducks fly ahead of the canoe. Two wood ducks surprise me by taking flight no more than a dozen feet from my paddle. The female's high-pitched flight squeal is my first inkling they are there. The male, with his red, green, blue, and white markings, is beautiful. Mallards, too, flush off the water as the canoe approaches.

Cat squirrels keep up a steady chorus. Only when four red-shouldered hawks begin circling low overhead do they hush.

The river channel is not as deep in these northern reaches as it is farther south. The shallow channel here affords more opportunities to see over the banks and out into the woods as I travel downstream.

The abandoned St. Louis Southwestern Railroad trestle briefly casts its shadow across the river as the current pushes the canoe and a floating Clorox bottle along. A large block of the forest has been clear-cut; hundreds of large hardwood stumps are everywhere. Many of the felled trees were growing along the water's edge.

Ahead of me, two cormorants flush and circle overhead, waiting for me to move downstream so they can return to their perch.

An old homestead sits just off in the woods, and a sound seldom heard any more reverberates up and down the river. Two hounds have spied the canoe and are baying their warning of my approach. The dogs must either be tied or be locked behind a fence; they never make an appearance. The canoe glides quickly past.

The river narrows, and trees of all kinds reach across and touch. A good, strong spring flows in, nourishing the river. The current takes me beneath a wild persimmon tree loaded with ripe fruit. It would be a treat to stop and sample the fruit, but there hasn't been a frost yet. Wild persimmons are delicious after a frost or after they are kept in the freezer overnight. A frost removes the bitter taste and greatly enhances their flavor.

Ch-luunk! Ch-luunk! Two turtles, each about the size of a cereal bowl, fall five feet from the bole of a small water hickory growing almost horizontally above the river and splash into the water below. For as long as I can remember, the Neches has had a robust turtle population. Today, as in the 1950s, logs lying in or near the water are covered with turtles basking in the sun. Sometimes they are lined up head to tail, looking like tiny Volkswagens waiting at a red light.

These turtles usually range in size from not much bigger than a silver dollar up to as large as a syrup bucket lid. (The larger ones, like the alligator snapping turtle, reaching weights of 150 pounds, spend most of their time on the bottom, and are seldom seen.) They all seem to have differing "comfort zones." Frequently only telltale entry splashing several hundred feet downriver reveals that a couple of turtles or perhaps a dozen have detected the approaching canoe and sought refuge below the water's surface. Others may allow the canoe to approach within fifty feet before bailing off their log, and on rare occasions, a small turtle may cautiously watch with outstretched neck as I paddle past. Most of these turtles are red-eared and yellow-bellied sliders, but other more interesting species lurk below the surface.

The ugly, ill-tempered and prone-to-bite common snapping turtle can reach a weight of twenty to thirty pounds and can

strike with the swiftness of a snake. Its strong, sharp beak can sever a finger or toe with blinding speed. Snappers are rarely seen except for the tip of a snout poking above the water or perhaps caught on a trotline. Many times I have lifted a motionless trotline or throw line, only to find that hungry turtles have stripped the bait from all the hooks. Sometimes the bait thief itself would be dangling from a hook that should have held an Opelousas mud cat.

Snapping turtle meat is considered a delicacy by some and is eagerly sought for making turtle soup, but the preferred eatin' turtle of the Neches folks was the soft-shelled. Like the irascible snappers, those shy creatures are seldom seen except when they can be surprised floating on the surface or basking near the water's edge. Old-timers used to say that soft-shelled turtles contained flesh that tasted like several different kinds of meat, including chicken, pork, beef, fish, and maybe others. One of my Zavalla friends, now deceased, used to tell of stumbling upon the camp of one of his elderly relatives. The old hunter-fisherman was sound asleep on a willow-shaded sandbar. Nearby was the shell of a twelve- or fourteen-inch soft-shelled turtle, carefully banked in a bed of hot coals, in which was baking a "pone" of golden brown cornbread.

Open Range and Livestock on the Roads

THE RIVER FLOWS under several wooden bridges before pastureland begins to appear on the Anderson County side. This appears to be cattle country. Seventy-five years ago these pastures were probably growing King Cotton instead of cattle.

My approach surprises a small herd of crossbred Brahmans; some are belly deep in the river, drinking. The fat, broad-backed, and hornless animals in this herd bear little resemblance to the tough cattle that ranged the Neches Valley prior to the enactment of stock laws in the 1950s. Livestock roamed freely in the

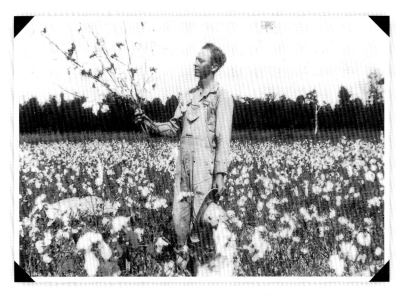

Cotton farming was an economic force in the area of the Neches redlands, Shawnee Prairie, and a few other places along the river's flow. At a smaller scale, for families along the Neches drainage a small cotton patch often provided the only means of acquiring cash for the essentials of life. Pictured in the 1930s, William Crain of the Bellevue community admires his crop, ready for picking. (Lois Broussard, Buna)

Neches bottoms and across Texas after early Spanish explorers brought animals here in the 1700s. As American settlers poured across the Sabine and Red rivers, after Texas' admission into the Union, they brought more hogs and cattle and released them to forage the open range. From the earliest settlement until the 1950s, custom, and to some extent law, regarded all unfenced land as common property for hunting, fishing, and grazing. This "living off the land" and the Indian idea that the land belonged to everybody worked fine as long as populations were sparse and automobiles were not tearing about at fifty and sixty miles per hour.

By the time of my first memories, large numbers of cattle and hogs still wandered the railroad tracks, roadsides, and just about anywhere vegetation could be found. Even towns and communities were not immune to the presence of these marauding animals. Progressive townspeople resented the hayseed image that cattle and hogs roaming in their streets fostered, but the half-wild stock was more than just an image problem. The animals could be a nuisance and were often destructive.

Southern Angelina County's rural community of Zavalla, nestled in a small valley nine miles from both the Neches River and the Angelina River, was typical of many small (and some large) communities across the state. Some of my parents' Houston friends dubbed Zavalla the "town of hogs, logs, and dogs." Cattle and hogs loitered in the streets, sometimes lying down and blocking traffic. The animals ravaged gardens, broke into barns, and deposited unsightly, stinking piles of dung everywhere. Occasionally someone's old, worn-out stock dog (many of these loitered in the streets, too) would stir to bark and chase intruders for a short distance. Then, satisfied with its brief work, it would return and resume napping on the sidewalk or under someone's wagon or truck.

Most people, even those living in town, kept a milk cow to provide milk and butter for the family. Most kept a number of "laying hens" and "fryers" in a small chicken yard. The laying hens produced fresh eggs, and the fryers provided meat for Sunday

dinner and other special meals. Almost everyone had a garden to grow fresh fruit and vegetables for daily meals and canning. Frequently watered and freshly mown yards had not become an American status symbol, but there were flowers—bachelor buttons, four o'clocks, cannas, verbenas, hydrangeas, gardenias, and more—gracing the majority of yards.

A loose, sagging fence or a gate carelessly left open was an invitation to disaster. Wandering livestock were sure to discover the opening, and there was no limit to the amount of damage they could do. They would eat the flowers and garden plants. They might tear down the clothesline laden with clean, wet clothes and trample them into the ground. They would shove the barn door open and eat the chicken and cow feed. Hogs were worse than cows. Almost anything a hog could get its snout under it could also crawl under. They were capable not only of eating the chicken feed but also of eating the chickens. They would root up the garden and fruit trees and might even get into the house. If a hunting or fishing camp were left unattended, all the food and gear had better be secured up in a tree. Feral hogs would likely be into it before the campers were out of sight. The only difference between a camp destroyed by hogs and one ravaged by a bear was: hogs couldn't climb trees.

As more and more people added more and more animals to their herds, the oft-repeated "tragedy of the commons" was played out—too many stockmen striving for infinite profits from a finite resource: the land. The once bountiful open range had been vastly overstocked and could not sustain the large numbers of hogs and cattle pastured there.

The land, too, had been forever changed. The logging of the forests, beginning in the late 1800s, had significantly reduced the bounty of foodstuffs the forests and river bottoms once provided and had forced the half-wild livestock to alter their traditional feeding habits and seek forage anywhere it could be found.

By the time World War II ended in 1945, numerous gravel and hard-surfaced roads had been built, and livestock began congregating along these roadsides for a number of reasons. Primarily,

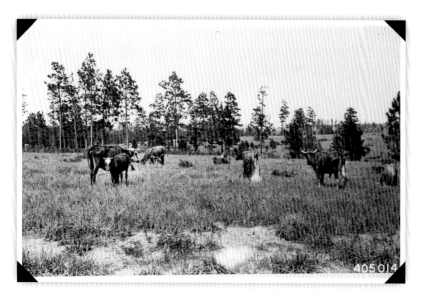

Open range: cattle graze poor quality grass on the Angelina National Forest in 1935, twenty years after the land was stripped of its trees. (U.S. Forest Service, Lufkin)

that was where the food was—grass and tubers growing in the rights-of-way. Hungry animals were forced out of the forests into towns and onto highways in search of food. In addition, the animals sought the open roadways for breezes that provided some relief from the stifling summer heat and the blanket of flies and gnats that constantly plagued and tormented them. Since large numbers of cattle were already collecting along the highways, it was only natural that stockmen would begin distributing winter hay along these roads.

Aaron Barge, owner of the local general store, cotton gin, and numerous farms and ranches, was the biggest cattleman I ever knew personally. He was not a Richard King or a Charles Goodnight, but there were cattle wearing his triangle brand for five miles in every direction from Zavalla. In the wintertime, when Mr. Barge's top hand Luke fed cattle at the corrals behind his house, cattle would spill over into the intersection of U.S. Highway 69 and State Highway 63, often blocking traffic on both

roads. I can still hear Luke's cattle call, "Wuhoooo, wuhoooo," carrying across these sixty years as he called the stock to come for hay. The cattle would come bawling from all directions, trotting out of the woods and running through the streets to eat the hay being thrown from the back of the truck. In a half hour's time, both highways would be blocked with a twisting, writhing sea of cowhide and horns.

Whoa!

Several really showy flowers growing on a round-topped sandbar catch my eye. Their fragile beauty warrants a stop for a closer inspection. The river is small and narrow, and the canoe is easily beached with a couple of paddle strokes.

The big hibiscus-like flower is a rose mallow. Its large blossom is white with a deep throat, changing from red to purple as it tapers to the bottom. The stamen begins pink and transitions to white on the ends. I had hoped this was the rare Neches River rose mallow, but it isn't. It is pretty and worth the stop; I snap several photos for the record.

This sandbar flattens along its margin with the river and forms a shallow beach covered with six to twelve inches of water. About three feet from the water's edge, a three- or four-inch black mussel is visible, creeping along the sandy bottom. Similar to oysters in appearance, mussels are clamlike bivalves and were once common in North America. When I was a youngster, mussels could be found in many creeks and streams far from the river, and most river sandbars were littered with their gaping pearly-white shells. Today, habitat destruction and pollution have rendered a large percentage of the species extinct.

The little aquatic creatures are vegetarians and feed by pulling water through a tube and over their gills. The gills extract tiny plant particles from the water before exhausting it out through another tube. If water quality is impaired, the mussels' gills become coated and clogged, causing them to die. To forage, a mussel moves by slightly opening its shell and poking out a tonguelike "foot" that it uses to pull itself along. As I watch, this one creeps

slowly along on its edge, leaving behind in the sand a small curving ditch one inch deep by one inch wide. An almost imperceptible current reveals the discharge of water from its exhaust tube as the mussel feeds in the shallow water.

Sometimes these little mollusks become stranded on sandbars and beaches as river flows decrease and water quickly retreats into the deeper channel. Hungry raccoons and river otters regularly patrol places like this, hoping to find stranded mussels on the beaches or in shallow water.

As I step back into the canoe, my curiosity about Ed Furman's misshapen paddle gets the better of me. I slide it carefully from beneath the seat, balance it in my hands, and study the area where the blade bends from perpendicular to the handle. Should the bent blade be turned fore or aft? Burying the blade in the water, I am surprised at how effortlessly it pulls through the water and pleased with the additional power it affords. I quickly decide that if the blade doesn't break off at the handle, this will be my paddle for the remainder of the trip.

Cattle choking the highways meant it became common, in both summer and winter, for large numbers of stock to bed down in the traffic lanes at night. Alert drivers traveling at forty miles per hour might see their headlights reflected from the animals' eyes in time to avoid a collision, but to travel at a highway speed of fifty-five at night was to tempt fate.

As more and more people bought cars and as speed on the roadways increased, it was inevitable that automobiles were going to crash into livestock. These crashes began to occur with alarming frequency and often with disastrous results. An angry public began to demand that the cattle, hogs, and horses be fenced.

Most of the Neches folks I knew, and the ones I didn't know, recognized that the proposed stock law was more than an ordinance aimed at keeping livestock behind fences. They knew it would exclude them from the things they needed to survive. Long-held tradition had given the stockman-farmer-hunter-

gatherer-trapper-fisherman of the Neches country the right to trespass and to range livestock on other people's property. This same tradition had also allowed them to go onto another's land to fish, hunt, cut firewood, collect honey from bee trees, burn the woods to promote grass growth, and conduct a host of other activities. The tradition had been intact in Texas for 150 years. Faced with a life-altering prospect, Neches people fought back every way they could. But in the end, the only battle that counted was the one at the ballot box, and that one they lost.

It was townspeople who brought an end to the open range. Cities and towns had grown in size and importance while rural populations declined, but public opinion did not change overnight. The open range notion held deep roots in the Texas soil. Against that strong tradition, all early attempts to enact stock laws went down in defeat. Only when the mounting carnage on the roads and highways became totally unacceptable did public opinion begin to change in favor of forcing stockmen to confine their animals. Even then, stock law proponents had few easy victories.

Their victories were earned in ballot boxes county by county and in some cases precinct by precinct. It had taken all the resolve they could muster to cross that threshold; but once across, there was no looking back. The Neches country was dragged, kicking and screaming, into the twentieth century.

As the ballot box battles whipsawed across the region, it seemed that often it took a dramatic auto-livestock collision involving loss of life to compel voters to vote the stock law ticket or, sometimes, to demand compliance with and enforcement of the law in counties where it had already been approved. Not surprisingly, elected officials, some of them stockowners themselves, had done little about enforcement.

The Angelina County experience is a vivid and painful example. Angelina County voters approved passage of a stock law early on. Lufkin, the county seat, easily outvoted the rural areas on May 1, 1952, and gave Angelina County one of the area's first stock laws. Timber companies, in an effort to gain

more control of their lands, also influenced elections. As one old Neches stockman put it, "The companies like Southern Pine and Carter, they's the two biggest companies right in here; then, they got all their employees to vote for it, and they passed it." But although voters approved the law, there had been little enforcement.

"Three Perish, One Injured in Fiery Crash of Trucks Near Zavalla; Stray Cow on Highway Causes Tragedy," thundered the headline of the December 21, 1954, issue of the *Lufkin Daily News*. This horrific wreck and loss of life, two and a half miles from my parents' home, galvanized the public into demanding that the stock laws enacted two and a half years earlier be enforced.

The *Lufkin Daily News*, in a later edition, quoted Angelina County Sheriff Leon Jones as saying: "Enforcing the stock law without a trailer and a cattle pound is like trying to enforce the drunk-in-public law without a jail."

The county was eventually successful in keeping livestock off the major highways; but politics being what they were, another decade passed before the last of the cattle were penned in more rural areas. County officials are elected officials, and rural voters were still an important constituency even if they were no longer the majority.

A large fallen oak tree lies completely across the river channel and brings my downstream progress to an abrupt halt. There is no way to unload and portage around the blockade; the loaded canoe must be dragged over the top. The trunk of the tree is about twelve inches in diameter, and it lies suspended from bank to bank with a foot of space between it and the water. This means I must somehow lift the front end of the loaded canoe up about two feet and skid it across the log.

The procedure for crossing fallen trees is simple but strenuous. First, the canoe is pulled alongside the log, allowing me to climb onto it. While grasping the bow firmly with one hand, facing upstream, I force the stern away from the log until the canoe paral-

lels the river's current, then quickly grasp the bow line and lift the bow over the top of the log between my spread-eagled legs. The next step is to grasp the canoe by the gunwales and slide it across the log by throwing my body backward. Each lurch skids the canoe forward only inches, so the movement must be repeated until the canoe breaks over center and the bow tips into the water on the downstream side of the tree trunk. With bow line in hand, I shove the stern forward off the log until the canoe settles into the water. Finally a tug of the line pulls the craft alongside and I carefully step into it. The soft, cooling breezes always feel good against my body after these exertions.

Something is swimming in the water ahead of me. It pulls its long V through the water and disappears around the bend. I never see the animal to decide what it is. My guess would be a nutria. These aquatic rodents were imported from South America to Louisiana in the 1930s for fur production. When the fur ventures failed, many of the animals were released into the wild and rapidly multiplied; they are a nuisance today. The brown, furry critters feed primarily on aquatic plants and can weigh as much as twenty pounds. Usually their nests are holes dug into the riverbank.

A tall red oak tree has broken loose from the edge on the Anderson County side and fallen into the river. A big gaping hole, showing an array of broken roots dangling out of the earth, reveals where the mighty tree had stood for at least fifty years. The relentless gnawing of the river and the irresistible tug of gravity have combined to bring the giant down. The tree, its leaves still green, blocks the river's course, but someone has sawn and removed six- and eight-inch-diameter limbs, offering a tight but adequate opening for the canoe to squeeze through. Smaller limbs reach out in an attempt to snatch my hat as I crouch and allow momentum to propel me through the opening.

Another wild persimmon tree laden with little orange-colored fruits leans over the water. I could easily pluck several as the canoe glides underneath. Birds, opossums, raccoons, and other wildlife will feast here in the coming nights and days.

The eventual passage and enforcement of the state's stock laws spawned considerable acrimony. Violence was not unheard of, and hard feelings persisted for years. In many cases it was impossible for the stockmen to put their animals behind fences. Most stockmen did not own enough land to pasture a fraction of their stock. What land they could call their own might be wooded, and they could not afford to have it cleared. Neither could they afford the cost of fencing. Many were forced to round up their animals and sell them. This was sometimes a formidable task, and some stockmen simply abandoned their stock, especially their hogs. The feral hogs to be seen while paddling the Neches probably descended from those early pioneer animals.

The voting in of stock laws was only one skirmish in the war that eventually blocked entry into what had historically been the commons. The battles of the grazing leases and hunting clubs followed quickly on the heels of stock laws. The dog wars began almost simultaneously with the passing of stock laws, and in some places minor problems carried over into the 1990s.

A white-tailed doe snorts her warning, interrupting my thoughts. From the west riverbank, she watches the canoe's progress for a moment, then, stamping her front feet, trots unhurriedly away. It seems as if every sandbar is dotted with deer tracks.

Hordes of little dome-shaped water bugs (whirligig beetles) blanket the surface of the river on either side of the canoe. Individually and en masse they skitter frantically back and forth, first one way and then another.

Occasionally the river is open and smooth, but now it is choked with logs. Suddenly, near a half-submerged treetop, a largemouth bass that must weigh three pounds explodes straight up out of the water. I see its entire body amid the spray and bubbles its leap produces. The bass must have been after a perch or frog swimming on or near the surface.

A tall, straight water oak has recently toppled across the river, and its still-green branches form an effective barricade. Luckily, a rivulet of the river is flowing between the downed tree's root ball

and the bank. I give a couple of hard strokes with the paddle, lean backward, and allow the canoe to run as far as possible into the narrow ribbon of water. When I step from the canoe, my sneakers sink from sight in the wet mixture of soft sandy topsoil and clay the tree brought with it as it fell. The quicksand almost pulls my shoes off with every step I make tugging the canoe. After the craft is floating again, I slump onto a piece of driftwood to rest.

A scarlet flower growing near the spot where the tree's roots were pulled from the ground prompts me to get the camera and scramble for a closer look. The lone plant is about two feet tall and its flower is a series of vermilion petals that droop from the top six or eight inches of the stem. This beauty is a cardinal flower. Despite being highly toxic, its leaves were smoked and used medicinally by Indians. Legends tell of it being used as a passion or love potion. Early Anglo settlers tried to duplicate the Indian remedies, sometimes with fatal consequences.

No more than twenty feet from the flower, clusters of 'possum grapes droop from a leaning sweetgum colored with both purple and green leaves. Bonnie likes to eat these tiny grapes, but they are much too sour for my taste. I would have enjoyed some of the last remnants of muscadine grapes, high and out of reach in the top of a sweetgum, growing alongside the river a short distance back.

Fresh hardwood stumps begin to appear on the western bank and continue for a mile. Trees have been cut so close to the river's edge that their green tops fell into the water.

The river makes an abrupt left turn and brings me almost nose to nose with a bandit-faced raccoon. It is walking along a tree trunk that extends out from the western bank, about four feet above the water and almost across the river. The ring-tailed animal tries to hurry to shore, but many limbs protruding from the log slow its progress.

Numerous kingfishers keep me entertained today. They dart back and forth in front of the canoe, sometimes diving into the water to grab a small fish. These interesting birds are easily

distinguishable and are almost always found around rivers, lakes, and ponds. The large head, blue-gray color, spearlike beak, and broad gray band across a white chest are distinctive, but it is the ragged brushy crest that makes a kingfisher so easy to spot. When fishing, the bird hovers over the water so as to spot its prey; it dives beak first but frequently comes up with nothing to show for its efforts. Sometimes kingfisher nests can be seen as fist-sized holes burrowed in steep banks.

The river is clean for the most part; but at almost every treetop or log that lies in the water, large numbers of drink cans and plastic bottles of every shape and color have been caught in drifts. One can only imagine what the bottom looks like. Most of this household garbage comes from clubhouses and from people tossing it off bridges as they drive across.

Arriving at County Road 747, Carey Lake Bridge, at 3:50 P.M., I stop for the day. CR 747 is a gravel road here at the river, transitioning to asphalt as it nears the intersection with U.S. Highway 79 near Jacksonville.

The first nine or ten miles of the Neches have been a pleasant surprise. The clean water, strong current, bars of sand and shale, rock outcrops, abundant wildlife, and much outstanding scenery make this a day to remember. The plentiful shade is another important plus for sun-conscious Texans. The narrow channel allows the tree limbs to reach across and touch, providing a cool canopy where there are not pastures or clear-cuts.

The Carey Lake Bridge is not a good place to launch a canoe or take one out. The access road down beside the bridge is not maintained and consists of a series of ruts and deep holes, probably impassable in wet weather. Bonnie and I manage it today and load the canoe onto the trailer for the short drive to Jacksonville. The litter under the bridge is terrible.

Sunday, October 3

Bonnie and I attend worship services in Jacksonville and shop for a few essentials before I push off beneath the Carey Lake Bridge

by 2:00 P.M. The thermometer is packed in the food box, but the temperature must be in the high eighties. There are no clouds in the sky and the sun looks like a brilliant fall pumpkin suspended in an ocean of blue.

The river's surroundings are mixed on the route to the Highway 79 bridge. Some stretches still have mature hardwoods growing along the banks. Sadly, some places have been logged heavily. Some loggers do not even leave the trees growing along the edge of the water. Others do. The riverbanks always suffer serious erosion when the web and tangle of roots are no longer present to buffer the water's current. The Texas Forest Service recommends leaving streamside management zones (SMZs) along watercourses, and its best management practices (BMP) program also recommends logging practices that protect water quality, but many loggers ignore them. Perhaps some just have not gotten the word.

The blackgum trees are beginning to announce the coming of autumn. Their leaves are turning various shades of red, purple, yellow, and orange.

In the distance someone is fishing on a sandbar. The angler turns out to be an attractive woman about forty years old, and her hook is caught on a limb. Gliding by, I give the line a jerk and it pops free, earning me a gracious smile and a pleasant, "Thank-you." Immediately below her a treetop is across the river, and a young woman, probably nineteen years old, sits in a lawn chair casting into the water. I begin trying to thread the canoe through the maze of limbs, and the younger woman says, "Would you like for me to pull you through, Mister?" Without waiting for my reply, she wades out into the water above her knees, grabs the canoe, and quickly leads it into open water. I thank her, and the current moves me on.

I cross under the Highway 79 bridge at 5:10 P.M. Travel time from Carey Lake Bridge is three hours and ten minutes.

Fifteen minutes downstream from Highway 79, the river makes a 90-degree bend with a small sandbar inside the sharp bend. White oaks and water oaks line the opposite bank, with

water elms and river birches leaning over the water. At the point of the sandbar, the river is no more than twenty feet wide. This is where I will make camp.

Knowing that darkness comes quickly in the river bottom, I hurriedly break out the small tent purchased especially for this trip. It would have been wise to read the instructions first! The tent takes so much time that dusk is rapidly coming on. Summer sausage and crackers are my first supper on the Neches River Canoe Expedition.

There are almost no mosquitoes. They usually avoid sandbars, and the dry weather has removed most of their breeding pools. It is dark as I crawl into the tent. The few pearl-white mussel shells that dot the sandbar give the place an eerie look as dusk turns to darkness.

The sounds of night begin with the frogs. It seems as if there are thousands of them; but to my disappointment, there are no bullfrogs. Could this be the omen of doom that we hear and read about? Frogs seem to be disappearing from the environment, and many that remain are deformed. Are they the contemporary "canary in the coal mine" warning us of the dangers in the environment around us?

Some say the genetic scrambling is caused by pollution. Could be. Amphibians live along the water's edge where pollution is likely to be most concentrated. Much of what they eat would be covered with contaminants. Others say the deformities are a result of depletion of the ozone layer, which is supposed to deflect the sun's harmful rays back into outer space. I hope both theories are wrong. But it's a fact: I don't hear any bullfrogs. Owls begin to call back and forth to one another. Across the river, the acorns keep up a steady *ker-plop* into the water all night.

Stars! I can see only straight up, but the stars are too numerous to contemplate. If those stars are really suns of other solar systems and they have planets revolving around them, surely the chances of life out there must be better than even.

Monday, October 4

The sounds of large fish striking in the water not ten feet from my tent awaken me at dawn. I can hear feral hogs grunting and eating acorns somewhere nearby. Sometimes these hogs can weigh four or five hundred pounds, and the old boars can be mean as sin, but usually a woods hog that goes over two hundred pounds is considered big. Sows with piglets can be ferocious if pressed, but most often feral hogs detect human presence long before we see them. The only reason I am close enough to hear them feeding now is that the wind is blowing my scent away from them, and I have been quietly sleeping in the tent.

At 6:45 A.M., it is light enough to roll out of the tent. The temperature is a comfortable 60 degrees. Breakfast is a cream cheese-glazed gourmet cinnamon bun, chock full of raisins, and a cup of delicious hot coffee.

Ducks are calling from the river as I break camp, load the canoe, and shove off. The hardwood forest lining the river is beautiful to behold even though there are pockets of clear-cuts. As the canoe slips through the water, hawks are circling low overhead and screaming.

The War on Hardwoods

THE CASE CAN BE MADE that the first skirmishes in the war to close the woods began with the so-called war on hardwoods. The first really significant harvesting of hardwoods began when the earliest settlers cut cypress, white oak, hickory, and walnut. The impact this tree harvesting had on these select species was significant, but it was nothing compared to what would befall the entire forest beginning in the latter part of the nineteenth century.

The eastern and northern forests were all but exhausted, so the northern lumber industry directed its efforts toward the southern forests and Texas. Their modus operandi was simple: cut out and get out. Stated another way, their purpose was to cut down and haul away anything of present value and not be concerned with what might be torn up or destroyed in the process. The seemingly endless stretches of pine trees were the original target of these mills, but later cuts also went after the centuries-old stands of hardwoods that grew along the Neches watersheds. When the loggers moved on, in the places where those towering trees had once stood stretched hundreds of thousands of acres of bare fertile topsoil that quickly eroded and silted creeks and riverbeds.

In the 1930s on the denuded lands and worn-out farmsteads they had acquired, some timber companies that followed the northern-owned mills, along with the newly born U.S. Forest Service in Texas, began initiating practices to help pines reestablish themselves. For the most part, this reforestation was accomplished through regeneration—simply letting the pines reseed themselves. In other cases, pine seedlings were hand-planted in areas where no mature seed-producing pines were present.

Pine timber was where the money was. The timber companies needed pines for lumber production. The U.S. Forest Service lost

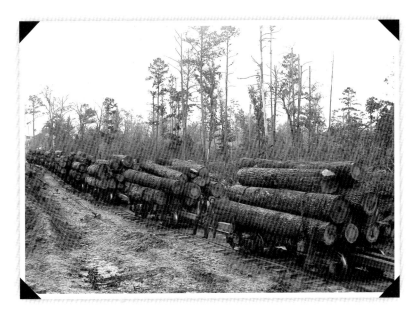

Railcar after railcar of hardwood saw logs sits on the tracks awaiting delivery to the mill, 1907. These trees were hundreds of years old. (History Center, Diboll)

little time in initiating "Timber Stand Improvement" practices, a program of still more hardwood suppression and eradication on lands not previously stripped of their oaks, hickories, gums, ashes, and other deciduous trees.

Hardwoods were killed, originally, by girdling them with an axe. Dan Hopkins of Zavalla, a retired U.S. Forest Service employee, well remembers his first job with the agency in 1949. At the age of eighteen he was issued a double bit axe and began "deadening" hardwoods on the Angelina National Forest. Dan recalls: "We deadened anything that interfered with the pines; it didn't matter if it was one inch or twenty-five inches through, we killed them. All the oaks were deadened." To girdle a tree a workman simply chopped a narrow, shallow notch around the circumference of the tree to interrupt the flow of sap. Deprived of its life-giving sap, the tree soon died. This labor-intensive girdling process was soon replaced with the Beaver, a motorized router. This gasoline-powered machine enabled a worker to

War on hardwoods: two men use axes to girdle hardwoods while another applies the herbicide Ammate, 1950. (U.S. Forest Service, Lufkin)

girdle and kill many more trees in a much shorter time than he could with an axe.

As technology progressed, the Forest Service turned to chemical herbicides for killing hardwoods. Tools such as the Injector and the Hypo-Axe could deliver lethal doses of poison into trees and kill them even faster and more efficiently than girdling. The accelerated pace of destroying hardwoods, with their wildlife food supplies, quickly made room for pines to grow.

Not content with destroying hardwoods on public lands, the government began subsidizing the destruction of hardwoods on private land. Using cleverly printed cardboard placards reminiscent of old Wild West outlaw posters, the Texas Forest Service encouraged landowners to rid their property of hardwoods.

Individuals could receive government cost-sharing benefits for killing hardwoods and planting pine seedlings on their personal property. The conversion from a mixed pine and hardwood forest to a sterile pine monoculture had begun.

These pine cultivation practices ran counter to the interests of most people who lived along the Neches. The removal and decimation of hardwoods not only reduced the amount of forage for their semiferal livestock but also contributed significantly to a startling decline in another commodity important to their livelihood—wild game.

Stockmen had always burned the woods to stimulate grass growth for their stock, but now fire would be used as a tool of revenge. The woodsmen angrily responded to the government and timber company efforts to eliminate hardwoods with the only weapon available to them: fire. They would burn the woods. A popular ditty of the time ran:

> *If you've got the money,*
> *We've got the time.*
> *You deaden the hardwoods,*
> *And we'll burn the pine.*

This was no hollow threat. The young loblolly pines that had been reseeded were extremely susceptible to fire, and thousands of acres of these tender seedlings were destroyed by arsonists

each year. Arson, the woodsmen's revenge, spawned four decades of environmentally disastrous woods fires in forested regions of Texas. The woods people resorted to a mode of retaliation dating back to biblical times. Samson had tied fire to foxes' tails before he loosed the animals in the Philistines' grain fields. Woodsmen torched pine saplings that the government and the timber companies were growing where wildlife-sustaining hardwoods had once flourished. This was war.

Random limbs and logs poke up in the river, but there is ample open water for the canoe to slip noiselessly through. The only sounds are those of nature; crows cawing, birds singing, and the occasional sound of a startled animal scurrying unseen through the brush. The cool morning air smells fresh and sweet. I gulp deep breaths and savor the moment.

An unsuspecting coyote has presented the highlight of my trip this morning. A large willow oak had fallen across the river, and some ducks were underneath it, feeding on acorns. The coyote had seen the ducks and had crept out on the tree's bole, attempting to get closer. He was so intent on the ducks that he didn't see me until I was ten feet from him. Somehow he sensed my presence and turned to look. Surprise, fear, or some combination of these expressions crossed his face as he flattened his ears, shot into the treetop, and disappeared. It is amazing what one can see gliding silently through the water in a canoe.

I hear a roar ahead and see two concrete abutments. They look like the footings of an old bridge. Luckily, at the last minute, I pull to the western bank and walk downstream to take a look. It turns out to be a five-foot waterfall spilling over a concrete weir that spans the river. There is a seventy-year-old man fishing just below the falls. He tells me there used to be a hydroelectric generator here. He says the plant was before his time, but the spillway has been here as long as he can remember. He tells me this place is called Rocky Point. I later learn that there never was a generator there. The City of Palestine takes its municipal water supply from behind the weir.

Decaying trees remain a food cache for birds, insects, and other wild creatures until the last powder of the rotting stumps returns rich nutrients to the earth. (Gina Donovan, Austin)

Downstream from the U.S. Highway 175 bridge, drooping ferns and a black exterior crust hide bright orange earth along the Cherokee County riverbank. (Gina Donovan, Austin)

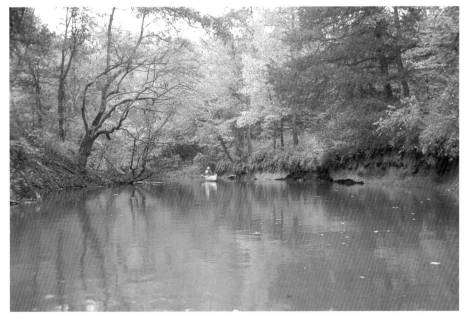

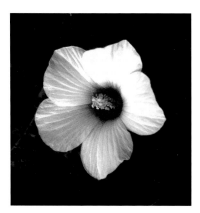

Richard Donovan points to a mussel stranded beside a piece of driftwood. A small trench in the wet sand reveals where the aquatic creature was feeding before the water level receded. (Author's collection)

Hibiscus-like rose-mallows bloom in damp places, usually along the outer edges of sandbars; these were in Anderson County. (Gina Donovan, Austin)

Crossing a log upstream of U.S. Highway 84—the procedure is simple, if strenuous. (Author's collection)

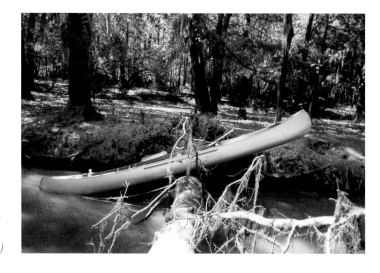

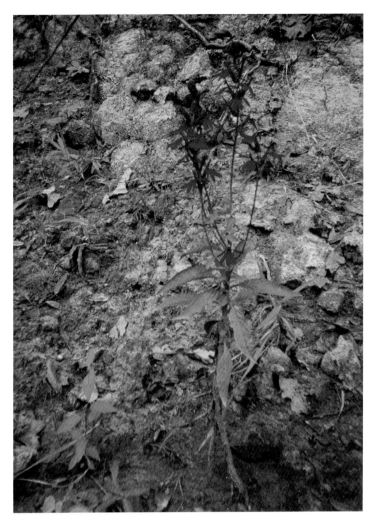

The cardinal flower is lovely but poisonous; misuse of this plant for medicinal purposes caused deaths among early settlers. (Author's collection)

Wild 'possum grapes droop from a leaning sweetgum tree. (Gina Donovan, Austin)

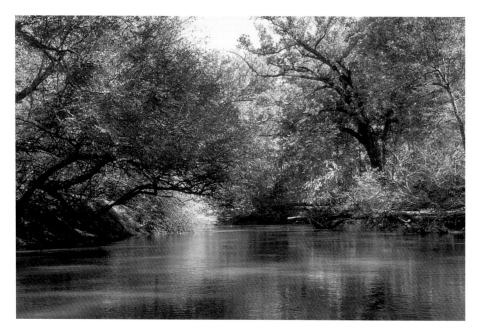

Leaves and limbs reach across and shade the narrow upper Neches. (Gina Donovan, Austin)

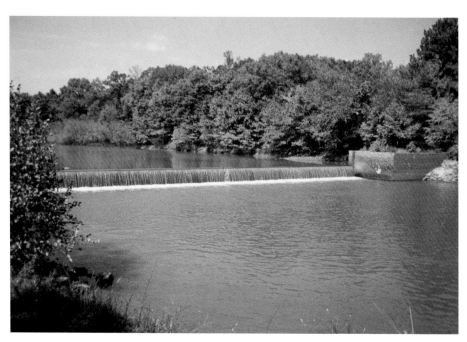

A concrete weir at Rocky Point holds back water for the City of Palestine. (Author's collection)

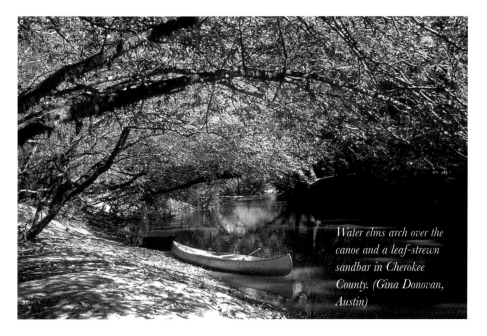

Water elms arch over the canoe and a leaf-strewn sandbar in Cherokee County. (Gina Donovan, Austin)

One campsite was on a flat, grass-covered sandbar in northern Anderson County. (Author's collection)

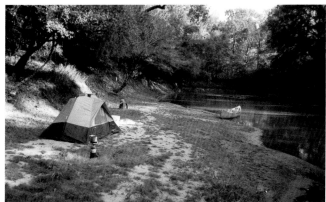

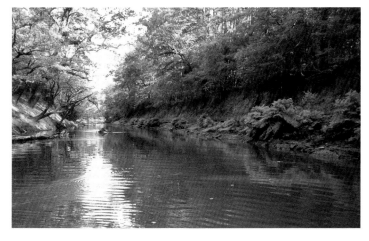

A variety of lush green ferns grows along a line of water seepage from an Anderson County riverbank. (Randy Courtney, Houston)

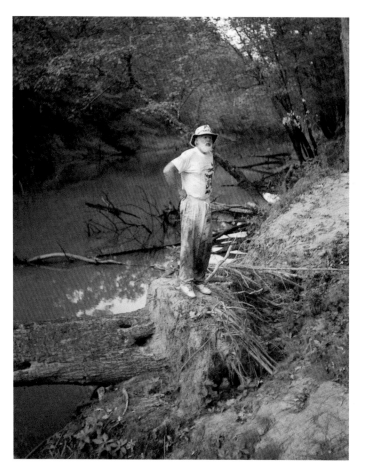

Richard Donovan assumes his position to talk to the cameras at a riverside press conference convened near the U.S. Highway 294 bridge, Cherokee County. (Bonnie Donovan, Lufkin)

Black gum, sweetgum, maple, and the autumn foliage of other deciduous trees mix with evergreen pines to color the Cherokee County riverbank. (U.S. Forest Service, Lufkin)

A twisting, turning, leaf-strewn creek makes its way to its confluence with the Neches. (Joe Lowery, Lufkin)

Ratcliff Lake is near the southern end of the Four C Hiking Trail, Davy Crockett National Forest. (Connie Thompson, Pollok)

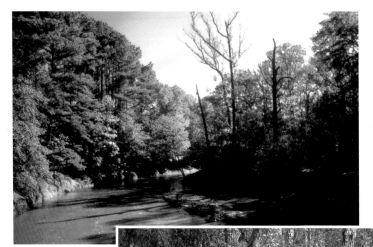

Towering pines along an elevated ridge in Cherokee County contrast with the dead snags so essential for healthy wildlife populations in the Davy Crockett National Forest. (U.S. Forest Service, Lufkin)

Palmetto fronds point their dagger-tipped leaves in the shade of numerous varieties of hardwoods along the Houston County floodplain. (Gina Donovan, Austin)

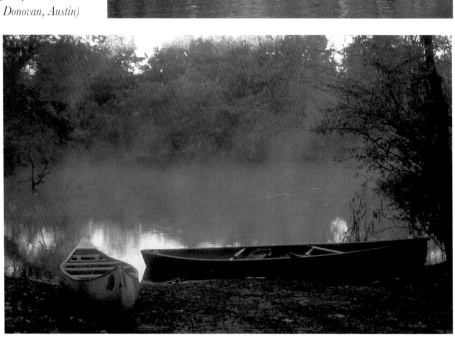

Wisps of early morning fog float above the river near a Cherokee County campsite. (Gina Donovan, Austin)

As I begin to drag the canoe up the bank and around the falls, a young man lays down his fishing rod and rushes to give me a hand. He tells me, above the roar of the falls, that he is from Elkhart. The weight of the canoe and the noise of the water plunging over the weir discourage any additional conversation. Just as we are about to return the canoe to the water, my benefactor stumbles on some slippery stones and almost falls. He heaves the craft and it lands in the water, just inches from a big rock. My trip almost ended right here. That rock would have knocked a big hole in the thin aluminum canoe. Soon a load of men, women, and children arrive, speaking a language I don't understand, and they all begin fishing. Why aren't these children in school? I thank my new friends for their help and information and paddle away.

At 1:30 P.M., I stop for a brief lunch and am soon back on the water. A snake has caught a frog, and the frog's pitiful cries fill the air. I stop paddling and study the left bank for any sign of the life-and-death drama. Suddenly, partly tumbling and partly crawling, the snake makes its way down a steep incline and into the water with dinner in its mouth.

Steep sandstone banks with small springlets trickling out here and there make me wonder if there aren't other springs close by. I have not gone a mile when the sound of running water reaches me. Under the canopy of a twisted elm tree is a rushing stream of fresh spring water cascading into the river. At the top of the sandy bank the stream forms a perfect little basin not much larger than an ordinary bathtub. I seize the opportunity for a much needed bath, strip off my clothing, and sink down to my chin in the clear cold water. The cool sand feels good under my feet and between my toes. The invigorating coolness soon has me feeling refreshed and ready to go again.

The river is full of surprises. I no sooner decide that it has gotten wider and the current has slowed than it suddenly narrows to no more than twenty feet and makes a torturous S curve between sheer banks on both sides. It gives me a fast ride for about one minute and makes me use the paddle a couple of times to keep from being slammed into logs and the bank.

There has been evidence of beaver since the beginning of this trip, but today is the first time I see one. It looks fat and healthy and must weigh forty pounds. At first it huddles under the limbs of a drooping elm, but after a few bangs of the canoe against stumps and limbs, it disappears under a pile of twisted logs.

Today has been a wildlife day. Gray squirrels have been everywhere. A white-tailed doe studied me from the bank before bounding away. The coyote, beaver, a couple of otters, plus the snake and frog round out the list of animals. Two egrets and two great blue herons were the bird highlights of the day. There were, it seemed, hundreds of ducks, kingfishers, and hawks. Two black vultures allowed me to pass underneath their perch in a dead snag without flying away.

Tuesday, October 5

The sky was filling with clouds when I crawled into my tent last night at dusk. Rain seemed to be in the forecast; but morning has dawned bright and clear with a temperature of 52 degrees.

Last night was very quiet; a couple of owl hoots were all I heard. The crows were the first to make a sound this morning. A chorus of *woof, woof* and the crashing of limbs tell me that my stirring has interrupted the feeding of a small herd of feral hogs.

After drinking a couple of cups of coffee and eating the last of my cinnamon buns, I load the canoe and push out into the current. Around the first bend, a couple of trees block my progress. The limb saw comes in handy on occasions like this. Without the saw, it would really be a problem getting through all the treetops.

The stretch of river to Highway 84 is uneventful. I see hawks, ducks, and another egret. The big bird lifts its body almost straight up and over the treetops as it flies away. I am surprised it can manage this. Although it initially looks like an old man trying to get up from a rocking chair, this bird is graceful even when laboring.

Sounds on the river can be deceiving. The river twists and turns upon itself, distant highway sounds rising and fading away more than once before I actually reach the bridge at Highway 84.

There are majestic oaks along here. They are draped with Spanish moss, which adds a southern ambiance to the place. Four men are sitting on five-gallon plastic buckets and fishing in the shade of the ancient trees. Two of them have their hooks hung. I offer to help, but they decline my offer.

Locomotives and Coyotes

I ARRIVE AT HIGHWAY 84 to find a good boat ramp. This is an ideal place for launching canoes. I wait for a fisherman or someone to show up, but no one does. Just as I am about to leave, a dilapidated old car stops to turn around. I approach the car to find behind the wheel a gaunt, dissipated man badly in need of a shave; I ask if he will call my home to let my family know I am okay. He agrees, and I give him the phone number and the only two one-dollar bills in my possession before he drives away. Something about the man fails to inspire confidence. Those two dollars may see a bottle of wine long before they see a telephone.

I step back into the Grumman, shove away, and paddle under the tall concrete bridge at Highway 84.

The Texas State Railroad, operated by the Texas Parks and Wildlife Department, crosses this stretch of the river. Wouldn't it be a stroke of luck if the old steam locomotive were pulling a string of passenger coaches loaded with tourists across the trestle just as I arrive? Smoke would be puffing from the engine's stack and trailing back over the coaches. Fire would be flashing in the firebox and steam spewing from numerous leaking packings and valves. Perhaps the engineer would even blow the whistle if he saw me.

Steam locomotives were an important part of commerce until about fifty years ago, when they were replaced by diesel engines. The Texas and New Orleans Railroad tracks ran no more than three hundred feet from my parents' home. A minimum of a half dozen trains rolled along the rails each day and night. During World War II there were more. These trains would be made up of an assortment of cars loaded with logs, pilings, crossties, cattle, pulpwood, clay, and an array of other things.

Most of the steam locomotives had to stop frequently to take on water. Although S. N. Carpenter's General Store and perhaps a gristmill were operating in the location as early as 1866, the community of Zavalla on the edge of the Neches Valley owes its existence to the "railroad springs" that once bubbled from a hill on the east side of town. (The first grave in the town's cemetery was dug for a Mexican laborer who was killed laying the steel rails here in 1900.) It was during their watering stops that the steel behemoths could best be admired and appreciated. I liked to stand near their big "drivers," or drive wheels, and feel the heat from the boiler against my body. On cold, still days the engine would be shrouded in clouds of steam and smoke, and at night the orange fire from the firebox would cast dancing shadows on the wheels and drive-rods and along the ground. The throbbing and pulsing of the air compressor and the soft screeching of water in the belly of the boiler made the great beast seem alive.

Then, unexpectedly, the engine bell would begin to clang; and an ear-splitting blast of steam and sound would erupt from the whistle as the engineer signaled he was about to roll. (Two blasts meant forward; three meant backward.) As the train began to creep slowly forward, there might be another crescendo of noise if the engineer suddenly threw the throttle open for an instant and spun those big drive wheels on the steel rails as easily as an automobile might spin on wet clay.

In the days of open range, cattle and hogs were frequently killed as they grazed and rooted in the railroad right-of-way. They became so accustomed to the passing trains that some of them paid scant attention to the wailing whistles of oncoming locomotives. The railroads were liable for any livestock killed or injured on their tracks and paid top dollar for many cows and hogs that were a little too slow in moving. It was probably coincidental, but it seemed almost always to be the stockmen's finest animals that were struck by the trains.

The men loading bags of oil-well-drilling clay into a railcar at the Magcobar plant, located four miles north of the Neches and

five miles south of Zavalla on U.S. Highway 69, once witnessed an unforgettable sequence of events. Two range bulls had been fighting near the plant all day. As the day wore toward evening, one bull finally prevailed and chased the vanquished contestant into the thickets. The battered but victorious bull climbed up the railroad embankment, raised his head, and bellowed his triumph to the world. His victory celebration was short-lived. A northbound "X-tra" (extra-scheduled freight that stopped only for water and fuel) began whistling its approach to the railroad crossing while it was still a half mile away. As the fast-moving freight train drew nearer, the engine crew apparently saw the bull on the tracks and held the whistle open. The king of the mountain remained indifferently between the rails with his rear end toward the screaming locomotive bearing down on him. The engineer did not let up on the whistle cord. At the last moment, the bull turned to face this new challenger to his just-acquired domain. He set his feet, lowered his head, and braced for the impact.

The freight was traveling at forty miles per hour or more when it collided with the bull. The V-shaped cowcatcher on the front of the engine caught the thousand-pound bull and tossed him ten feet into the air. When he struck the ground, he took another flip or two and came to rest against a stack of crossties. He did not get up. I have no idea how much the railroad had to pay to the party who showed up to collect the damages.

Today the cows, bulls, and hogs are all safely behind fences. All the steam locomotives have been retired, their whistles silenced, and the T&NO tracks have been pulled up and hauled away. Magcobar is no more, a casualty of the decline of domestic oil production. The clay plant still hangs on under a new name, but it is a mere shadow of its former vigor.

I turn back to struggle with the river. The bottomland along either side had flattened out before I reached Highway 84. The area continues to be very flat, causing the river to take many different channels. The people of Alaska and the North would

call this a braided river. Whatever it's called, paddling is very difficult. Most often I shove the paddle into the mud and use it as a pole to push the canoe along. Sometimes I have to get out and drag the canoe. A couple of times I choose a wrong channel and have to backtrack and try another.

It looks almost like another world in here—nothing but flat country and a tangle of haws and river elms. Finally I break out into an area of forest and high banks, with a nice spring flowing from the bluff on the west side.

The sound of a heavy machine running reverberates through the forest. I stop and walk a hundred yards or so through the woods to find a clean-cut young man enjoying life. He is lying in the back of a pickup truck, sipping a Coke. He must work for the man running the dozer. I introduce myself and can tell he is not very impressed. I must look pretty scruffy and dirty after having fought my way through all those treetops and over those logs. Without stirring from his reclining position, he tells me his name is Vernon Thompson. I try to mooch a Coke, but he says he is drinking the last one.

I tell Vernon that my family hasn't heard from me in a couple of days, and will he please give them a call? He says he will (and he did). After drinking some of Vernon's ice water, I thank him, walk back through the woods, and return to the journey.

The river is getting wider with much higher banks. Another spring flows from a bluff bank just below Hopson's Crossing. Vernon has told me this will be the next bridge I see.

At 5:10 P.M., I make camp on a flat sandbar. Supper consists of Vienna sausage, a tortilla, and cheese crackers with a cup of hot chocolate. My junk food is going fast. I may soon have to resort to cooking.

The temperature at 7:00 P.M. is 72 degrees. Sometime during the night I faintly hear dogs baying in the distance. Somewhere a man is yelling; it is probably someone coon hunting. Just before dawn a pack of coyotes comes close to camp and spends about five minutes, all the animals howling at once. They are likely just beginning to form a pack for the winter.

Two cups of coffee feel good in the 41-degree temperature this morning. Hawks are circling and screaming overhead as I push into the water.

I have not covered much distance when I encounter a mammoth pine log blocking the river. I bank the canoe to search for a way to portage around the log. Quarter- and nickel-sized overcup oak acorns cover the hard, dry ground. Several more logs block the channel, but the river makes a fishhook bend to the west and comes back near to where I am stopped. There is a little sandbar that will make it easy to reload the canoe. I decide to portage my gear overland to the sandbar, drag the canoe over the top of the logs, and then paddle to the sandbar and reload.

Working, I listen to someone squirrel hunting with a .22 caliber rifle. Of all the hunters I have heard since leaving Highway 175, this is the only one using a .22. All others were using shotguns. Squirrel hunting with a .22 was my passion when I was young.

Finally, the canoe is pulled over all the logs, the gear is stowed, and I shove off from the sandbar. On one of the trips carrying gear to the sandbar, a saw vine drags across the top of my foot, leaving it burning and stinging. Neches folk would have applied coal oil (kerosene) to the abrasion. Coal oil was the wonder drug of the day. It was used for everything from cleansing wounds to curing internal illnesses.

Less than a quarter of a mile downriver is a hunters' camp: pickup truck, tent, and all the trappings. They surely must be having a good time. They will have some entertaining yarns to spin with their friends when they return home. If the dams planned by the Region I water development board are built, these outdoorsmen and hundreds of others will be forced to compete for hunting space elsewhere.

Just below the hunters' camp, a spring as big as my arm is flowing into the river. A little blue heron fishing along the water's edge almost lets me pass without flushing. At the last minute, its courage fails: it takes wing.

The sound of rushing water lies ahead, presenting what looks like a giant dump-truck load of boulders in the river. I steady the canoe and shoot through the brief turbulence of the outcrop.

The thermometer shows only 76 degrees, but paddling in the sun is hot work. A flat, brown gravel bar offers a place to clean out the canoe. The debris that falls into it while passing through downed treetops and the mud off my feet from frequent ins and outs have it looking like a pigsty.

The swift, cool water rippling over the rocks looks inviting. As soon as the housework is done, I sit and let the water rush around me. After a few minutes of sitting in the rushing current, I feel better. Back into the canoe goes the gear, and I push away from the gravel bar.

The river makes another of its many 90-degree bends and brings me head-on with two great blue herons flying side by side just above the water. To avoid me, one begins the difficult task of lifting itself to clear the treetops. The other veers hard to the left and heads into the forest. I watch in amazement as the giant bird threads its five-foot wingspan up and through the tree limbs until it is clear.

Some paddling and many tree-falls later I make camp on a narrow, sandy hummock at the mouth of a small, curving, leaf-strewn swale that probably brings a lot of water into the river during rainy season.

Today was a very hard day. The sun is setting behind un-counted tree-falls, numerous portages, and miles of paddling. I make a cup of hot chocolate and sit for a few minutes to allow the fatigue to drain out of my body.

The tent goes up quickly, and I have a few minutes before dark; so I read a little in the Bible that Bonnie thoughtfully packed in my box. The thermometer shows 72 degrees when I crawl into the tent.

Another glorious, 42-degree, sunshiny day greets me as I crawl from the tent. That first cup of coffee is always so good!

Sleep has eluded me for most of the night. Some coyote pups about two hundred yards east of camp yelped and barked while I was putting up the tent. Then some of the most spectacular howling I have ever heard took place: many long, drawn-out, mournful howls. (Could there be remnants of wolf blood coursing through the veins of some of these animals?) The adults must have left the youngsters to hunt, because the pups, or whelps, resumed their raucous yelping. Hours later, the return of the adults and the sounds of celebration awakened me.

The haunting serenades of a pack of coyotes, or the mournful howls of a lone individual, are sounds to soften the hardest of hearts and quicken the spirit of the most ardent city dweller. My family and I wait and listen expectantly to hear them on early fall and winter evenings when we are spending time at our farm.

It has not always been so. Like the red fox, armadillos, cattle egrets, and fire ants, these wily canines (possibly the most intelligent of all North American wildlife) are relative newcomers to the Neches country. Wes Carnes created quite a stir here when he caught a coyote in a steel trap in 1952 or 1953.

Carnes was definitely one of the old ones. His grave marker shows that he was born in 1889, making him sixty-three or sixty-four years old at the time he caught the coyote. That was enough for me to think of him then as ancient indeed; now sixty-four doesn't seem to me very old at all. But Mr. Wes was more "of the old ways" than old in years. Without boasting, he would tell you he could trap any varmint that walked on the ground or swam in the water, and he had the reputation to back up his words. He grew up on the banks of the Angelina River and hunted and trapped to have something to eat. He later learned to trap *Canis latrans*, the coyote, during his sheep and goat ranching years in the Hill Country of Central Texas. While in Central Texas, he perfected his secret scent bait.

Made with a mixture of a zinc compound and animal urine, the bait was deadly. Animals were irresistibly drawn to the smell and, in their inquisitive search, would step on the trigger of the cleverly concealed trap. A light touch was all that was needed, and the jaws slammed shut.

To illustrate just what an uncanny trapper Mr. Wes really was, sometime during the 1940s, Jasper County had posted a bounty of one dollar per head for all foxes trapped or killed. Foxes had become a serious problem for residents of the county, killing people's chickens and eating their eggs. Wes Carnes answered the call and made a hundred dollars in his first five days of trapping, averaging twenty foxes per day.

Many years later, Wes was trapping along the little creeks that ran behind his house in Angelina County when he began noticing a puzzling sight: coyote tracks in the cattle trails that crisscrossed the area. That was strange. Coyotes had never been seen this far east in Texas. Wes returned to where he had seen the coyote sign and set a no. 3 Victor steel trap in a shallow hole, concealed it with decaying sawdust, and applied the scent bait. When the trapline was next run, Wes confidently carried a big burlap sack under his arm. Just as he had suspected, a coyote had poked a foot into the jaws of the trap and been caught. Utilizing a forked stick to pin the animal's head to the ground, Wes was able to get the coyote into the burlap sack and, from the sack, into a big chicken coop at his home.

People came from all around the area to see the "wolf" that Wes Carnes had caught. Since there had never been any coyotes in the timbered regions of the state, folks reasoned that this had to be a wolf. Some coyotes trapped later did show signs of hybridizing with wolves—wider noses, larger heads, and bigger bodies than coyotes ought to have—but wolves had long been exterminated from the Lone Star State except for a small pack of red wolves near the coast in Chambers County between Beaumont and Houston. As populations of Texas wolves declined due to habitat loss and aggressive trapping, the instinct to survive compelled the remaining animals to breed with the overpowering

numbers of coyotes—to hybridize. In 1972 the U.S. Fish and Wildlife Service trapped the last remaining wolves and confined them in a zoo to rescue the species from extinction. It is my understanding that the wolves that have been reintroduced into the wilds of Tennessee, the Carolinas, and other southeastern states are descendants of this Texas stock.

There are several theories as to why the coyote moved east into the timbered region. First, and perhaps foremost, their feared adversary and competitor, the wolf, had been exterminated. Coyotes now had no natural enemies. Land use practices are often cited as one of the most important reasons for their arrival and survival. The areas where timber had been cut and hardwoods deadened had become overgrown with brush and briars, providing ideal habitat for a population explosion of rodents and rabbits. These animals are staples in the diet of coyotes.

Personally, I always thought it more than coincidence that the coyotes timed their arrival almost precisely with that of the broiler industry. In the early years of that industry, growers simply removed the dead or sick birds from their broiler houses and threw them into any nearby ditch. It is only reasonable to suspect that the coyotes feasted on these abundant castaways.

I'm not complaining about last night's sleep interruptions; I would rather listen to coyotes howl than be sleeping. There will be plenty of time to sleep when I can no longer hear that wild, stirring call.

In addition to the howling coyotes last night, the giant red oak that covered my tent was the feeding place for a couple of flying squirrels. Their *chip, chip* call and the constant rain of acorn debris on and around my tent were enough to keep me awake.

This is the prettiest campsite I have had. The swale runs inland from the river and fans out into a broad depression. The ground is already carpeted with autumn leaves. White oaks, water oaks, black gums, pines, red oaks, and sweetgums are all at least twenty-four inches in diameter. Mixed in with these beautiful giants is an understory of ironwoods, elms, hollies, and haws. Gray squirrels are whistling everywhere.

As I begin to break camp, the bright morning sun is being hidden by thin, white clouds that are moving in from the southeast; it looks as if it may rain.

This northern part of the Neches makes me wish I knew more geology. There is an impermeable stratum of mostly black shale-like material that is frequently visible in the river's banks. Associated with this black stratum are numerous seeps and, sometimes, strong springs. The immediate vicinity of these seeps usually contains luxuriant growth of royal and cinnamon ferns. At times, this formation juts out into the river and forms a flat, smooth shelf that would be ideal for picnicking or camping when the river is low. Many times, these black outcrops signal swift water and a thirty-second ride through rapids.

On the west side of the river the bank is worn smooth around a Tarzan rope tied to a limb overhanging the water. There must be a camp house nearby. Something about kids makes them want to go swinging out over water, let go, and make a big splash.

There, half submerged, is what appears to be a shopping cart. I have much more respect for these carts since a store manager told me they cost approximately sixty dollars each. It is the beverage cans, drink bottles, and empty propane canisters floating on the river that really depress me.

Straight ahead in a giant red oak that has toppled into the river, a cormorant holds its wings out to dry after spending the morning diving for fish. It lets me get as close as it dares, then takes flight. The cormorant is sometimes confused with the anhinga but is not nearly as pretty. When I was growing up, the anhinga was known as a "water turkey" by river folks. The bird's long tail, slender neck, and peculiar habit of keeping its neck folded in the shape of an S make it easily identifiable.

The nearby forest and river have been quiet this morning. Even the normally raucous crows have been silent. Wild creatures probably sense the moods of weather as humans do and are staying near their dens and nests in anticipation of bad

weather. The sky is looking even more threatening, so I pull to a protruding shelf of black rock and quickly cook a bowl of rice for lunch. I get busy getting my slicker out of the gear box and let the rice boil over on the stove.

A light rain begins as I slip the canoe into the water. I decide at the last minute not to put the slicker on just yet. I am thankful to find the sprinkle lasting for only a few minutes, but it looks as if rain may resume at any time. The wind picks up and grabs the bow of the canoe, and I have to struggle to keep it pointed downstream. To my relief the river makes a bend, and the wind comes at me from the side. Yet this has its perils, too, especially when trying to navigate through a maze of jutting logs and limbs. The canoe can be pointed in just the precise direction required, but then a strong blast of wind can slide the entire craft sideways.

I saw two cabins today. One looked new, and part of it appeared to be walled with the fabric commonly used at plant nurseries. It is mesh material, but it breaks up the sun's rays. The next structure looked like a pavilion, or arbor, the kind found at old cemeteries. Perhaps it belongs to someone who likes to have big parties.

A large hand-lettered sign nailed to a tree proclaims: "Bull Creek Hunting Club, Keep Out."

Closing the Woods

NO PHASE OF THE CLOSING of the woods engendered more animosity and bitterness than did the organization of the land into hunting clubs and the enactment of laws making it illegal to hunt deer with dogs.

To understand this bitterness, one first must understand the connection between the woodsman, his dogs, the land, and wild game. Woodsmen had walked through these forests with dog and gun all their lives. Their forebears had done so before them. Deer, squirrel, fox, and other animals, they reasoned, were put here by God and were the property of no man. The game jumped fences, crossed property lines, swam rivers, and belonged to everyone who could get the animals in their gun sights and squeeze the trigger. As time passed, many families left the land for better paying jobs in towns; but during every possible weekend, day off, or vacation, they were back home in the woods or in a boat putting nets or hooks into the river.

The formation of hunting clubs, or "clubbing up the woods," was interpreted as something akin to class warfare, the "haves" against the "have nots." The haves were rich people who were either well connected or could afford the price of membership in a hunting club.

The local people felt squeezed out of the commons. The land they had long regarded as part of their "natural right" was being altered and taken from them. Fences were being built, hardwoods were being killed, pine plantations were being encouraged, and new hunters from the cities were crowding local people out of their traditional hunting places. The people responded in what was, I suppose, a predictable manner. Out of bitter frustration, they accelerated the war of annihilation on Texas' fish and wildlife—and almost won. They almost succeeded in wiping out the alligator, otter, beaver, and the

white-tailed deer and did successfully eliminate the black bear. The last black bear in the region was killed along the Neches in 1962. If a rumor surfaced of a sighting of a big predator or some scarce animal, people rushed to be first to kill the last one.

Unhappily, I remember people driving down to McGilberry Lake, a long, beautiful oxbow lake now deep under Sam Rayburn Reservoir, to kill perhaps the last alligator of the time in these parts. They sat in their cars and panned the lake with spotlights until they saw the light reflected in the big reptile's eyes. Then, with a crook of a finger, they sent a rifle ball burrowing between those brightly shining eyes and drove happily away, proud of their bravado.

By the late 1950s there were almost no fish left in the Neches. They had been taken in wasteful quantities by any and all means available. Illegal nets, "telephoning," and to some extent dynamiting were the preferred tools of the trade.

Telephoning for catfish (it will work on no other species) is unbelievably productive when done by people who know the art. Today's outlaw fishermen employ the electrical systems of outboard motors and generators, but the original shocker was the old hand-cranked telephone. The operation was simple. Several men with dip nets would get into boats and float slowly down river. The telephone operator would sit in one of the boats and, after throwing two electrode wires into the water, would begin twisting the crank. The boats might float for some distance with no result; but suddenly, perhaps over an old fallen treetop or a pile of sunken logs, catfish would begin popping to the surface. Some would float on top of the water; others would swim crazily about; and still others might propel themselves onto sandbars or other flat beaches. The dip netters worked quickly and carefully. The paralyzing effect of the electric shock did not last long, and to touch a fish and not secure it was to lose it.

Hunting, especially for white-tailed deer, was carried out in an almost fanatical, desperate passion to "kill all I can before they are all gone." The deer were hunted mercilessly day and

night, 365 days a year. In the hot, dry summer months when it was impossible for the dogs to trail the animals' scent and run, hunters waited for summer showers or thunderstorms to cool and wet the earth. Then they loosed the hounds. Men and sometimes women would be strategically placed along roads, pipelines, and fire lanes. There they would wait and listen to the peal of the hounds as they pushed the deer toward the guns. It mattered little whether the deer running ahead of the hounds was a buck, doe, or fawn; it was a dead deer if it entered a hunter's range of fire. The 12-gauge shotgun loaded with either 0 or 00 buckshot was the weapon of choice. The fleeing deer usually offered only a blur of a target as it bounded across the road or pipeline. There were few second shots. Eventually it became such a rarity to kill a legal buck that lucky hunters went to great lengths to show off such a trophy. Some folks, went the local joke, would drive around with a buck in the back of the truck, or draped across the fender, until the meat spoiled.

The newly formed hunting clubs began taking measures to secure their boundaries against nonmember hunters and fisher-men. Gates were put up, and cables were stretched across all the old river roads. Ditches were plowed across other access roads, and miles of fences were built. Pasture riders, many of them savvy old stockmen and outlaw hunters themselves, were hired to patrol the clubs and arrest any and all poachers. Some pasture riders and landowners resorted to killing hounds that continu-ally pursued deer across their posted properties. This ratcheting up of private restrictions guaranteed that the frequency and intensity of clashes would escalate. More than one old dog man has told me something along the line of: "My dogs can't read no damn posted signs, and no SOB had better not shoot one of 'em." Others quoted poetry with the dark threat of forest arson in its rhyme:

> *Pines won't grow,*
> *Where my dogs don't go.*

Treed: hunting dogs were an essential part of Texas culture for at least 150 years. These hounds could have a raccoon, opossum, gray fox, or even a bobcat up this dead snag. (Matt Williams, Nacogdoches)

Some hunters floated or motored up and down the river at night armed with a .22 caliber rifle and carbide or battery-powered headlights. They would kill numerous deer of both sexes and take nothing but choice cuts of meat, leaving the rest for the buzzards. Game wardens and pasture riders made some arrests,

but the miles and miles of remote river made apprehending the illegal hunters difficult. One of Texas' best wardens, Walter Kirby, was shot and wounded one night while staking out a stretch of river where night hunting occurred frequently. He probably would have been killed had his game warden companion not opened fire on the hunters. Luckily no one was killed; and in keeping with attitudes of the time and place, no one was prosecuted either.

Pasture riders arrested and filed charges on many trespass hunters, but the fines levied by judges were usually so paltry that many riders turned to prosecution on the spot. Jake Douglas, who rode the Shawnee Creek Ranch in Angelina County and the Pine Knot Club in Trinity County for Angelina County Lumber Company, relished catching trespassers on company lands. If the trespasser resisted or "talked back, somebody was going to get a whuppin.'" It was usually the trespasser.

Incidents involving dogs aroused the most violent passion. They could be deadly. Christmas Day of 1954 was unseasonably warm as my grandfather Martin Ener and I shouldered our .22 rifles and walked into the woods near Newton County's Scrappin' Valley. As we hunted that day, we were unaware of the savage gun battle that erupted between two landowners and a group of dog hunters a scant two miles away.

The landowners, Dalph and Sterling Garlington, were brothers and cattle ranchers. The dog men were from Beaumont, Jasper, and Newton. The Garlingtons had long let it be known they did not like hounds trailing and running deer across their land and through their herds of cattle. In fact, it was commonly accepted that the two brothers and their sister did not hesitate to kill dogs that were creating problems with their livestock.

On this warm Christmas Day, things had gone terribly wrong. The hunters had released their hounds near the Garlington ranch the previous day, and some of the dogs had not returned. The dogs' owners returned to the entrance of the Garlington ranch to wait. They didn't wait long. The two brothers soon appeared in their truck and were stopped by the hunters. I don't

think it was ever satisfactorily determined who fired the first shot, but that mattered little. When the shooting stopped, at least forty shots had been fired. The two Garlingtons were severely wounded, and Roy Muench, one of the hunters, lay dead. The two ranchers survived, but Sterling would spend the remainder of his life severely crippled. Once again, perfectly in keeping with public attitudes of the time and place, the courts were unable to convict the participants of any crime.

The passage of the "dog laws," which made it illegal to hunt deer with dogs, brought to an end the last remaining vestige of the old free range. These laws as originally enacted sometimes caused as many problems as they solved, if not more. In some counties deer could be hunted with dogs, while just across an invisible line in the adjoining county, it was against the law. Some counties allowed hunters to pursue wounded deer with dogs. It did not take much serious thinking to figure out how many were wounded deer in that kind of county: all of them. Finally, the Texas Legislature and Texas Parks and Wildlife Department stood their ground and outlawed deer hunting with dogs altogether.

It was over. The woods were closed. The commons were fenced and cross-fenced. The vast land holdings of timber companies were clubbed up and enclosed behind boundary lines marked in colors of orange, blue, and white.

How can I say it? A way of life died here on the Neches River. The last remnant of the Texas frontier was swept away by the current of time. Most people did not seem to notice the change, but for those who were affected, it was a major social and economic upheaval. One thing is certain, however. The closing of the woods saved from oblivion much of the wildlife that inhabits the Neches region and allowed it to rebound to the healthy numbers I would see on my canoe expedition.

Down and up. Up and down. Ahead, a "sawyer" jerks in the middle of the channel. Most often, sawyers are flexible limbs protruding up from a tree lying below the surface. The current repeatedly pushes the limb forward until the accumulated ten-

sion in the limb forces it to spring backward. There is no telling how long the sawyer will endure this monotonous cycle. As it relentlessly saws, it creates rhythmic swishes in the water, *swish, swish, swish*, like something trying to escape the grasp of an unseen snare.

Tall, stately shortleaf and loblolly pines are becoming more abundant on the bluff banks of the river. The height and smooth brown bark of the pines make them stand out among the hardwoods.

An osprey comes in low over my left shoulder, makes a graceful swoop, and climbs to about a hundred feet; then it turns a hard left and disappears down the river. What a rare treat to see this wonderful fishing hawk.

A glance at my watch tells me I am running behind schedule. The plan was for Bonnie to expect me at the Highway 294 crossing, twenty-four miles west of Alto, at 4:00 P.M. At 3:30 I can't even hear the traffic on the highway yet, and another huge treefall looms ahead in the river. After a time and several tree blockages later, I begin to hear sounds of traffic; the highway must be near. A strong spring-fed creek rushes into the river, its rounded banks covered with a rug of multicolored leaves. The bright red plumage of two cardinals is distinct against the gray of a dead tree. There is no time to stop and explore this inviting place.

Finally, at 6:00 P.M., I round a curve and see a white pickup ahead. Bonnie and Gina are there with some cold water and a thermos of hot chocolate. To my surprise, reporters from the *Lufkin Daily News* and *Jacksonville Daily Progress* and Katrina Berry of KTRE-TV are waiting, too. They have been waiting for two hours or more. After emptying a bottle of cold water on my dry throat, I apologize for keeping them waiting. They can tell by my mud-stained clothes that I have been in the backwoods for six days and have experienced difficulties negotiating shallow water, logjams, and treetops. We laugh and joke about my disheveled appearance. Katrina starts her TV camera rolling while the two young newsmen whip out notepads. They are eager to hear of my adventures. I gladly tell them about the wildlife and river

conditions. They need to know that the hard work has in no way diminished the unimaginable pleasures I have enjoyed. Someone notices that the evening sun is sinking into the western treetops, and after a round of enthusiastic good-byes, the news people depart.

As I hurry to collect dirty clothing and empty food wrappers from the canoe, Gina brings me up to date on the media coverage the expedition has received. The day before the launch, the *Lufkin Daily News* had run a front-page article headed: "Lufkin Man Planning to Canoe Down Neches." The article was highlighted in a colored square and gave a brief preview of the expedition. The following day's edition carried a photo of the launch and a story detailing the consequences that await the Neches unless Congress acts now to protect it. The *Jacksonville Daily Progress* ran a color photo, dominating the front page on Sunday, October 3. The accompanying article, "Passion for a River," provided a brief history of the river and why it should be protected from the dams currently being considered.

The news people have told me we are in for two or three days of rain, so I elect to tie up at the Highway 294 crossing until the weather blows over. I pray for rain. My job will get progressively easier with each additional inch of water in the river.

The rain that had been forecast never materialized, but I took the opportunity to pick up supplies and to re-outfit my gear. The big plastic food/equipment box and the seven-gallon water can were major hindrances when threading the canoe through treefalls. Both containers stuck up about four inches above the gunwales, caught every limb I tried to pass, and were painfully heavy and difficult to unload from the canoe at camp every night.

I switched the foodstuffs into two five-gallon plastic buckets with lids and the water into one-gallon plastic jugs. Gina let me borrow two rubber dry bags for the tent and sleeping bag. We also eliminated all other excess weight. Nothing but dry noodles, water, and essential gear remained. Getting across those logs and through the treetops was taking its toll on me.

Into the Wild

Following church and lunch in Lufkin, Bonnie delivers me back
to the river, and I shove away from the Highway 294 bridge west
of Alto. There are a few treetops in the river just south of the
bridge, but soon the river flows straight and, for a distance, clear
of brush. I make good time until I find a small grove of Ameri-
can hornbeam, more often called ironwood, growing at the
upper edge of a sandbar. The trees get their common name from
the quality of their wood. It is strong, hard, and durable and of-
ten used for handles of tools. This is a good place to pitch camp.

It is 72 degrees when, satisfied with a good afternoon's prog-
ress, I crawl into the tent. I hear almost no sound except for a
few frogs croaking. There are still no bullfrogs.

Monday, October 11

The thermometer reads 60 degrees at 7:00 A.M. I fire up the little
stove, make coffee, and eat a cinnamon bun. I count my blessings
as I sit on the riverbank and watch the sun coming up.

The water is as smooth as glass when I push off at 9:00 A.M. In
late morning, strong gusts of wind begin to fill the river channel
with clouds of colorful river birch leaves. Autumn leaves cascad-
ing through the air are beautiful, but the wind makes paddling
difficult.

Fastrill, an old Southern Pine Lumber Company (now
Temple-Inland) logging camp, was located in Cherokee County
somewhere along here. I don't know what to look for, but it
would be interesting if I could locate the old community.

Fastrill was the last logging camp built by Southern Pine
Lumber Company as it pushed its Texas-Southeastern Railroad

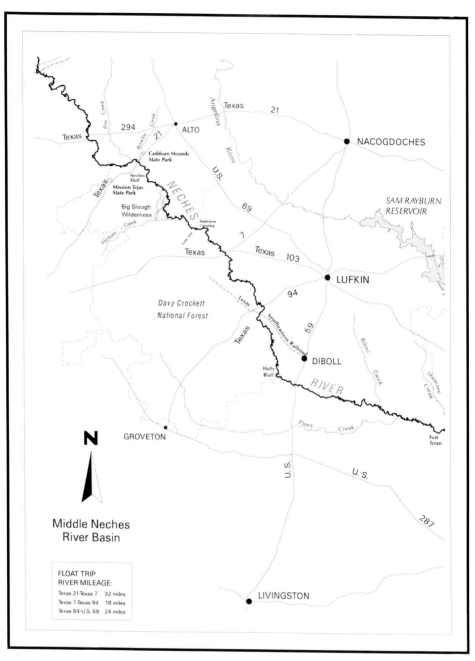

MAP 3. *Middle Neches River from State Highway 21 to U.S. Highway 59.*
(Courtesy Natural Area Preservation Association)

northward. Along the way the virgin forests of the Neches were cut, loaded onto rail cars, and hauled back to Diboll to be converted into lumber. It was not uncommon for mills to saw thirty-inch-wide by fourteen-foot-long knot-free boards from pine, gum, and magnolia logs taken from the Neches woodlands. Established in 1922 and closed in 1941, Fastrill, the longest-lived of any of the camps, boasted more than a hundred houses and even a U.S. Post Office. Old-time residents tell me that swimming in the river was one of their favorite Sunday pastimes.

This stretch of river, its hunting clubs, camp houses, and forests may all be drowned under the waters of the Fastrill Dam someday. The proposed dam site is near old Fastrill, and the earth and concrete wall would back water up across Highway 84 and northward almost to Highway 79 (see maps 2 and 3). Our state water planners, in their rush to promise dams and water projects, listed thirteen potential reservoir sites in the East Texas region alone. These dam building projects are a reckless waste of our natural resources. Some individuals (not all are environmentalists) are convinced the projects are advocated by a state bureaucracy that exists primarily to serve real estate speculators and industries likely to benefit from building dams and selling water.

The Texas Legislature instructed the state's Regional Water Planning Committees to recommend "stream segments of unique ecological value" in developing the state's long-range water plan. Of the sixteen planning committees across the state, *only one saw fit to nominate a single segment* of a creek or river worthy of being preserved. (That was the committee for Region H, representing Houston, Galveston, and surrounding counties; indications are that Region K, around Austin, may also recommend some.)

The current moves the canoe past numerous black gravel beaches before I come to a sandy delta deposited in the river by a little spring creek. Looking up the creek, I can see it twisting and turning between leaf-strewn, sandy banks—a really nice spot. About one mile farther down the river, I find another spring creek, but it is much smaller.

The river flows clear of tree-falls for a while and is swift in areas of rock outcrops. I make good time. The skeletal remains of pilings that once supported a bridge protrude up from the water. It must have been the Highway 21 bridge many years ago.

The map says I have passed the mouth of Bowles Creek. The creek takes its name from the last Texas Cherokee chief, and here the Neches forms the western boundary of Cherokee County. A large population of Cherokees and fragments of other Native American tribes once inhabited this area. They had been forced to migrate here as the advancing tide of European-Americans displaced them from their homelands in eastern North America.

The first Cherokees began arriving in Texas as early as 1807, and additional bands continued to arrive through 1820. Tribal leaders received permission from Spanish officials to settle on the land, but bureaucratic bungling and slow communications with Europe prevented title transfer before the Mexicans revolted and overthrew their Spanish masters. The Cherokees then petitioned the Mexican government, but before the Mexicans could grant title to the land, fate dealt the Indians another setback. On October 2, 1835, approximately 230 miles to the southwest of where Texas Highway 21 crosses the Neches, a detachment of Mexican soldiers attempted to take a small cannon from a "Texican" community called Gonzales. Again the Cherokees would see their hopes for a homeland in Texas dashed by a revolution.

The Texicans, hoping to keep the Indians neutral in the war with Mexico, sent Sam Houston, John Forbes, and John Cameron to negotiate with the Cherokees. In February of 1836, a treaty was signed giving title to the lands between the Angelina and Sabine rivers and northwest of the Old San Antonio Road (El Camino Real) to the Cherokees and their associated groups. Unfortunately for the Cherokees, the war with Mexico was brief. Following the defeat of Santa Anna at San Jacinto, the Texas Senate saw little value in ratifying the treaty. In December, 1837, despite Houston's strong objection, the treaty was declared null and void. The rescinding of the treaty and incursions of settlers into Indian lands provoked bitter resentments that led to several uprisings in 1838.

The Killough Massacre, the largest Indian attack that occurred in East Texas, took place in northern Cherokee County and was a direct result of the abrogation of this treaty. On October 5, 1838, just two years after the battle of San Jacinto, the Wood, Killough, and Williams families were in the field gathering crops when they were suddenly attacked by a band of Indians. It had been the settlers' practice always to carry their guns to the field, but that day they had left the guns behind. In the mayhem of that afternoon, eighteen members of those families were either killed or carried off. Those carried off were never heard from again. Eight others managed to escape on horseback, while three women and one baby were saved by a friendly Indian.

The first message to the Texas Congress from the second president of the Republic of Texas, Mirabeau B. Lamar, as included in the legislative record, announced that time had come for "the prosecution of an exterminating war" on Texas Indians, a war that would "admit no compromise and have no termination except their total extinction or expulsion." He specifically addressed the Cherokees, saying they held no legitimate title to the land on which they had lived for almost forty years. Most Anglos at the time had lived in Texas less than ten years. Lamar immediately dispatched a message to the Cherokees to leave Texas or be forced out.

Cherokee Chief Bowles recognized the Indians' precarious position and responded that they would leave if they could be allowed to stay until their crops had been harvested. Lamar's answer to that request was an emphatic no. He ordered the Indians to get out of Texas immediately. The Cherokees had little choice but to answer the ultimatum with: "We must fight." In July of 1839, Lamar ordered General Kelsey H. Douglass, General Thomas J. Rusk, and an army of five hundred men to move the Cherokees from Texas to Oklahoma Territory. The battle that ensued in Cherokee, Henderson, and Van Zandt counties killed many of the Indians, and many more died of cold and hunger in Oklahoma. When the body of eighty-three-year-old Chief

Bowles was found on the battlefield, he was wearing a sword given to him by Sam Houston.

I look up as my canoe glides under the Highway 21 bridge. This route is the Old San Antonio Road, El Camino Real, dating back to Spanish ownership of Texas; it served as the immigration route for many Americans into early Texas. For much of the time it was only a trail through the forest. The birthplace of Helena Kimble Dill's daughter, the first white child born in Texas (1804), lies a short distance east on Highway 21, and a marker noting the location of the first Spanish mission in interior Texas, San Francisco de Los Tejas, can be found a short distance west on Highway 21.

El Camino Real, the King's Highway—so much history is connected with that name. Names are important; they mean something. With the naming of rural roads for 911 emergency purposes, many Texas counties forfeited a never-again-to-be-seen opportunity to honor and exploit their region's traditions, historical sites, and geographical areas. For reasons known to only a few, counties chose to name roads for people rather than to give them names like Wild Woman Road, Spur, Longhorn, Log Wagon, Wilderness, Longleaf, Sawdust, or Crosscut Road. The names of people now define many of our rural roads, and it will soon be forgotten that something uncommon occurred there or that a geographical wonder lies just around the curve.

Immediately below the bridge at Texas Highway 21, a wisp of blue smoke spirals gently upward from a campfire in the Neches Bluff Campground. I see no one and keep paddling downriver.

The Neches Bluff Overlook on the Houston County side of the river is the northern terminus of the twenty-mile-long Four C Hiking Trail. The trail here follows steep ridges and skirts the edges of hollows so deep that hikers can look over the crowns of pines and hardwoods growing on the floodplain far below. In places it is possible to look across the wide Neches Valley and see the distant tree-lined eastern rim shrouded in blue haze. The hiking trail is named for the Central Coal and Coke Company, which

logged the timber from this region and hauled it to their giant sawmill at Ratcliff, Texas. The lake at the U.S. Forest Service's Ratcliff Lake Campground was a log-holding pond for the mill and is the southern end of the Four C Trail. The trees hikers can see and walk beneath along the route comprise the forest that grew back after the company completed its logging activities in the 1920s.

There are two primitive camping areas between Ratcliff Lake Campground and the Neches Bluff Overlook, and a portion of the trail traverses the 3,639-acre Big Slough Wilderness Area. Below the overlook the familiar yellow and black signs nailed to trees tell me I have entered the Davy Crockett National Forest. I begin to look for a place to camp.

The canoe rounds a bend and shows a collage of towering pines and oak trees along an elevated ridge silhouetted against the orange, red, and purple hues of the setting sun. A small stringer of a sandbar lines the Houston County bank. This will be home for tonight.

Two fox squirrels are making such a fuss in a black gum just above my head that I have to stop camp chores and listen to them for a minute. The noisy squirrels probably have a den in the old tree. As black gum trees age, many frequently develop hollows that provide homes for cavity-nesting birds and animals. Wild honeybees build their hives in the hollows of these trees and fill the voids with rich, sweet honey. Old settlers learned from the bees and built their own beehives with two-foot sections sawn from the trunks of hollow black gums. They called the hives gums or bee gums. Long after it became common to build beehives with nails and boards, many old people I knew still referred to them as gums.

Hollow black gums are considered worthless in today's managed forests. They, with the wildlife dens in them, are among the first of the undesirable trees to be cut down and hauled away.

I know it's time for bed when a barred owl says, "Who, who, who cooks for you all?" Besides, I am tired. Coyotes are faintly yipping and barking in the distance.

It is 60 degrees at 7:00 A.M. The fox squirrels are back at it again, scolding and chattering. Some distant coyotes did a little yelping just before dawn.

Sitting here with my coffee, I count at least fifteen gums that have either been killed or been severely damaged by beavers. Some of the trees are about thirty inches in diameter. A red-bellied woodpecker is drilling on one at this moment. He is still hard at work when I push off.

The river has lost its clean look and has taken on a grayish cast. The current is not as strong except when the channel narrows because of changes in topography. Some parts of the riverbanks in this area are really pretty. Sandstone cliffs colored in hues ranging from brown to gray loom fifteen feet above the water. In places they are covered with pale ferns and moss in varying shades of green. Luxuriant clumps of wax myrtle sometimes cling to the faces of the small cliffs and grow in other nearby openings.

It is amazing that the native wax myrtle is not used more in Texas landscaping. This large evergreen shrub is of great benefit to wildlife; some forty species of birds relish the wax-coated, BB-sized berries that grow along its twigs. The plant is hardy, will grow almost anywhere, and tolerates drought conditions well. Landscape watering accounts for a significant amount of our water usage. If more native plants were utilized in our yards and around our businesses, landscape water consumption would be reduced significantly, less maintenance would be required, and we would sacrifice almost nothing in beauty.

Four belted kingfishers put on a show. They chase one another back and forth in front of and behind the canoe for a mile, it seems. Every few minutes they give a burst of their harsh *tch, tch, tch* call, reminding me of an old WWI movie dogfight.

A coot is not the most aerodynamically designed bird on the river. It must get up speed for takeoff by running on top of the water. The one I surprise starts its run but does not have room to

get airborne, so it plows full speed into a pile of tree trunks. After falling back into the water and collecting itself for a second or two, it gets pointed straight down the river and makes its get-away.

I pass an almost new four-foot stepladder and an eight-foot section of stockade fence lodged up in a tree. They have hung there since the spring rains. I would like to have the ladder if my canoe would hold it.

I enter the Big Slough Wilderness Area and choose to stay in the river rather than enter Big Slough itself, a smaller alternate channel. Big Slough Wilderness, as the name implies, is a place of moist earth, forest, and water. The Neches River defines most of the nine-mile eastern boundary of the wilderness, and the slough halves its northern region. Southwest of the slough lies an area kept wet by beaver and alligator ponds. Button bushes that attract millions of butterflies surround these ponds, and white rose-mallows, with their large, hibiscus-like flowers, bloom here in profusion. Overcup oaks, which do best in terrain where water covers their roots for several months of the year, flourish along both margins of the slough. "Overcup" describes the acorns that fall from these trees. The cup virtually encloses the little acorn to protect it from rotting while in its wet residency. Later when the ground is dry, the acorn can sprout to grow another tree.

The wilderness area has not been logged since 1968, and the five-square-mile, mostly damp island that lies between the slough and the river has never been logged. Several times a year, following heavy rains, the river rises and spreads across the island, swirling around the trees and sometimes remaining for days. Even when the river is not "out of banks," the only ways to reach the island are to find a tree-fall across the slough to use as a foot-bridge or to go by boat.

The eight-mile loop of river and slough is a famous canoe trail. Most paddlers prefer to travel the circuit clockwise. The easiest place to launch is Scurlock's Camp, one-fourth of a mile from the end of Forest Road 517. From that starting point, one paddles downriver and returns to the launch site via the slough.

I have been told that the slough has become choked with logs and is no longer canoeable except in times of high water; very unfortunate, if true.

I detect movement on the Houston County bank and rest the paddle on my knees. A black pineywoods rooter sow and three shoats (feral hogs) come to the water to drink. They all wade in, then see the canoe. They freeze, trying to decide what it is. The sow snorts, and they lunge up the bank, spraying water everywhere as they go.

Approaching a clump of water elms, I hear thrashing and sliding. I give a couple of quick strokes with the paddle and break into the open just in time to see the violent swirl of water where an alligator has just disappeared. I drift downstream for a few yards and wait, but it does not reappear.

The bottomlands here are spectacular: giant oaks, gums, hickories, and the usual array of understory trees. Spying a good place to camp, I pull to shore and walk into the Davy Crockett National Forest. After the tent is pitched, I settle back against the rough bark of a black gum and watch the day grow dim until darkness envelopes my camp. Still, I sit. Openings in the dark canopy of leaves overhead reveal clusters of faraway stars in the inky black sky. I am alone in the darkness on the quiet bank of a log-choked river. There are no sights or sounds to manifest that humankind was ever here. No one knows my location more closely than within twenty miles. Bonnie saw me disappear from sight at U.S. Highway 294 and expects to hear from me again when I reach Texas Highway 7, some forty-eight miles downriver. A sense of minuteness and utter insignificance grasps my heart.

Wednesday, October 13

It is a brisk 56 degrees at 8:00 A.M. A cow is bawling in the far distance. This river has twisted and turned so many times that the sun is lost. It seems to me that it rose in the north this morning. I study the map to try and figure out my location. I decide I too am lost and give up.

After breakfast, I feel like walking. The open woods allow me to see in almost all directions as I slip silently along, hoping to catch a glimpse of any kind of wildlife. After walking perhaps a hundred yards, I arrive at what must be the mouth of Big Slough. There is no current in the slough, and the top of the water is covered with duff, leaves, and an occasional spider. The woods are quiet except for the hammering of a couple of red-bellied woodpeckers. The leaves are soft and spongy where I turn and begin following the slough as it leads away from the river.

I move north for perhaps a quarter of a mile. The early autumn forest across the still water is so enchanting that I select a good tree to lean back against and just sit and watch. Even though most of the leaves still remain on the trees, enough have fallen to give the ground a luxurious carpet of yellow and brown. I sit for perhaps half an hour expecting some animal to show itself. In the meantime, the woodpeckers have moved their jackhammering to a tree almost over my head. Tired of sitting, I strike a course east to intersect the river. Along the way several depressions, now dry, ringed with water elms, lie in my path. These will all fill with water during the next big rain and will remain full until next summer's dry season.

My course brings me right into camp. I quickly begin breaking down the tent and rolling up the sleeping bag. I am now eager to see what is around the next bend.

Yesterday presented about two or three miles of open water, allowing me to make good time, but the big logjam that can be seen ahead is not too encouraging. To avoid double work, I drag the canoe past the obstructions before loading the gear. It is 9:00 A.M. before I push off and lift the paddle.

The river shows many faces today. Sometimes it sprawls deep and wide with no more current than a pond. At other times it is choked down between fifteen-foot-high sandstone banks and a current that pushes the canoe along at a fast clip. My favorites are the shallow, gravel bottom areas where the water is swift and noisy and as close to rapids as one will find on the upper Neches.

I encounter a sandy delta extending out almost across the river. A clear, spring-fed creek that enters from the west bank is depositing the sand. Looking up the path this creek follows as it disappears into the woods, I see a winding course through leaf-strewn forested hills.

The river silently moves me on.

There must be fifty or more black and turkey vultures sitting in trees around a small clubhouse perched high above the water on a bluff bank. The reason for their congregating turns out to be the carcass of a deer. As I paddle by, my presence creates an almost surreal scene. The vultures take flight. When they all fly, the sky is black with birds.

This is, as I count, the third skinned deer carcass I have seen. Some hunters open the season a little earlier than others do.

Outlaw Hunting and the Albino Buck

"OUTLAW HUNTING," or illegal hunting, has been a plague on Texas wildlife for over a century. Those who know attest that Southern Pine Lumber Company, now Temple-Inland, probably saved white-tailed deer from extinction in the eastern half of the state. Texas was primarily open range, and the animals had simply been hunted with dogs and killed until they were exterminated from most areas. One 1913 Trinity County hunter said that so far as he knew, there were only one doe and one fawn in the entire county.

In 1913, Southern Pine Lumber Company established a cattle ranch on cut-over land near where Texas Highway 7 crosses the river—now the site of the legendary Boggy Slough Hunting Club, a few miles downstream from the Big Slough Wilderness Area. Several thousand acres on the west side of the Neches were fenced, including a one-square-mile section that was surrounded with hog-proof (also dog-proof) fencing. The few deer that had been able to survive the relentless hunting pressure soon learned to leap inside this section to elude the bawling hounds.

As the deer population inside this area and on other parts of the ranch began to increase, so did the poachers. The company first sought help from the Texas Game, Fish and Oyster Commission, predecessor of today's Texas Parks and Wildlife Department, but their aid was ineffectual. Temple then began to lease grazing rights and hunting clubs to individuals interested in preserving wildlife.

J. W. Austin, an official with Humble Oil and Refining Company, the forerunner of today's giant Exxon Mobil Corporation, received one of the first leases in 1935. Eason Lake, Old River, and Renfro Pasture hunting clubs were also organized in the 1930s.

Over time, the deer that had sought sanctuary on the Boggy Slough Ranch multiplied to the extent that the browse was

exhausted, and a great number died of starvation. As the newly organized clubs gained more control of their borders, deer gradually expanded their range outside Boggy Slough Ranch. Later laws, making it illegal to hunt deer with dogs, enabled the deer population to multiply rapidly and spread over most of its original habitat.

Would the deer have returned to the region without the efforts of the timber company? Probably, but it would likely have been a painfully slow process and would have cost the State of Texas a lot of money. I received an up-close and personal experience at one of the state's unsuccessful attempts to restock wildlife populations along this river.

One of my most enjoyable jobs during my high school years was working for the Texas Game, Fish and Oyster Commission. The commission had an agreement with Ed Durham, Dow Nerren, and other landowners along Shawnee Creek to establish the Shawnee Creek Wildlife Preserve. W. T. (Bill) Wright was the commission's biologist in charge of the project, and I was Bill's left-hand man for a while. The primary objective of the preserve was to reestablish the extirpated wild turkey and scarce deer along Shawnee Creek. We planted food plots and built fences all over the area in an effort to improve habitat. On several occasions the Game, Fish and Oyster Commission brought in trailer loads of deer and turkey and released them into the wild. They did not last long. Hunters learned where the birds were roosting by walking into the woods on moonlit nights and stopping occasionally to "holler." The roosting birds would answer the hunter's yell with a gobble and lead the poachers to the roost. It was then only a matter of getting the birds silhouetted against the moon and picking them off one at a time.

The transplanted deer fared little better. My friends and acquaintances found them easy pickings. Some headlighted and shot the deer at night. Others loosed their dogs near the preserve's boundaries and allowed the dogs to chase the deer into their waiting guns. Shawnee Creek Wildlife Preserve was soon abandoned.

Looking ahead on the river, I see that some lucky individual has a fourteen-foot Weldcraft boat and a new Johnson outboard motor chained to a tree. Just downstream I can see a gas-fired barbecue grill and a cook shed. People build memories in places like this. One can wonder what kinds of meals have been cooked under that shed: venison, squirrel, duck, fish? A scenic designation for the river would ensure that memories and traditions could continue to be fostered here and at hundreds of other cabins and campfires up and down this stream.

The noise of rushing water tells me I am about to get a fast ride. Sure enough, the longest run of swift water I have encountered moves the canoe along at a brisk pace for several hundred feet.

I have been off National Forest land for some time; but as I round a bend, directly in front of me is a towering bluff bank topped with tall loblolly pines. Nailed to a tree is a black and yellow sign denoting U.S. Forest Service land.

A tall narrow steel bridge looms ahead. It must be on County Road 1155 at Anderson Crossing. The bridge at this location was made of wood until just a few years ago. Somebody got mad at somebody else, soaked the wooden bridge in oil, and set it ablaze. This steel will not burn so readily.

A spring creek enters the river just south of the bridge. The canoe comes to a scratching, screeching halt, aground on a wide gravel bar that extends across the river. Nothing to do but get out and push to reach deeper waters.

A flat sandbar offers a good place to beach the canoe, so I pull over to make camp. At the top of the sandbar I can easily tell that this place is used occasionally to launch boats. I walk up the bank and am greeted by a picturesque little road that winds around, almost like a tunnel, through towering hardwoods. It is difficult to resist the temptation to walk down the pretty road. I have not seen any "Posted" signs near here, but there may be one fifty feet downriver. It is definitely private property and probably a hunting club. They absolutely don't appreciate trespassers. One

sad note is the number of fresh Budweiser cans recently strewn on the ground.

This is one of the most tiring days I have had, or perhaps fatigue is just catching up with me. At any rate, I put up the tent and am soon in it and fast asleep. The temperature at 7:00 P.M. is 74 degrees.

Thursday, October 14

At 7:00 A.M. it is 56 degrees, and there is a bright blue sky.

I have not noted anything in my journal about the songbirds seen and heard these past several days. Even though this is autumn, some still add their songs to the day. Mornings, when I am eating and breaking camp, are when they are most noticeable. Some I can identify, and others I cannot. As I was preparing to make these notes, a warbler of some kind was in a tree directly above, belting out a melodious tune that belies its tiny size. Two barred owls, apparently unaware that day had arrived, were directly across the river, not making the traditional owl sounds but rather the *ha ha* or barking variety. Now I hear a flicker on a dead tree and a woodpecker on another one.

Suddenly the sounds of the forest change. Men have arrived to work, and the sounds change to the roar of chainsaws and giant trees striking the earth. I hurry to leave the stillness-shattering racket behind.

The river has opened up and allows an opportunity to paddle. I stroke on one side until I am tired, then change sides. I repeat the procedure over and over, stopping occasionally to thread my way through logjams.

It seems as if most of the clubhouses along the river never quite get finished. I passed one earlier that was sided with Temple foam sheathing; I wonder how many years has it been since they quit making that product. The clubhouse that gets my vote for being most memorable so far is the old yellow school bus that someone parked at the river's edge a mile or two above the Highway 7 bridge. Of course, it has not been used in ages. It's

just an old yellow hulk destined to remain there for decades until it finally rusts away.

The noise of a powerful diesel engine greets me as the bridge at Highway 7 comes into view. A highway construction crew has a giant water pump set up at the boat dock, and water trucks are scurrying back and forth. The canoe scrapes to a halt at the dock. I drag it up on the bank sufficiently to keep it from floating off and start walking toward one of the little service station–grocery stores located on the Angelina County side of the river.

A young man wearing a black T-shirt that reads "6th Annual Piney Wood Stock" on the back glances my way to make sure I am not pilfering from his tackle box and resumes watching his bobber. "Fish aren't biting," he says.

No wonder. How can he fish with that pump roaring and shaking the earth?

Butch Sorenson is minding the store today and sells me a good, cold Dr. Pepper. I call Bonnie to come and pick me up. I need water and supplies and a hot shower.

Bonnie arrives, and we begin loading the gear into the truck. A small, tanned, friendly man approaches Bonnie and asks, "Ain't that the man that's canoeing down the river?" Bonnie assures him that it is the one and the same. "Well, he is sure welcome to tie up at my pier," he says, pointing a hundred yards downriver. I introduce myself and learn that my benefactor's name is Johnny Steele. He asks some questions about the conditions I have encountered upstream (logjams, etc.), and he tells me I can expect more of the same on the way to Highway 94. I appreciate his hospitality and interest in this expedition. Before we go, Mr. Steele goes to his pickup truck and brings a tiny baby gray squirrel for us to see.

As Bonnie drives me the thirteen miles into Lufkin for a shower, she fills me in on the media coverage. KTRE-TV aired Katrina Berry's Highway 294 interview on the 6:00 P.M. and 10:00 P.M. newscasts. The *Jacksonville Daily Progress* has again given the story front-page position with a color photo and a positive news piece on Sunday, October 11. With a smile, Bon-

nic thrusts the October 9 issue of the *Lufkin Daily News* in front of me. There on the front page, in living color, is a photo of me with twigs and spiderwebs in my shaggy gray beard and with my pants muddied to the waist. The photo makes me look as if I had been spelunking instead of paddling a canoe downriver. Zach Maxwell snapped the photo at the Highway 294 interview. KTRE-TV had shown an almost identical image in their newscast. Our story was being told. That was what mattered. That was our goal.

Friday, October 15

Shoving away from Johnny Steele's dock near Highway 7, I welcome the fog that hangs over the river. Some time later the river forks, the old channel bearing left, the new to the right. I turn right.

The sun quickly burns away the fog, and a strong south wind begins to blow. It gives me a fit with the canoe; and when a big gust blows, the oaks rain acorns into the river.

In the midmorning sun, I see the white underbody and legs of a deer high up on the bluff bank. It moves away before I can see if it is a doe or a buck.

The Neches has brought me into the realm of Temple-Inland's Boggy Slough Hunting Club. For the next fifteen miles or so, the river forms the eastern boundary of this legendary wild area. This big club has long been renowned for the quality and quantity of wildlife found within its borders. Squirrel, ducks, feral hogs, turkeys, and the whole array of wild creatures are plentiful in these forested bottomlands, but it is the white-tailed deer population that draws so much acclaim. The offices and homes of hunters across the nation proudly display wall mounts of eight-, ten-, and twelve-point bucks harvested in these woods. But no horned or antlered animal taken here, or for that matter anywhere else in the state, will ever compare with the trophy Joe C. Denman bagged alongside the old Texas-Southeastern Railroad bed that runs through the club.

The occasion for that memorable hunt was the Temple Industries (now Temple-Inland) 1958 safety awards dinner and hunting trip held for the company's production supervisors. This particular dinner and hunt had been different from the beginning. A special aura of excitement had permeated the dinner and awards presentation. Everyone had been talking about the big albino buck that had been seen flashing through the woods all summer long. Several sightings had occurred just within the last few days.

That evening, as the men gathered around the big stone fireplace in the clubhouse, stories of the albino deer continued to dominate the conversation. As was customary, before retiring to his bunk for the night, each man registered on a big wall map where his hunting stand would be the following day. When Joe chose his stand, several knowledgeable individuals jealously congratulated him on his selection. The albino deer, they asserted, had been seen in that vicinity a couple of times in recent days.

The next morning the eager hunters rolled out of their bunks to a breakfast of bacon and eggs long before daybreak. The mood of excitement present at dinner had carried over into the morning. Much of the breakfast conversation centered on bagging the albino buck.

It was cold when Joe stepped from the auto that dropped him off near his stand. As the headlights of the car moved away, the darkness of the woods settled around him. Only the sky overhead held a promise of the approaching day. The trail Joe followed led to an abandoned railroad right-of-way and a wooden trestle that stretched across several sloughs. Joe moved along the roadbed until he reached his stand near the end of the old wooden trestle. There he would wait.

As he sat, the trunks of the trees gradually emerged from the misty gloom, and the forest floor began to take shape in the half-light of dawn. Joe continued to sit, almost motionless, and study the woods around him for any sign of the presence of one of those majestic Boggy Slough bucks. Or perhaps, he dared hope, the albino buck. A movement just beyond a fallen tree caught his

attention. Slowly, ever so slowly, he drew the .30–06 rifle to his shoulder and squinted through the scope. He caught his breath. A fine set of antlers filled the scope's lens, but the rest of the animal was obscured behind the fallen treetop.

As he continued to peer through the tangle of limbs and pine needles, he saw something that almost made his heart stop. The antlers he had seen decorated the head of the albino deer! Feverishly trying to focus on the almost indistinguishable gray form in his scope, he must have thought: Could this really be happening? Then as the antlers were thrashed up and down against the limbs of the fallen tree, the animal took a step forward, presenting in the crosshairs of the scope a view of the antlers, the top of its head, and its gray neck. Joe squeezed the trigger, and the antlers pitched headfirst to the ground.

Joe lighted a cigarette with trembling fingers. His spirits must have been soaring as he paced off the 110 steps to his quarry. That was a pretty darn good shot, he probably thought as he marked off the distance. My kids are going to be so proud of me. This may even make it into the Boone and Crockett records, probably went through his mind.

Things were going so well when suddenly, like a bad dream, everything began to unravel. As Joe circled the fallen treetop and approached to within about twenty-five feet of the still animal, he remembered thinking: That certainly is a poor, shaggy-looking little ol' deer. Something about the antlers appeared odd, too. The next instant, Joe realized he had been had. He was in almost uncontrollable laughter when his hunting companions, who had been hiding and waiting for the shot, burst out of the woods guffawing and congratulating one another for pulling off a once-in-a-lifetime "Ripley's Believe It or Not" prank. The "albino deer" lying at Joe's feet had a rope around its neck and was securely tied to the treetop. It was shaggy looking because it was a white billy goat with a fine set of eight-point deer antlers wired and taped to the top of its head.

Someone in the crowd had quickly gotten on the car's two-way radio and contacted company president Arthur Temple

The famous "albino buck" of Boggy Slough Hunting Club would be a trophy to remember.

at corporate headquarters in Diboll to let him in on the story. Temple's response had been: "Whatever you do, don't let Joe get his hands on that goat. I want it." Temple had the goat mounted and hung in a prominent location above the fireplace of the old Boggy Slough clubhouse. The plaque underneath the mount read: "Killed by the Great Hunter, Joe C. Denman," or something like that.

That should have been the end of the episode, but it wasn't. Strangely, the story and photograph made the front page of the *Diboll Free Press*. Even stranger, the story somehow made its way into one of the national fish and wildlife magazines. At that time, Temple still delivered their building products with a fleet of company trucks that bore the Temple logo on each door. Sometime after the magazine article had appeared on newsstands, one of their trucks was passing through New Mexico and was stopped by two New Mexico highway patrolmen. As the startled driver dismounted with his driver's license and logbook in his hands, the officers laughed and said, "We didn't stop you for a violation. We just wanted to know if that story about the man shooting the goat was true."

All the emotions of life have been played out along the banks of this historic stream. Sadness, joy, drama, and shenanigans all combine to form and define the character and mores of the people who live here.

A gust of wind brings a shower of leaves and acorns off the overhanging trees and into the river. Several acorns rattle into the aluminum canoe, and others hit my hat. The river changes itself and everything around it. The new channel I am following is not as wide as previous reaches and is blocked much more by fallen trees.

But the water is not loyal to this channel either. There are already new high-water cutoffs that the water takes during times of abundant rainfall. Someday, these will be the new river. As the river current twists and turns, it is eroding the bank on the outside of its curves and building up the opposite banks on the

inside of the curves. Large oaks and towering pines cling precariously to the outside banks, while willow and river birch quickly lay claim to the new land being formed along the inside of the arcs. (The curly bark of river birch makes excellent tinder for starting campfires.)

Two pines come into view; one is four feet in diameter, the other slightly smaller. The earth has been cut from under both of them. How do they hang there? Following this winter's rains, they probably will fall and block the river.

The forest's stillness is broken by the snort of a deer. I strain to see it. No luck; it has seen me first. This is wild and remote country through here. The forests are mostly hardwoods, but there are tall, stately pines on the small hills and ridges.

The canoe clears a tree-fall, and at least twenty gaudily dressed wood ducks lift into the air and head straight downriver. They peel around and come back between the canoe and the sun, flashing their shadows on the water as they streak overhead. The Neches is a rest stop for ducks and other waterfowl. They will languish here until the first really cold norther comes roaring through, and then they will move farther south along the coast.

I am momentarily out of the treetops when I see a six-foot alligator lying on an oak log that spans the river. A loud, crashing noise in the woods draws my attention to the east bank, and I look back just in time to see the alligator slide noiselessly from the sloping bank into the river. Its scaly six-foot body disappears beneath the surface, barely making a ripple. From behind me the shrill, raucous cry of a pileated woodpecker, dubbed an Indian hen by early settlers, reverberates through the forest. A damselfly perches daintily on the prow of the canoe. Everything smells of autumn leaves, river water, and decaying cellulose. Sunlight filters through the trees and dances on the surface of the upper Neches River. Silently, I lift my paddle from the water and wait for the big reptile to reappear—I want to repeat the primal sighting. Finally, tired of waiting, I turn the canoe and begin to stroke the paddle through the water.

A white-tailed doe daintily dips her head to drink, barely fifty yards ahead of the canoe, before she realizes that there is a strange object on the water. She wheels and is gone.

Two fat black feral hogs are busily rooting on a sandbar and fail to see the canoe until I am very close. With much woofing they enter the forest and are joined by at least twenty more, judging by the sounds they make. These hogs, like those I have seen earlier, carry no markings in their ears. No one is claiming ownership of them. They are the property of whoever owns the land they happen to be on in their wandering quest for acorns, roots, hickory nuts, snakes, or anything else that is remotely edible.

Hog Killin' Time

WHAT INCREDIBLE SOCIAL CHANGES have been recorded just in my lifetime! Prior to stock laws and the closing of the free range in the 1950s, these woods would have been filled with hogs, and every one of them would have been carrying someone's ownership mark on its ears. An ownership mark served the same purpose as a brand on cattle; and like brands, the marks were easily distinguishable to a practiced eye. A mark might have consisted of a swallow fork and an over-bit in the right ear, and a cross-split and an under-bit in the left, or any one of dozens of other variations. Sometimes these marks, if crudely done, left the hogs and cattle with only a tatter for an ear.

Each year, during the first really cold spell, usually in November or December, the men would call their dogs, mount their horses, and ride into the bottoms looking for fat hogs. Cold weather was essential to keep the meat from spoiling during processing. The success of these hunts was vital to the river people. The very survival of the family sometimes hung on the efforts of that cold day. Tomorrow's dinner plates and lunch buckets would see sausage, bacon, ham, and roasts. Lard would be rendered from the fat, and cracklin's would flavor the cornbread. Some families would make lye soap by mixing a portion of the lard with ashes taken from the woodburning cook stove.

From the time the earliest settlers crossed the Sabine and Red rivers into Texas until the closing of the free range, pork, not beef, was the mainstay of those living along the Neches. This pork came from razorback hogs that roamed the hills and bottomlands, following the progressive ripening of muscadine grapes, persimmons, and other fruits. As winter approached, they thrived on the abundant mast of beechnuts, acorns, and hickory nuts in the wet hardwood lowlands. It would be during the acorn season that they would be at their fattest.

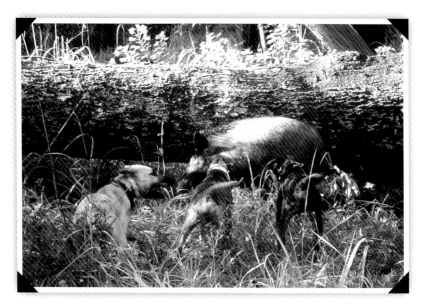

*When pursued by dogs, feral hogs establish a defensive position
with a fallen tree, thicket, or water to guard their rear. Dogs
face serious injury and death in such confrontations. The dog to
the right was ripped open by a slashing tusk and killed shortly
after this photo was snapped. (Ray Modisette and Robert
McDonald, Huntington)*

These hogs were wild and savage. A mature boar could wield
up to five inches of curved ivory "tushes." These dagger-pointed
tusks could rip open a dog's belly or a man's leg in a single blur-
ring slash.

It took a special breed of dog to handle these wild rooter hogs.
Early country folks sometimes used hounds to trail the hogs, but
when it came to baying, catching, or driving, the dog most relied
upon was the black-mouthed cur. This dog was perfectly suited
for the work: of medium size, highly intelligent, strong, and fear-
ing nothing that moved on the face of the earth.

As the horsemen wound their way through the woods, the
dogs would sweep back and forth in front of them until they
"struck scent." Sometimes the dogs would trail the hogs two or

three miles before they were able to hold them at bay. When pressed, the hogs would bunch into a tight herd and face the threatening dogs. A boar or sow might charge out, slash at a dog, wheel, and return to the herd.

Frequently, the arrival of the men and horses would excite the hogs to attempt to break and run. This attempt at flight would be futile. The well-trained dogs would grab the leaders by the ear or shoulder and hold them, precipitating ear-splitting squealing and ferocious tusk and teeth clicking from the entire herd. The hogs would then charge en masse at the source of their fury. But they were usually no match for the speed of the nimble, aggressive dogs.

When the hogs, usually about ten to twenty animals, were finally steadied into a bunch, the best rifle shot in the group of hunters would ease his horse slowly around the herd and expertly dispatch two or three of the fattest animals. The dogs would then be called off, allowing the remaining hogs to break free and run for the thickets. If a dog had been maimed, this would be the time to take a large sewing needle and twine from the saddlebag and stitch him together. Sometimes, it would be necessary for one of the men to hold the wounded dog in his arms or to tie him behind the saddle and carry him out on a horse.

Some of the men would quickly throw ropes around the dead hogs' necks, perhaps with a half-hitch around the nose, then wrap the ropes around the saddle horns and drag their kills to the nearest road or wide trail. There they would await the arrival of the wagon.

The river bottom stockmen depended on blowing horns to communicate with one another and with their dogs. Long blasts of the horn were used to communicate with people, while short, rapid blasts were for signaling their dogs. The blowing horn was made from a cow or steer horn that had been scraped and polished. Fitted on the small pointed end was a mouthpiece, also carved from horn. When blown in a fashion similar to blowing a bugle, the horn would produce a distinctive sound that would resonate for at least three miles on a cold, clear day. (Brady Jones

of Zavalla tells of his brother Jim blowing a horn while standing on Cyclone Hill, and the sound carrying to Bouton Lake, some five miles distant.)

When the men arrived at a road with the kill, they would begin sounding their horns as a signal to those at home to bring the team and wagon. Three long blows meant "Come to me." Two long blows meant "Where are you?" One long blow meant, "I'm here." The hunters would continue to blow occasionally, sounding a reference to guide the wagon to them.

Meanwhile, the folks at home would rush into action, building fires around their giant cast-iron wash pots, drawing water from the well, and carrying it to fill the pots. Hot water, along with sharp knives, "gambling stick," and other equipment, would be essential in dressing the hogs and preparing the meat for curing. It was cold, hard, and sometimes dangerous work; but it was also a festive time, a time of sharing and working together. The smokehouse would be filled with hanging meat, and the meat boxes would be filled with ham hocks and salted bacon.

My first experience with hog hunting was also the most memorable. I recall the events of that day with the clarity only youthful eyes can record.

For the first six or eight years of my life, I spent almost as much time with my grandmother, Ada Lowe Ener, as I did with my parents, even to the extent of calling her my "Other Mama." I would have stayed with her more if my parents had permitted it. One of the many reasons I enjoyed staying with my grandmother was that I also got to spend a considerable amount of time with her parents, my great-grandparents Calistus Montgomery Lowe and Belle Nerren Lowe of Sabine County.

The way of life of my great-grandparents, Pop and Mammaw, differed little from that of the first settlers to float their wagons across the boundary between the United States and Texas—or from that of Daniel Boone, for that matter. They never drove an automobile or had running water or electricity in their home. Mammaw cooked every meal on a stove fired with "stove wood." The only heat in their house came from a fireplace with a

Stick and mud chimney: in areas where rock and stone were unavailable, early pioneers resorted to building their fireplaces and chimneys with a mixture of Spanish moss and mud. This mixture was fashioned into "cats" or patties and plastered over a framework of sticks and laths to form a fireproof barrier. (Museum of East Texas, Lufkin)

chimney built of mud and Spanish moss. The Lowes personified the stockman-farmer-hunter way of life.

In this environment I awakened at 4:00 A.M. one cold winter morning in 1941, crawled from under a pile of quilts on a feather mattress, and dashed for the fire leaping in the fireplace. Pop was going hog hunting today. Mammaw already had biscuits in the oven and bacon frying in the skillet. Pop was at the barn milking the cow.

After breakfast, under the yellow light of a coal oil lamp (they later got an Aladdin Lamp), Pop had wound the big clock that sat on the fireplace mantle and had gone outside. I stood in front of the fireplace constantly turning my body to warm one side while the other side froze. Every few minutes I would walk to the

window and peer down the dirt road to see if anyone was coming. It was still dark outside.

Then, as night turned to dawn and daylight played across the treetops, I saw them. There they came, Uncle George Nerren and a companion, two men on horseback, with a couple of dogs trotting alongside. They were just crossing the little branch at the bottom of the hill. Each time the fast-walking horses exhaled, puffs of steam pumped from their nostrils. The dogs, mouths open and tongues hanging out, were loosing steady clouds of steam as their hot breath contacted the cold air.

Pop's big stock dog Pal spied the new arrivals before I did and was loudly announcing their approach as he rushed to confront them. The visiting dogs broke away from the horses and charged forward amid shouts from Uncle George to "git back." That call was enough to avert a fight. The dogs met with growls, raised hackles, and much smelling of one another before falling in beside the horses again.

Pop already had old Shorty saddled and tied out front. He opened the front door, stepped into the room where I was, and took a .32 caliber lever-action rifle off the wall. He told me good-bye as he thrust the rifle into a handmade saddle boot and swung his leg across the saddle, and the hog hunters rode into the woods.

Some time later, my grandmother arrived in her Model A Ford. The three of us enjoyed a cup of coffee. I had to have a saucer so that I could pour the coffee into it, like Pop did, before I drank it. (No wonder I loved these people.) Still later several other folks put in an appearance and began drawing water from the cistern, piling wood around the wash pot, and making ready for the work that lay ahead.

We waited with ears turned expectantly in the direction from which the grownups anticipated that the call would come. Sure enough, there it was, almost indistinguishable because the north wind was blowing the sound away from us, the faint summons of the blowing horn.

My grandmother and I piled into the Model A and drove east on the county road. This road was infamous for awful conditions in wet weather all the way to U.S. Highway 96, but on this occasion it was reasonably dry. We stopped frequently to get a new bearing on the blasts of the horn until my grandmother turned the little Ford down a dim, crooked old logging road toward the Moore Plantation. After dodging rotting logs and chug holes, we reached the men. They had killed several hogs and dragged them out to the little road. The hunt had not been enough to wear the edge off the dogs; they were impatient to be on the move. The men lifted the hogs into the small bed built into the little car, and we headed home to an essential and time-honored practice that reached back across the Atlantic and into antiquity.

Today has been difficult. I look for an early campsite and decide on a low, flat sandbar at 4:10 P.M. The sandbar is covered with deer tracks, and a sweetgum across the river has turned a brilliant purple.

Having taken on new provisions at Highway 7, tonight I am having Nissin Hot Sauce Beef. On a scale of five stars, this stuff rates a strong four.

Late evenings and early mornings are such special times of the day. I settle into a comfortable spot by the tent and begin transferring my daily notes from the small booklet dangling around my neck to the spiral binder that travels safely in the dry bag.

Below me the lazy stream, with its cargo of red, yellow, and brown leaves, murmurs noisily as it passes over an almost submerged log anchored in the opposite bank. All the smells of the river and its surrounding woodlands waft past on invisible waves. I have smelled these scents before, but thoughts of them have been buried beneath years of absence from their domain. These sights, scents, and sounds stir faint memories of another time, another place, and another era. As I sit and thoughtfully turn through memories, pressed between the yellowed pages of my mind, the rich, melodious songs of black-bibbed meadowlarks

come to me across green pastures. Bobwhite quail answer one another with clear whistles from a dozen places around the edges of the woods. The hauntingly lonesome "chip fell off the white oak" call of a chuck-will's-widow floats softly in the twilight of a closing day. A young tow-headed boy races through the woods to answer the urgent summons of his barking dog. My mother's voice calls for me to come home; it's suppertime.

These nostalgic musings stir me to wonder about the tomorrows we will leave for children of some future time. How will their minds and lives be shaped by the things we bequeath them? Will they know the beauty and solitude of deep woods or experience places where the only sights and sounds are those fashioned by the mind of God? History may well judge our generation not so much for wealth and progress but for how much of the natural world we allow to survive.

It is beginning to grow late when I fold the notepad and journal to close another day. My position, slouched against a black gum, is comfortable; as has been my custom, I sit and wait for darkness to hide the forest. Watermarks five feet above the forest floor encircle every tree at this campsite, and old logs lie lodged against trees growing in the flat areas along the river. The musically murmuring stream at my feet can be deceptive and can change almost overnight into a swaggering bully that pushes down and sweeps away everything that isn't prepared to withstand the vicissitudes of life in the river's realm. When it does get out of banks, it may be weeks before the waters return to the channel.

There would be no tree-falls to pull canoes over during such times and no portages to worry about. Getting lost would be the primary concern for those paddling the river when the waters have flooded into the bottoms. With water covering all clues about the lie of the land, it is unbelievably easy to stray out of the main channel and become lost in the surrounding woods. Everything looks the same, and one can bang around for long hours before finding the way back into the unobstructed current of the primary channel.

It is well past dark when a great horned owl gives a series of four deep hoots and encourages me to seek the thin air mattress inside the tent.

Temperature is 72 degrees at 7:00 P.M.

Saturday, October 16

At 2:35 A.M. I am startled awake by a terrific loud noise that lasts for several seconds. My first thought is *thunderstorm*, but there is not a cloud in the sky. When the noise subsides, I realize the crash must have been a large dead tree falling. No wind, no rain; its time had simply come.

After repositioning myself to avoid the hardness of a root beneath my tent and sleeping bag, I doze off, to be awakened early by the noisy cawing of nearby crows. Condensation has collected inside the tent, and every time I touch it as I dress, water cascades down on me.

It is 62 degrees at 7:00 A.M. A thick layer of fog clings to the earth like a soggy blanket. The gray shrouds the river channel, and long tongues of soft mist lick back into the woods through every opening in the bank. The Coleman propane burner soon has water rolling and tumbling in the little enamel boiler. Extra strong coffee helps make up for the sleep I missed last night.

A small, shallow dry pond not fifty feet from the river is surrounded by what appear to be mayhaw trees. The spring fruit from these tiny trees is not very tasty, but in the hands of someone who knows the ancient art, it can be made into a delicious jelly. Few people know the mayhaw jelly art better than does my sister-in-law Eva Farley. Each year for decades she has made me a Christmas present of eight or ten pints of the sweet, rose-colored delicacy. Mayhaw jelly on a hot, buttered biscuit is as close to fine cuisine as I ever expect to get.

While preparing my gear to stow it in the canoe, I hear dry leaves rustle and a large twig break. I raise my head just as a peculiar looking buck steps from beneath willows and sycamores onto the sandbar. We see each other at precisely the same time;

neither of us moves. The wind is not in his favor, so he has not gotten the dreaded human scent. We stand eyeing each other. Finally, the deer begins rotating his head and neck from side to side in an almost circular motion, hoping his nose will pick up a clue. (Although deer have uncanny hearing, they collect much more information by smell than with either their ears or eyes.) Still I make no move, although my back begins to feel as if it will break. The buck's antlers are almost comical: tall, extending almost straight up some ten or twelve inches before branching out into six small points. After what seems like minutes, he decides circumstances are not to his liking and turns back into the woods.

When I ease the canoe into the water at 8:20 A.M., visibility is still almost zero. The thick fog fills the entire river channel. Slowly, I inch along until the sun begins to burn through.

Numerous clubhouses begin to appear on the Angelina County side of the river. Up ahead, gleaming through the fog, is an array of lights. It appears to be a very large building, but as I draw closer it turns out to be a little red shack with electric lights strung all over the outside. I assume the owner left before daylight for squirrel hunting.

Farther on two hunters are standing at the water's edge, watching my progress. One is drinking coffee from a thermos cup. They are both lean men, the lines of hard work in the sun etched in their faces. "Have you had much trouble coming down the river?" one asks. I answer in the affirmative. One of the men says, "We are behind you 100 percent." "Yes," agrees the other, "keep up the good work."

Since I left Highway 7, the riverbanks have been tough, sticky mud. Then, after passing the mouth of an old slough, there is plenty of mud, but rock and gravel begin to reappear. Much of the time, the river bottom is sandy.

The faint sounds of traffic on Highway 94 become audible just as I discover a small waterfall ahead. It turns out to be water cascading over a half-sunken log. I steer the canoe hard to the left and avoid the turbulence. The river channel quickly be-

comes mud; it narrows and is choked with more logs. The canoe squeezes through a narrow gap between the root ball of a tree and the Trinity County side and breaks out into open water.

My watch tells me it is 11:30 A.M. when I arrive at the bridge, approximately thirteen miles west of Lufkin. I maneuver the bow as high up as possible on the Trinity County side to avoid the sticky red mud that borders the edge of the water. It is not easy getting out of a canoe with the bow firmly planted on the bank and the stern still in the water.

I pull the Grumman farther up on the bank, grab my empty water jugs, litter bag, and a few assorted items, and walk toward the series of chug holes and ruts that pass for a road in dry weather. Even now, during the drought, some deep holes still hold water, and I have to walk cautiously in a couple of places. The rough opening for river access leads to the highway directly across from a long white metal building with a red false roof across the front. A weathered sign fastened to a steel post outside reads "Pete's Liquor Beer Wine." A sign at the far end of the building proclaims "Neches Lounge."

As I walk toward the building, I note that the roadside mailbox has been punctuated with a couple of rounds from a rifle or maybe a pistol. The solemn-faced store manager, Buel Davidson, is sweeping cigarette butts into a dustpan as I approach. "How 'bout using your phone?" I ask. He nods his consent, and I precede him out of the bright sunlight into the dark store.

Inside, the walls and cooler are adorned with neon signs announcing that Bud Lite, Budweiser, and Silver Bullet are sold here. Boxes of Lone Star beer are stacked in the center of the room. Bottles of Cactus Juice and Jose Cuervo share the wall's shelves with Chivas Regal and Wild Turkey. Buel shows me the phone, and I call Bonnie to come and pick me up.

In Texas vernacular, this is a beer joint. Trinity County is wet. Alcohol is sold here, while on the other bank of the Neches, Angelina County is dry. Today's Lufkinites (Lufkin is the Angelina County seat) have cleverly circumvented this inconvenience with

*John Young Fowler stands in the walkway to his liquor store,
about 1937. Fowler owned a honky-tonk on the Neches in
Angelina County just downstream from the present State
Highway 94 bridge. In March of 1936, Angelina County was
voted dry by a margin of eighty-five votes. Fowler circumvented
this inconvenience by building a small liquor store in the flow of
the Neches River just past its middle in (wet) Trinity County.
The patrons of the honky-tonk had but to walk a few extra
steps to purchase the beverage of their choice. Not to be outdone,
the prohibitionists charged Fowler with "obstructing a navigable
stream." The case went to trial in March, 1938, and the jury
returned a not guilty verdict. Finally, after much wrangling, the
Court of Criminal Appeals ruled in favor of Angelina County,
and Fowler himself took an axe and directed the destruction
of the store, walkway, and pilings. (Museum of East
Texas, Lufkin)*

any number of clubs around town. The clubs all dispense adult
beverages by the glass and by the bottle. "Lufkin is the wettest
dry town in the state," goes a local quip.

That has not always been the case. For generations, residents
of Angelina, Nacogdoches, and surrounding counties streamed
across the Highway 94 bridge (and some still do) every Friday
and Saturday night, seeking excitement, dancing, romance,

alcoholic beverages, and fist fights. Within thirty minutes after coming "across the river," most of the visitors gained at least fifty pounds, grew seven feet tall, were invisible, and became bullet-proof, a sure recipe for trouble. Fights were common. Occasionally combatants were cut or stabbed, but for the most part disputes were settled with fists.

It has been only in the last forty years or so that fighting has fallen out of fashion. Before his death some years ago, I asked longtime Zavalla Constable "Cotton" Gaskamp how people had changed during the more than thirty years he wore a badge. His unhesitating response: "People now want to kill you; they all have guns. When I started, they came out of businesses or their cars wanting to fight." Cotton was forever ready to oblige. He was not a large man, perhaps 180 pounds, and almost never wore a gun, but he was tough and able. He took his law enforcement respon-sibilities seriously, not to mention serving as a free ambulance, taxi, courier (mostly of bad news), and fireman and conduct-ing many other miscellaneous deeds of benevolence. He never had any help, and except when his wife Abby rode with him, he always worked alone. Tough men came from far and near to "try him out." They all wound up in jail with contusions and lacera-tions about the head and body as rewards. He regularly pulled over bootleggers transporting liquor from here in Trinity County, from Long's Station in Hardin County, or sometimes out of Louisiana.

Of the many incidents Cotton came up against during his thir-ty-five-year tenure as constable of Precinct 4, Angelina County, a half dozen or so remain lodged in my memory. (Texas folk history suffered a loss when his career exploits were allowed to die with him and his contemporaries.) I suppose the fracas and bizarre shoot-out that left the constable with a bullet hole in the crown of his hat occupies a spot at or near the top of the list of things I will not likely forget. The event as it played out could easily have been high drama in one of the old Wild West B-movies of the 1930s.

The morning of July 9, 1963, began warm and quiet like most Texas summer days, but before that day was done, at least

three and perhaps five people could easily have died. As the day turned to evening, Cotton encountered a slightly inebriated Royce Stanley on a hot, dusty street in Zavalla and told him to go home before he got into trouble. Some time later, thirty-one-year-old Laura Beth Runnels was visiting a neighbor across the road from her residence on Highway 63 at the east edge of town when she saw Royce pull into her driveway and begin talking to her three young sons. As she left her visiting and approached the car, the man began accusing her of calling the law on him. He grew agitated and pulled a .22 caliber pistol with which he struck her across the head. As she struggled to her feet, he struck her again. Then, when she regained her balance and tried to escape toward her home and her boys, he shot her twice.

Lovie Roberts, the neighbor Mrs. Runnels had been visiting, witnessed the episode and rushed to call Cotton. When he arrived at the scene some minutes later, he was told that Stanley had sped away in his car.

Moments later the enraged Stanley stopped at the home of Mr. and Mrs. Charlie Perkins, who lived nearby on Highway 63, and he accused them in turn of reporting him to the law. Luckily the Perkins's eleven-year-old daughter Wanda had managed to crawl undetected out of a window and was running down the highway when Cotton found her. "He's fixin' to kill Daddy," the child told him. She said Royce had told them he had shot Laura Beth and left her on the ground and that he was going to shoot them, too.

Arriving at the Perkins's, Gaskamp approached the house and hollered out, "Royce!" but received no response. When he opened the front door, he could see the couple sitting on the edge of the bed in an adjoining room but could not see Stanley crouched behind the door. As he stepped into the room and asked the Perkinses if they were all right, Stanley stepped from behind the door and fired three quick shots from almost point-blank range. Fortunately, this time the constable was carrying his .45 caliber semi-automatic pistol. He whirled and fired one shot. The bullet's impact knocked Stanley down, and he slumped

against the wall, crying out, "I'm dying." But he managed to squeeze off two more rounds before the barrel of Cotton's .45 cracked across his head.

Gaskamp then dragged the subdued man out of the house, but Mrs. Perkins didn't get to see them leave. She had fainted.

Mrs. Runnels was rushed to Lufkin's Memorial Hospital, where it was determined that she had been shot once in the abdomen and once in the shoulder. She made a full recovery but still bears the scars, along with scars on her hands where she had attempted to protect herself from the pistol blows to her head.

The shooter was not seriously injured. The .45 slug had struck with enough force to knock him down, but a heavy metal cigarette lighter in his pants pocket had miraculously deflected the big bullet and left him with only a badly bruised leg. Cotton ended the day with a bullet hole through his hat and the law-breaker in jail—just another of the many close calls this tough lawman encountered during his distinguished career as constable of a rough and tough area.

The clattering of a diesel engine outside lets me know that Bonnie has arrived to pick me up. We plan to attend assembly in the morning at Central Church of Christ in Lufkin, have lunch, and repack some gear. I will push away from the bridge at Highway 94, nine miles west of Lufkin, in the late afternoon.

Loggin' Camps and the Last Black Bear

Sunday, October 17

Wind is gusting from the north and the sky is gray and threatening as I approach the tall, abandoned but still intact Texas-Southeastern (TSE) Railroad trestle stretching across the river ahead. The bridge's pilings hold a mountain of various-sized trees and logs that form a six-foot-high barrier across the entire river channel. A quick reconnaissance reveals that the only route available is over the top. It will be necessary to slide the canoe, with the gear stowed inside, up the sloping pile of logs and then maneuver it down to the water on the other side.

Everything is going as planned until the canoe reaches the very top log and pins the cuff of my trousers against a protruding knot. I am stuck, spread-eagled across the canoe six feet above the swirling water, and am unable to shove the craft forward or backward. The words *don't panic* come to my mind. One thing is certain—do not teeter backward. Finally, I am able to work one finger, then two, then three, under the cuff of the trouser leg. I pull upward as hard as I can; luckily the cotton fabric is thin, and the jagged edge of the knot is sharp. The cloth tears and I breathe a sigh of relief and carefully work the canoe through the limbs and back into the water.

The TSE Railroad built this bridge in the early 1900s to transport logs from Southern Pine Lumber Company's logging "fronts" in Trinity, Houston, Cherokee, and Anderson counties to the sawmills in Diboll, Angelina County. This river crossing was shown on company maps of the 1920s as Gilbert. There was a large water tank and "section house" located here. The steam locomotives would stop at the tank to take on water to replace that being used as steam. Maximum allowable speed for any train crossing this bridge was six miles per hour. In some other

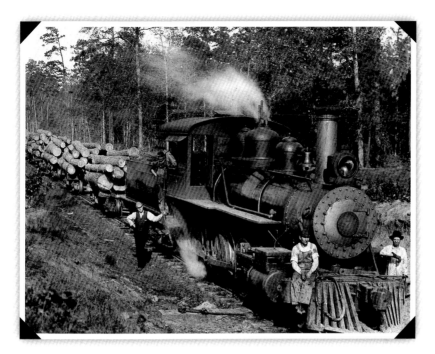

A Texas Southeastern Railroad log train approaches Diboll with a load of logs, about 1907. These steam engines were often fired with "pine knots" (resin-rich pieces of pine). Jim Jones and his father, of the Shawnee Prairie community, paid for a forty-acre farm by picking up pine knots and piling them alongside the rails that led to the Carter-Kelly Lumber Company mill at Manning. (History Center, Diboll)

places on the TSE line, passenger trains were allowed to attain speeds up to thirty miles per hour.

Today the rails that once carried powerful locomotives and their cargo of virgin logs across this trestle have been pulled up and replaced with a single eight-inch pipeline. The pipe once transported oil from Temple's wells in Trinity County to a main trunk line passing through Angelina County.

In its glory days, the TSE crossed the river here and paralleled the river in its course to the northwest. As the rail snaked through Trinity, Houston, and Cherokee counties, at least seven

logging camps were established along the way. Camps with names like Vair, Rayville, Neff, Walkerton, Kenleyville, Bluff City, and finally Fastrill were hastily thrown together, but except for Fastrill, their existence was just a brief moment in time. When the logs "played out" in an area, the workers' boxlike houses and tents would be loaded onto a railcar and hauled to the next logging front.

Life in these logging camps was austere and primitive. The families living in them were virtually cut off from the world. The only news from the outside to penetrate these deep forest camps came from the train crew as they returned from delivering their daily trainload of logs to the mill. Water was usually hauled in by tank car from the river, and the logging families' meager clothing and supplies were purchased from the company's commissary railcar parked in camp. Six days of the week the men left the camps for the woods at 6:00 A.M. and did not return until 6:00 in the evening.

For twelve hours a day, six days a week, these "flat heads," as the sawyers were called (for the beetle that makes a sawing sound as it bores into logs to lay its eggs), sawed down trees, chopped off limbs, and sawed the trees into specified lengths. The main tools of their trade were crosscut saws, double bit axes, files for sharpening, and whiskey bottles filled with coal oil (kerosene). The neck of the whiskey bottle would be stuffed with long green pine needles. As the sawyers dragged the saw blade back and forth through the trees, sap, or "rosum" (resin), would accumulate on the blade. This accumulation would increase friction and make sawing much more difficult. To disperse the resin and lubricate the blade, a sawyer would take the whiskey bottle of coal oil from his hip pocket and flick several sprinkles of oil through the wick of pine needles onto the blade. Sawing immediately became easier. (Note, I didn't say "easy.")

The working men of that day always wore a hat and long sleeves. Tradition taught the dangers of exposure to the sun. Many working men wore a denim jacket in the summertime. As they went about their strenuous work, perspiration would

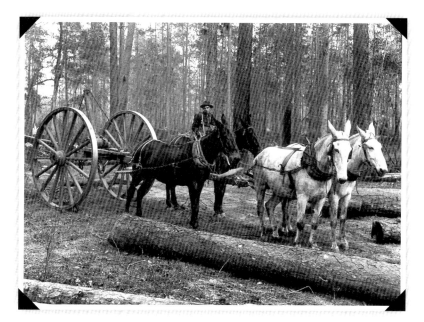

Matching pairs of white and black mules are hitched to a high-wheeled log cart, used to drag logs to tram roads where they could be loaded onto railroad cars and hauled to the sawmill, 1907. (History Center, Diboll)

saturate the jacket. The evaporation of moisture from the jacket helped to keep the wearer cooler.

Life for the women of the camp was also incredibly hard. All the family's meals were cooked on a hot, woodburning stove or outside over campfire coals. Fresh bread was often baked twice daily. Those tiny box houses became like ovens. Wash day was dreaded by most. Large quantities of water had to be carried from the tank car or drawn from shallow wells with ropes and buckets. A fire was built around a cast-iron wash pot filled with water. The women would spend hours bending over a "rub board." Each garment, towel, and sheet, and sometimes quilts had to be pushed up and down the board many times to remove the dirt and stains.

The men's clothing was the most difficult. Some wore bib overalls, cotton shirts, and denim jackets. Pushing these heavy garments up and down the rub board was hard work, but

that was the only way to remove the accumulated sweat and grime from the men's work clothes. After the clothes had been scrubbed, they were transferred to the rinsing tub, and finally to the wash pot of boiling water. A "punching stick" about the size of a broom handle was used to stir the items and to remove clothing from the cauldron of boiling water.

Leaning over that pot with heat and smoke in one's face and flames and red-hot coals scarcely inches from one's feet and legs was not a pleasant experience. After the clothes were washed, rinsed, and wrung out, they were pinned to a wire or clothesline and left to dry. Finally, they were ironed with a heavy smoothing iron heated on the cook stove. The iron was so hot that the handle had to be grasped with a layer of rags to protect the hands.

Life on the Aldridge logging front: this remarkable if tattered photograph from about 1910 portrays the incredible hardships that families who followed the logging fronts endured as the virgin forests of Texas were cut. Pictured in front of their home and dressed in their Sunday best for the camera are Mrs. Pilot Williams, holding baby Easel, and young Aza standing at her side. Mrs. Williams died at a young age. (Sammy Crain, Huntington)

It is well to remember that the women were doing this in addition to cooking, canning, rearing the children, working a garden, quilting, and sewing. Pity the oldest girl child in each family; she had to grow up in a hurry.

A short distance below the TSE trestle and about five miles downriver from Texas Highway 94, the canoe glides past the mouth of an old river channel that gives its name to the Old River Club. Membership in this club is highly prized for both the quality hunting and excellent fishing it affords.

Below the mouth of the old river, the skeletal remains of a long dead hardwood, probably killed by a bolt of lightning, stand erect near the river's edge. The main stem of the old tree still pokes above the canopy of smaller trees surrounding it and basks in the late evening sun. Lower on the trunk, three or four gnarled remnants of big limbs reach out and upward as if imploring the heavens for a reprieve from oblivion. Woodpeckers, nuthatches, flickers and various other species of birds have feasted at the decaying tree's banquet of bugs and worms. There are seemingly thousands of small cone-shaped holes drilled into its rotting limbs and bole. The powerful beaks of pileated woodpeckers have chiseled big chunks from the tree's trunk, revealing a large hollow void that was once probably the den of a bobcat, owl, raccoon, or an opossum. Someday soon, when the stem is weak from soaking rains, a strong wind will topple the old giant, and its carcass will host the multitude of critters and bugs that inhabit the forest floor. Death begets life. Already the dead tree's progeny is taking root in the soil around its base. The dense canopy of leaves that once sifted the sunlight is gone, allowing the acorns that littered the ground to germinate and grow.

Less than a mile downstream from the old river channel, I begin to make camp as two dogs are "cold trailing" nearby. Their howls reverberate through the darkening woods. Shortly the tempo of their voices quickens, and it appears I am going to hear a good chase; then nothing. The dogs simply quit.

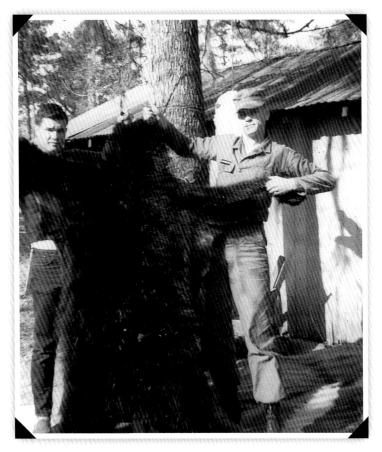

*Joe Harber (left) and Henry Lawrence display the skin of the
black bear killed at Eason Lake Hunting Club on Christmas
Eve, 1962. (Charlie Harber, Lufkin)*

If this were 1962, I would think the hounds had perhaps run
upon a bear, tucked their tails between their legs, and headed
home. It was on Christmas Eve in 1962 that longtime hunt-
ing club rider Charlie Harber was making his rounds in nearby
Eason Lake Hunting Club with his son Joe and Joe's teenage
friend, Henry Lawrence, when a four-hundred-pound black bear
crossed in front of them. Young Joe quickly dropped the running
bear with one shot from a .30–30 rifle. When it became evident
that the animal's back was broken and a second shot was needed

to finish the bear, Henry Lawrence was allowed to administer the coup de grace.

Two years later, four hunters from Vidor killed another four-hundred-pound black bear near Pineland in Sabine County. These men had a harder time bringing their bear down. They reportedly needed thirteen loads of buckshot to knock the big bruin off its feet.

Black bears would return to East Texas to stay if they could find sanctuary. They have already crossed the Rio Grande from Mexico into West Texas and are doing well. Oklahoma, Arkansas, and Louisiana have reestablished a strong black bear presence in their states, and transients from these populations are crossing the Sabine and Red rivers into East Texas. If these animals could be protected in a large river bottom area, such as the Neches bottoms, the population could quickly revive.

I see my first geese of the season, southbound in a long, sweeping V with three irregular fragments trailing behind. More keep coming, and they honk into the night. "I must go where the wild goose goes," is the old refrain. How many times, as a youth, did I hear that wild, free honking sound of geese flying south to winter in mystical places one could only dream about?

The wind is getting stronger. I crawl into the tent for the night. I hope this tent doesn't leak!

Monday, October 18

The patter of raindrops hitting the tent makes me feel warm and snug all zipped up in my sleeping bag. About 7:00 A.M. the rain lets up and then stops completely. I roll out of the tent, make a quick cup of coffee, pack the gear, and am paddling down the river by the time the next shower arrives.

My downstream progress should become easier from this point south. The river channel is getting much wider, making it less likely that a tree-fall will block the width of the watercourse. No doubt there will still be tree-falls, just not as many as the upper reaches have presented.

The biggest drawback of the trip has been the extremely low water level. At a higher water level, paddlers could simply maintain river position and cover more distance by pure floating than I have been able to do. In addition, scrambling around and over logs and treetops has presented a small measure of danger that I would prefer to avoid. On the other hand, the low water has let me observe many interesting bank and geologic features and large numbers of wildlife coming to the river for water. Also, the low water conditions have afforded a good choice of campsites.

Two female deer stand atop a tall bluff bank and study my approach for a few seconds; then, turning, they lift their flags and jog stiff-legged into the brush.

The rain has stopped, and I see the blue smoke of a campfire. The thought of a cup of hot coffee comes to mind. I arrive at the smoke and see no one, only a dirt road leading away from the river. That would probably be the Trinity County Holly Bluff campground, and the smoldering coals are remnants of a hunter's early morning campfire.

The constantly flowing current brings numerous shacks and clubhouses on the Angelina side of the river into view. All are deserted except one. Once again I see smoke and this time a pickup truck. As the current takes me past I shout, "Hello," and listen to the faint echo. No one responds.

Straight down the river is a craggy old snag, forked at the top, sticking thirty feet above the water. On each fork a great blue heron is silhouetted against the gray sky. One quickly takes wing, but the other remains until the canoe is almost underneath. Then the second bird stretches out those magnificent wings and takes to the air.

I hear a noise carrying through the woods that causes me to stop paddling and rest my hands on my knees. The high-pitched whine and staccato chatter must be coming from an in-woods chipper. These powerful, portable machines and their more consumptive counterpart, the chip mill, are like giant pencil sharpeners. Entire trees, with their limbs lopped off, are fed end-to-end into the slashing teeth of these ravenous machines and

emerge seconds later as chips, to be discharged into large trailers of waiting trucks.

Chip mills are the bread of life for clear-cutting. They are the essential tools for converting mixed hardwood and pine forests into loblolly pine farms. Theoretically, the chipper makes it possible for every tree and sapling growing on the land to be converted into fiber and dollars.

Prior to chipping operations, a tract of timber is usually high-graded for all saw logs suitable for lumber production and for pulpwood. The remaining trees are then chipped. The small or inferior pines are chipped for paper and manufactured-board production. Small quantities of hardwood chips are used in some U.S. paper products, but a large part of the chips find their way to Houston, Beaumont, Port Arthur, or Lake Charles for loading into the holds of ships bound for Asia, where they are converted into paper products.

When the dust has settled from the wake of the last hardwood tree skidded from the tract, the land begins its new role on this earth as a pine farm to be harvested on a twenty-five-year cutting schedule.

Proponents of clear-cutting argue that the practice promotes diversity of species and provides necessary habitat for certain species of animals. A close examination of this argument reveals the opposite. In the short run, clear-cutting does benefit some birds and animals, but in the long run, it hurts them. Forbs and shrubs that proliferate immediately following clear-cutting do provide tremendous browse that lasts for about four years. After that, the land will support almost no wildlife for fifteen or twenty years.

Some timber companies, to their good credit (and I appreciate their efforts), are leaving narrow hardwood stringers, SMZs, along streams as they clear-cut their lands. Still, these sylvan gifts cannot come close to replacing the hardwood forests lost every day. Even the wet bottomlands are no longer safe for hardwoods. Pines are being ingeniously forced into these areas by plowing up terraces so that their seedlings' roots will be kept above temporary floodwaters.

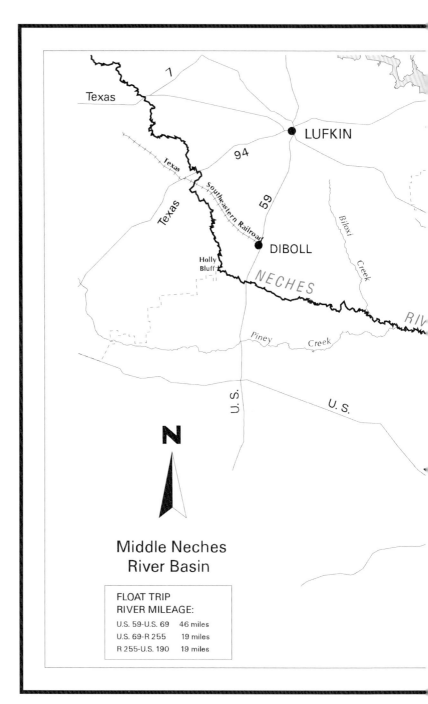

MAP 4. *Middle Neches River from U.S. Highway 7 to U.S. Highway 190.*
(Courtesy Natural Area Preservation Association)

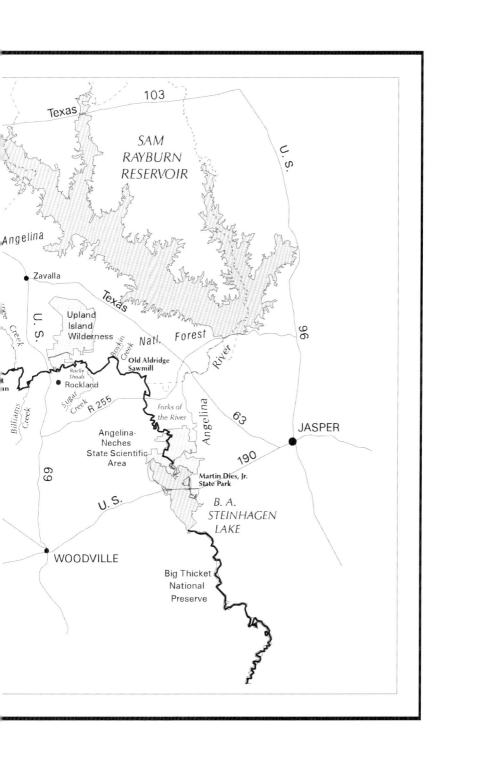

The rain resumes, and I begin to look for a place to pitch camp. It is raining hard now, and I hear the sound of a freight train. Highway 59 must be closer than I thought, so I abandon the thought of camping and really begin to ply the paddle. By the time the canoe's prow slides onto wet grass at the Highway 59 boat ramp, it is 6:00 P.M. Rainwater is sloshing in the canoe, and my clothing is soaking wet.

It is a three-minute walk from the boat ramp to the Hendrys' house alongside Highway 59. I ask Mrs. Hendry if she will please call Bonnie to come and pick me up. I am so cold that my teeth are almost chattering. Mrs. Hendry invites me to come inside, but water is dripping off me. I thank her and remain on the porch, water puddling around my feet. In a few minutes, she reappears at the door with a cup of scalding hot coffee. I stand shivering on the front porch, savoring the hot liquid as it warms me. Bonnie arrives in no more than thirty minutes. I have already stowed my wet gear under the bridge, so it is a quick matter to load it into the truck and get as close to the truck's heater as possible.

This has been a special day. Little wildlife presented itself, but it was worth getting cold and wet for the scenery. The giant forests, high hills, rocky cliffs, and rapids were interesting facets of the diverse landscape along the river.

Tuesday, October 19

The news media have scheduled a 3:00 P.M. meeting at U.S. Highway 59 today. The canoe expedition seems to have struck a chord with the public. Bonnie tells me she has received numerous phone calls from friends and strangers alike asking for information about my downriver progress and about the threats to the river that we are trying to highlight. People stop her in the supermarket and other places around town to inquire about the adventure. The president of the Anthony Smith Chapter of Daughters of the American Revolution called to make a monetary contribution to help save the river.

While waiting for the reporters, I dump the canoe and give it a thorough cleaning. It is full of mud, water, leaves, twigs, and debris of all kinds. I have the canoe clean, loaded, and ready to resume the downstream journey when Zach and Katrina arrive. Katrina quickly sets up her camera while Zach snaps some photos. We discuss details of the trip while they work, but the interviews are brief. The weather is cold. The news people want to get back inside their warm automobiles, and I want to warm up by pulling the paddle through the water.

The noise and clamor that we call civilization is deafening when I shove away from the Highway 59 boat ramp. Eighteen-wheelers, bumper to bumper, are roaring across the bridge overhead, their large tires singing songs of protest as they hurtle along the concrete. The engineer of a southbound Union Pacific freight train is "laying on" the whistle as he thunders toward the Neches trestle. I begin to stroke the paddle into the khaki-colored waters as rapidly as possible. I want to put some distance between myself and these noisy arteries of commerce before making camp for the night. Progressing downriver, the first thing I notice is the autumn foliage of the bald cypress trees on the water's edge. The needles have changed to burnt-orange overnight. Bald cypress gets its name because it is one conifer that sheds its leaves in winter.

I am scarcely out of sight of the bridge at Highway 59 when a big, broad-tailed beaver bolts out of a hole in the river's bank and almost splashes water into the canoe with its belly flop into the river. The sky is cold and gray, and a north wind is blowing. The cold wind makes tears come to my eyes.

Steamboats and Logs

THE WEATHER WAS VASTLY DIFFERENT on a hot July day in 1963, when Robert Reynolds, Johnny McWilliams, and J. D. Tarver discovered an old steamboat's anchor at this spot. The river was extremely low, and the three young men were trotline fishing for catfish when they noted an odd-shaped piece of iron protruding up through the mud and water. With the curiosity and energy of youth, they began to uncover the mysterious object. After hours of toil, they were able to break the hundred years' grip of Neches mud and silt and slide a 150-pound anchor out onto the riverbank. They cleaned and sandblasted the old artifact, but time and rust had obliterated any markings of identification. It could have come from any one of the old steamboats that plied these waters during the years between 1840 and 1894. I wish I knew the circumstances that brought the antique to this spot.

In the early 1800s, the Neches was a major artery of commerce. By 1840 the steamboat *Angelina* was plying the Neches waters and had opened up the East Texas interior to a booming trade with New Orleans and Galveston. The decks and holds of these Gulf-bound stern-wheelers would have been piled high with bales of cotton; otter, mink, and beaver pelts; and skins of deer, bear, and panther (cougar). Their southbound freight would also have included handmade baskets, handles, gourds, and jars, both glass and stone, filled with ribbon cane syrup, wild honey, and bear grease. Their upriver or northbound cargos would have included axes, saws, rifles, ammunition, coffee, sugar, flour, salt, and the whole list of staples needed for survival by those who lived in what were then called the "Texas Western Woods." Riverboats that once navigated the Neches were small and of shallow draft. They had to be, for the river was shallow, crooked, and dangerous to travel for months of the year. There

were many seen and unseen obstructions that could tear the bottom out of any boat. Boat captains particularly dreaded Rocky Shoals, near Rockland, and few ventured north of the shoals after the heavy spring rainy season had passed.

The Neches steamers little resembled the grand boats that paddled up and down the Mississippi. One irate traveler described the boat that carried him up the Neches as small, filthy, and horribly managed. The boat's menu of tough beef, Irish stew, and strong coffee was not particularly pleasing to his palate either.

That disgruntled passenger's description did not fit all of the Neches steamers. Captain Andrew Smyth's *Laura,* for one, was a brightly painted vessel that featured private cabins, meals, and a saloon complete with a mahogany sideboard, grand piano, sofas, and mirrors. The 115-foot-long and 32-foot-wide vessel could carry as many as six hundred bales of cotton in addition to its passenger manifest. All who saw the *Laura* or traveled on her were impressed. Smyth had traveled all the way to Evansville, Indiana, in 1871, to purchase the *Laura* for the princely sum of $11,000. His business partners had authorized him to pay as much as $9,000 for a steamer, but Smyth recognized the value of the boat and borrowed the additional $2,000.

After purchasing the *Laura* Smyth hired a crew, secured a load of freight, and steamed for Bevilport, Texas. His trip home carried him south down the Ohio and Mississippi rivers to New Orleans, then west across several hundred miles of the Gulf of Mexico until he reached Sabine Lake and the Neches River. This was quite a journey for a man with the meager boating skills Andrew Smyth possessed at the time. His business partners were delighted with his purchase.

The steamboat's dominance of transportation was brief. Railroads began to siphon off commerce by the 1880s. The last of the steamers, the *Neches Belle,* made its final run in 1894. There is a story about the last paddle wheeler to travel up river as far as Boone's Ferry and Fort Teran (near the point of intersection of Angelina, Jasper, and Tyler counties) in 1882. It was said that after

the cargo was unloaded, the crew threw a dance on the deck of the boat and invited all the local settlers. The dance lasted until the morning hours, after which the crew slept off the effects of their nightlong revelry. When they awoke later in the day, they discovered that during the night the river had dropped so much that the boat could not move. It was six months before a rise in the river would permit them to return south.

The paddle wheelers had other serious problems besides competition from the railroads. Beginning barely five years after Texas statehood in 1845, during every rise in the river, at the same times that the riverboats wanted to be plying the water, timber men would unleash thousands of pine and cypress logs into the bloated, swift current bound for Beaumont's new sawmills. It was these loggers who ushered in the era of decimating Texas' virgin forests. They cut down trees just about anywhere they found them if there was easy access to the river. The floating logs clogged the river, and steamboats could not move for fear of puncturing their hulls. In every battle between boats and logs, the steamboats lost.

Troy Lakey of Zavalla (and White City, before the waters of Sam Rayburn Reservoir crept over it) was a renowned bull puncher—driver of oxen—and also floated logs to Beaumont in the early 1900s. He told of using oxen to skid logs cut during the hot, dry summer months to the river's edge to await the rising water that winter and spring rains brought. As the river rose, timber men would roll the sun-dried logs into the water, hack or stamp their mark into each one, and crib them into rafts of five or six logs using small poles and white oak dowel pins to hold the logs together.

Lakey's grandson, Brady Jones, who was eighty years old when I talked to him, recalls his grandfather and others recounting stories of float trips to the Beaumont mills. As Brady tells it, the last logs to be rolled into the river were rafted together as the "camp" raft, complete with cooking shack. This raft trailed the logs downriver to supply the crew with meals and a place to sleep.

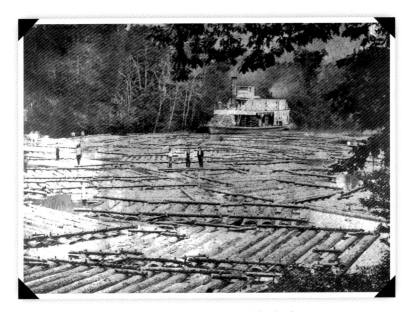

The steamboat Laura, one of several that plied the Neches in the late 1800s, sits dead in the water, trapped by a massive logjam of pine saw logs being floated to sawmills in Beaumont, about 1878. (Tyrrell Historical Library, Beaumont)

Brady tells the story of one crewman who preceded the floating rafts downstream in a small johnboat. The crewman was some distance ahead of the main body of logs and was attempting to free a lodged raft. Somehow, in his work, he had cut himself. The wound was serious, but the man continued to work and drip his blood into the water. Shortly, he noticed a very large alligator slowly approaching his boat. The workman paddled to the bank, abandoned the boat, and watched the big 'gator put its head and front feet into the little skiff, capsizing it.

It was a constant struggle to keep the logs floating in the river channel. Sometimes a raft of logs would lodge. Before the workmen, scrambling around on the logs in their hobnailed boots, could use their push poles to get the raft dislodged, other rafts would come crashing in and create a colossal logjam that might require days to unsnarl. There was always the problem of not enough or too much water. If the river overflowed its banks, the

logs would float out into the woods. If the river dropped too low, the logs would be marooned until the next heavy rain, perhaps months later.

Newspapers of the period left some poignant accounts of those earliest rapines of the Neches woodlands. The November 12, 1887, issue of the *Galveston Weekly Times* posted a story from Beaumont reporting that the Neches was experiencing the highest rise in several years. The story went on to tell that the river had been full of logs for the past ten or twelve days and that some owners would lose a considerable number of these logs. Many logs had been swept downstream before the owner's mark could be applied. The intercepting boom—logs held together with chains and stretched across the river at the Beaumont sawmill to capture logs arriving down the river—had broken; numerous logs were on a journey to the Gulf of Mexico. It was reported that a large percentage of these logs were cypress, and mill men were expecting this to be the largest "run" of cypress that was ever made on any one rise in the river. Projections were that at least two thousand logs of cypress alone would reach the mill before water levels fell.

The *Beaumont Journal* reported that a Mr. Carlysle had put some ten thousand pine logs into the river in Tyler and Jasper counties and they were scattered from Beaumont to Bunn's Bluff, a distance of forty miles. Carlysle expected to lose at least a thousand of these logs.

The *Galveston Weekly Times* article concluded: "Drunkenness has been quite common in town for the past week. The depressing tendency of the weather and the loss of numerous logs caused a downward flow of spirits which has led to a great many downs and ups, and the worst of it was that many of the downs were not able to help themselves up. Those who have been participating in this debasing habit are not citizens of this town or county."

Losses were common in these log runs, especially as the number of logs in the river increased. Many logs became "waterlogged" and sank to the bottom of the river. As years passed and equipment was improved, some of these "sinkers" were pulled from their watery grave of decades and sawn into excellent lumber.

During the extreme drought conditions of the 1950s, I recall several peckerwood sawmillers retrieving old sinkers that had been submerged for half a century or more. Nap Boykin and his son "B" used a small tractor along with a double block and line to remove enough pine logs to build a foundation and provide partial siding for a new house in the Saron community.

Downriver Louis Craven, using a truck equipped with a powerful Tulsa winch, skidded enough of the sunken logs from the river to build an entire house near where U.S. Highway 69 crosses the Neches. I suspect there are plenty of those old sinkers still here; there just is not any way to access them.

By 5:00 P.M. the clouds are beginning to break up, and one hour later it's a beautiful fall evening. I pass a cozy little red cabin perched high upon a cliff. The river is cutting under the cabin despite sacks of cement and rocks the owner has put in various places. Some of the big trees around the house have already toppled into the channel.

On the Angelina side is an oil well drilling rig. It is surprising to see drilling here. All the reports indicate that oil prices are too low to justify the costs involved in exploration.

There have been a few cypress trees scattered along the river, but today many of these tall, stately trees begin to appear, numbers of them growing at the water's edge. Some are putting up knees higher than a man's head. A hundred years ago the Neches was famous for its cypress, the trees of eternal wood. Lumber from these majestic conifers has always been much in demand because of its utilitarian properties. It is beautifully colored, smoothly grained, and resistant to decay.

A slight rise in elevation on the Angelina County side presents a wide, forested ridge and a fifteen-foot-high cut bank along the river. A large huckleberry bush loaded with small blue-black berries grows near the edge, seemingly awaiting a not too distant flood that will wash the dirt from around its roots and send it downriver.

A couple of hard back-strokes with the paddle turn the canoe

around, and I aim back upstream for a mat of tree roots that cover the ground along the water's edge. With the bow line hitched to a strong root, I follow a dim game trail to the top of the ridge. The huckleberry bush turns out to be not one but two bushes growing close together, their branches intertwined. I begin to pluck the little purplish berries and pop them into my mouth a handful at a time. Even though they taste dry, seedy, and slightly sweet, I like them. Could be nostalgia.

Native Americans used the bark from the roots of these bushes to concoct a remedy for diarrhea. Wildlife, especially birds, feed on the fruits. A small flock of migrating cedar waxwings may discover these bushes and strip them of their berries in a matter of minutes. Berries like these and those of the rusty blackhaw, American holly, dogwood, American beautyberry, yaupon, hawthorns, and a whole list of other trees and shrubs that we humans seldom notice or care about are essential to the entire roster of birds that live in these woods and migrate through here.

With my taste satisfied, and probably with blue teeth, I return to the trail that leads back to the canoe. Before pushing out into the current, I turn up one of the jugs of solar-heated water and take a long, warm drink.

Eight great blue herons rise up from behind a fallen water oak. They are in no hurry to gain altitude but fly just a short distance and renew their quest for fish and frogs until my approach makes them repeat the process.

There is a major pile of logs ahead. Darting in, out, and around the logs are blue-winged teal. When my approach exceeds their comfort zone, they take to the air in a flurry of wings.

White-Tailed Deer
and the Fredonia Rebellion

THIS IS IT! This is a moment I have been hoping for but never really expecting. A handsome eight-point buck steps grandly from the forest barely seventy-five feet in front of the canoe. The deer stops, lifts his head, and cautiously sniffs the air for danger. Then he lowers his head and, moving it from side to side, sniffs along the ground. Sensing no threat, he walks majestically down a narrow, sandy spit to drink from the river.

At the same instant his muzzle touches the water, he becomes aware of my presence and, in a blurred motion, jerks his head to stare at me. For a split second of suspended time, I peer into those black liquid eyes and see droplets of water falling from his chin. When he makes the feared human identification, there is no reaction time; he simply explodes. He wheels so abruptly his hooves cast large chunks of wet sand into the river. With three incredible leaps and the sound of hooves scraping sand, he is up the sandbar and disappears into the sanctuary of the forest. The last fleeting glimpse he offers is a raised white flag and a set of trophy antlers crashing through the thick growth of sunlight-loving shrubs that occupy the margins where the river and forest meet. It is almost beyond comprehension to share an instant in time and space with such a superb animal. It was awesome to witness the precautions he employed to avoid danger and, then, when danger was perceived, the power and speed of that lithe, sleek body. The paddle hangs motionless in my hands. I sit and watch the woods where the big buck disappeared and relive the incident several times before turning back to the journey.

Probably it was deer like this one that a couple of friends of mine were hoping for one dark, moonless night some fifty years

ago. The two were my old friend and benefactor Ezra Stanley and his nephew James Allen Stanley. The place Ezra still called home was a little place about three miles north of the Neches on U.S. Highway 69, but he had a well-paying job in one of the shipyards or oil refineries along the coast and had lived there for several years. Like others of that time, Stanley headed "home" to the woods or river every time he got a day or two off.

In this memorable instance, he made the trip home in a shiny new Buick. Stanley was a man of uncommon skills to be able to afford a new car of any kind, but a new Buick would have been the topic of conversation for days. He was a young man then (I never knew a better man) and would enjoy a social drink or two on occasion. One night, following a couple of those social drinks, Ezra and his nephew gathered up shotguns and a carbide light, piled into the Buick, and headed out to procure venison for the table. Make no mistake—Ezra was an excellent woodsman, hunter, and fisherman. He and James knew how and where to look for deer. Ezra had always disdained "fire hunting" and had refused to participate in the unsportsmanlike practice. This time, however, his nephew, whom he had not seen for a while, had prevailed with cajoling and an assortment of pleadings, winning Ezra over to do it "just this once."

When they arrived at their destination, an old, abandoned field, they parked the Buick and began to work their way carefully around the perimeter of the field. Slowly they walked, scanning the open area and the edge of the woods with the sputtering and fizzing carbide lamp. Ezra held the gun at the ready. The field was large, and they crept along for some time; but not one eye did they see reflecting the fizzing light. Suddenly, Ezra and James stopped and raised their guns to their shoulders. There were the eyes of several deer glowing in the night's blackness. The guns' roar shattered the stillness, but the deer remained frozen. Again, their 12-gauges spoke, and still the deer did not move.

Incredulous, Stanley and his nephew moved forward to find the explanation for this inexplicable behavior. As they drew

closer, it became painfully clear why the deer had not fled. They had shot the car! The hunters had seen the light reflecting from the shiny chrome and glass on the new Buick, and there it sat, pumped full of 00 buckshot holes. I suppose the effects of the "socials" wore off pretty quickly as the pair stood there staring at the freshly ventilated automobile. Someone was going to have to explain this to Ezra's wife Faye. Ezra and James are both gone now, and they took the old ways with them.

My friends had been headlighting, or fire hunting, a time-honored method of obtaining meat for the table since the origin of fire. It is highly illegal today, as it was then; but few then thought of hunting in the context of "legal" or "illegal." Game wardens and game laws were scarcely considered relevant at that time. Fire hunting took its name from the practice of using the glow from a burning fire to reflect the light from an animal's eyes. My great-grandfather, Pop Lowe, had the only real "fire pan" I ever saw. Carbide lamps had already made the old pan obsolete by the time I came along.

I am sure Pop had built the fire pan in his blacksmith shop. It consisted of a metal pan about sixteen inches in diameter with a three- or four-inch rim around it. Numerous vertical slits had been cut into the rim. The metal pan was attached to one end of a seven-foot long, two-inch-diameter pole. The device was simple to operate. A few rich lighter splinters of fat pine were placed in the pan and set on fire with a brand from the cook stove, lantern, or, later, with a match. The hunter then placed the pole over his shoulder with the fire pan behind him and walked until the flickering fire illuminated the eyes of deer, raccoon, or other quarry. The pole put the fire behind the hunter and did not obscure his vision. This placement also allowed the hunter a free hand to hold and fire his shotgun or rifle.

The sky is clear, and I feel good. I paddle until, just at 7:00 P.M., I find the perfect sandbar for a campsite. The canoe slides easily onto the sloping beach. I pitch the tent at the top of the incline on pure, pale sand. The river is running noisily about eighteen

inches below. This is the best campsite I have had on the entire expedition. A can of beef stew provides a not-so-tasty supper before I settle down to listen to the sounds of the night.

A brilliant three-quarter moon lights the river. All is quiet; not even the frogs make a sound. Then a barred owl in a water oak directly across the river lets out a shriek that would stop any living thing in its tracks. A couple of seconds later, the owl follows up with the traditional *hoo-ah, hoo-ah*. It is quiet after that.

Wednesday, October 20

Temperature at 7:30 A.M. is 39 degrees. River water temperature is 62 degrees. The air is brisk, and the sunlight is filtering through the leaves when I crawl from the tent. My breath comes out as bursts of steam. Crows are making sure that everyone is awake.

By the time I have had my second cup of coffee and broken camp, the sun has cleared the treetops. Its warmth feels good on my back. Deer tracks, raccoon tracks, and opossum tracks are all over the sand. This must be a watering site for wildlife.

I shove the canoe into the water at 8:50 A.M. The river is filled with the usual soft steam and makes looking for logs difficult. Ahead, through the steamy fog, I detect movement and see a doe watching me and raising and lowering her tail. I can make out another one standing by her; and ten feet below them, a third doe stands at the water's edge. They linger another few seconds while the doe near the water scrambles up the steep bank. Then, with flags raised, they quickly hide themselves in the forest.

Large quantities of Chinese tallow trees began appearing along the river's edge north of the Highway 59 bridge. The trend continues today. This plant may become to the forests what water hyacinth and hydrilla have become to our lakes.

The sky is bluer than blue, and the sun quickly begins to warm things up. I take off my long-sleeved shirt.

Oh, there was an old miller,
And he lived by himself.
All the bread and cheese he got,
He laid it on the shelf.

Hands in the hopper,
And the hopper's in the sack,
The miller cried out,
"Ladies forward and gents right back."

Raining, hailing, dark stormy weather,
You go; I'll go; we'll all go together.
You do the reaping, and I'll run the grinder.
I lost my true love, and here I'll find her.

Where did that rhyme come from? It has been rolling around in my head for most of the day. That is a tune we sang at high school parties, but I'll bet its roots reach back hundreds of years. Perhaps it could be part of a Scottish reel.

This river does things to you. It gives you memories you will never forget and makes you revive memories long forgotten. The river's legacy is old. I hope it gets much older and continues to enrich the memories of generations of Americans yet unborn.

On the Angelina side of the river, a hundred yards down, is what looks like a spike buck and another deer I cannot determine. The canoe is hugging the bank, so the deer do not see me. I barely move the paddle through the water, not making a sound. The deer move out of my sight, but I can plainly see their reflection in the water. They are playfully sparring with their antlers. A breeze nudges the canoe toward some brush and limbs, and I work the paddle as frantically as I dare.

The current moves the canoe into the open, and there stand a six-pointer and a three-pointer. They still do not see me, and the six-pointer breaks away from his dueling and walks into the river, belly deep, to drink. (If I could hold a camera instead of

the paddle, I could get an excellent picture.) When he notices the strange object in the water bearing down on him, he is not unduly frightened. He leisurely rejoins his companion on the bank and stands watching until I am hidden from their view by a bend of the river. These deer probably won't pass along their genes unless they significantly alter their behavior patterns before hunting season opens in a couple of weeks.

There are few obstructions in the river now. Its channel is so wide that when a tree falls, it does not reach the other shore. There is usually a ribbon of unobstructed water.

An outboard motor starts up some distance downstream and roars and growls as it strikes logs and hits sandbars. Soon the boat comes into sight. The operator, I learn, is the elderly Mr. Bacon of Corrigan. He hails me to stop and says: "I been seeing you and reading what you are doing. They been talking about building that Rockland dam nearly all my life." We discuss fishing, hunting, and the weather before we bid each other good-bye, and I paddle on. Bacon pulls his hat down on his head and starts his motor to continue his trip upstream to "run his hooks." Soon his motor's propeller resumes hitting logs and sandbars.

Ed Havard has a neat clubhouse near the river's edge in Angelina County. He knows I must be tired and invites me to stop for a shower and a Coke. I imagine what that hot water will feel like and accept without hesitation. After the shower, we sit on the front porch of his log house and sip a cup of coffee. Reluctantly, I tell Mr. Havard, "I have miles to go before I sleep." Before leaving, I ask him to call Bonnie and let her know where and when I estimate the next pickup to be. Neches people are exceptional folk. Imagine that touch of kindness from someone I had never met. Havard believes our goal of saving the river is worthwhile and wanted to make his contribution.

There are rapids just below his cabin. These Neches rapids and the others I have recorded are strictly low-water phenomena. The Neches is basically a float stream, but experiences can vary greatly with the season and water flow. Normally, it is an ideal paddling experience for novices and family outings. The

only perennial rapids on the river are those at Rocky Shoals in Upland Island Wilderness, and they are moderate for most of the year. The stretch of river just below old Fort Teran also presents an increasing amount of turbulence as the river's water level drops.

The river runs against thirty-foot-high sandstone banks on the Polk County side. Water is trickling down the face of the stone banks. Both hardwoods and pines are growing atop the cliffs, providing some really beautiful scenery. Moments later, a small, sandy, spring-fed stream enters from Polk County.

The Neches forks ahead. It is difficult to decide which fork to take. Then it is apparent. The river forks around a small sandy island and quickly rejoins itself. The island is covered with tall, straight cypress trees. These and other cypress trees scattered along the Neches manifest the gallant attempts this graceful, indigenous species is making to recolonize the river.

A short distance downstream, a long, slim pole of a tree lies lodged against several snags protruding through the water and forms an effective floating boom across the entire channel. Narrow currents of water gurgle and flow across several crooks in the tree's trunk. I quickly select the largest of these currents and aim the canoe toward it, hoping to slide some distance across the log before having to get out and push. As the canoe gathers momentum, I am suddenly aware of a dark form in one of the other ribbons of water flowing across the log. My vision is not what it once was, but as the canoe approaches the barrier, it becomes plain that an animal is cradled on its back in the thin stream, holding and eating what appears to be a green hickory nut husk. It is an otter!

When the canoe is no more than ten feet from contact with the log, the lithe creature drops whatever food it is holding and flips onto its side, disappearing into the river. As the bright sunlight strikes its wet fur, the otter looks so black as to seem almost blue. The canoe skids about halfway across the log and lurches to a stop. I don't mind having to pull it off the log after what I have just been privileged to see.

The mouth of Biloxi Creek is feeding a small stream of coffee-colored water into the river. I decide to make camp on a white sandbar two hundred yards below the mouth of the creek.

Biloxi Creek, heading up just east of the city of Lufkin, is a major watershed stream for the south-central part of Angelina County. Biloxi, like its sister Shawnee Creek, some nine miles downriver, takes its name from the Indians who once lived along its banks. The Biloxi Indians never had a strong presence in Texas, but not so the Shawnees. The Shawnees were instrumental in putting down the notorious Fredonia Rebellion that occurred in January of 1827.

Empresario Hayden Edwards and his brother Benjamin had received a contract from Mexico to bring eight hundred families to settle in the "red land" country of East Texas: now Nacogdoches, San Augustine, and Cherokee counties. In the agreement, Edwards had promised to uphold all good claims to lands occupied by those presently living there.

Apparently there were more settlers living on the Edwards grant than the Mexican authorities knew about. When Edwards, in violation of his contract, attempted to evict them, a small war broke out. Edwards and his followers succeeded in occupying the town of Nacogdoches. They raised their flag over the Old Stone Fort and proclaimed the government of the Fredonia Republic. After issuing a proclamation giving all settlers fifteen days to vacate the grant area, Edwards sent a hundred men to a camp about a mile and a half east of Ayish Bayou in San Augustine County. At the end of the fifteen-day period, they were to begin moving the homesteaders from the land by force of arms.

The militia set up a fort in two "double-pen" log houses and a barn. A double-pen cabin consisted of two small rooms with a "dog trot"—a roofed passage similar to a breezeway—connecting them. One room had a fireplace for cooking and keeping the family warm in winter. The other was used as a bedroom. Later, when wood-burning stoves were used for cooking, a kitchen might be added onto the rear, but often it was separated from the house

because of the constant danger of fire from the stove. The double-pen construction was usually placed so that prevailing breezes were funneled through the dog trot, where families spent much of their time, even sleeping there during the summer months.

As the Edwards's militia waited, Stephen Prater, who operated a store and trading post on the east bank of the Angelina River (now flooded by Sam Rayburn Reservoir), began assembling a force to repel the insurgents. Prater was no stranger to military conflict. He had served as an officer under Andrew Jackson and possessed a sterling reputation as a brave and honest man.

On the fourteenth day of the proclamation, Prater assembled this group: himself and his two sons, Steve Jr. and Freeman; James Bridges and his two sons, James Jr. and Ross; Peter Galoway, seventeen-year-old Sandy Horten, John McGinnis, and about sixty Shawnee braves. By nightfall this small force of sixty Indians, one boy, and eight white men pitched a cold camp within striking distance of the Edwards militia. Prater called his group together and gave instructions "not to fire unless fired upon"; but he told them he intended to take that Fredonia garrison in the morning or die in the attempt.

By daybreak on the fifteenth day, the group had stealthily surrounded the heavily armed garrison and awaited the signal to attack. At first light, Prater shouted, "Charge," and the Shawnees raised the war whoop as they quickly burst into the fort and overpowered the unsuspecting militia. The dreadful yells of the Indians so unnerved the surprised Fredonians that they threw down their guns and ran. On learning of the capture of their forces at Ayish Bayou, the Edwards brothers and their lieutenants fled for the Louisiana border and safety in the United States.

I suddenly notice the long shadows stealing across the river and realize that as I sit daydreaming of the ghosts of the Neches, darkness has almost stolen the day. Temperature at 7:00 P.M. is a comfortable 54 degrees. What could be better than sleeping under the stars on a cool, breezy autumn evening and listening to the night calls of nature's wild creatures?

Temperature at 7:30 A.M. is 37 degrees. A slight breeze is blowing from the north, and the sky is clear. It has been my practice to record morning and evening temperatures and comment on weather so that others wishing to enjoy outings on the river will have a general idea of weather and temperature conditions they may encounter.

I break camp quickly, anxious to be on my way. Around the first bend in the river, two deer are eating acorns underneath a huge post oak.

A quarter of a mile farther downstream, I interrupt a small doe at the river's edge. She is standing at the foot of a thirty-foot bluff bank. She bolts at my appearance and tries to go straight up the bank. She makes it to the top and manages to get one foot over when either her strength fails or the ground fails. At any rate, she tumbles all the way to the bottom. She tries again, but this time she takes the climb at an angle and succeeds.

We tend to think of nature's creatures functioning flawlessly, that a bobcat catches a rabbit with each predatory pounce, all the eggs in a bird's nest always hatch, and the sharp talons of the hawk unerringly clasp a mouse when the bird drops to the ground. They don't, and nature can be so unforgiving. It is not unheard of for the antlers of sparring bucks to become entangled and for the animals to starve, locked in their fatal antlered embrace. Box turtles, in their search for moisture, fall into stump holes and are unable to crawl out. All too often the vagaries of wet, cold, hot, and dry weather deprive animals of sufficient nutrition, and many die of starvation. Nature works efficiently but without emotion.

The tumbling deer is the last to make an appearance until, just before I make camp, a large, very dark doe runs away at my approach. The reason for the shortage of wildlife today, as compared with yesterday, probably lies in the condition of the forests. Yesterday's forest was a more mature hardwood forest, but today's run reveals woodlands that are at least thirty years

away from being dependable mast producers. Even the cypresses have disappeared from along the river's edge for several miles.

So much Texas history is connected with this river. Today the canoe carries me past four long ago abandoned railroad trestles. All that remains are their slowly rotting pilings. What kind of wood are these pilings to survive this long in a constantly wet environment? Certainly they were never treated with creosote. Perhaps they are cypress. I pull the canoe alongside one, open my pocketknife and, with some difficulty, shave off a small sliver. To my surprise, behind the black weathered crust is "rich lighter," or fat pine. These pilings must have been twenty or thirty feet long when this trestle was built! It is incredible to think that so many huge rich lighter timbers were available for constructing bridges of such size and height. The virgin pines that produced them must have been giants. Wouldn't we love to know the stories these old relics could tell? A lot of human toil and sweat traveled across these bridges.

Numerous clubhouses have dotted the landscape for the past couple of days. Some are quite appealing, and I wonder what it would be like to spend a couple of days there. Most of them, though, are ramshackle and sadly in need of repairs. I have been told that one small clutch of clubhouses I will pass is called "Robins' Roost." I look as I go by. I don't see any robins. This is probably just a place where some old roosters come and hang out.

Crossing the mouth of Piney Creek, I leave Polk County behind and pick up Tyler County on the west bank of the river.

Fort Teran and Shawnee Creek

THE NECHES HAS BECOME the Neches of my youth. The channel is wide and deep, and the water runs a khaki color. The farther south I paddle, the more numerous the sandbars and occasional black gravel bars become.

The ten-foot-high stilts of an Angelina County clubhouse are mute testimony to the volume of water this river is capable of presenting during rainy season. Occupants of the high-rise clubhouse are afforded a view of a glistening sandy beach that must be three hundred feet long. A couple of crawfish-baited throw lines along this beach would likely catch a drum fish any time one wanted to give it a try.

The sound of water rushing over rocks and boulders almost the size of Volkswagens and located at the bottom of an unusually abrupt hill lets me know that I have arrived at Old Fort Teran. I ease the limb- and rock-scarred Grumman alongside a flat slab of rock and sit staring up the hill toward the cave that I know is there. The "money cave."

Named for General Manuel de Mier y Terán, Commander of Mexican Forces in Texas, Fort Teran was built in 1830–31 by the Mexicans in a futile attempt to halt Anglo expansion into the province of Texas. There is a monument at the brow of the hill marking the location of the fort, but in reality the fort was located almost a mile downstream. The Mexicans placed it at a strategic spot known then as "the Pass to the South." There, the flat rock bottom of the river provides a natural low-water crossing that was used by buffaloes and Native Americans for centuries before Europeans arrived. In historical times, at least four important trails are known to have utilized this natural crossing: the Orcoquisac Indian Trail, the Bedias Trail, the Nacogdoches to Liberty Road, and the Old Spanish Road.

A rogue with the very non-Spanish name of Peter Ellis Bean was appointed to build this fort and was named commander of the fifty soldiers garrisoned here. I will never understand why a book or movie has not been produced about this man. He was as colorful a character as ever traipsed across the pages of Texas history.

Bean was born in Tennessee. He filibustered in Texas with Phillip Nolan, spent ten years in a Mexican prison, sailed with the pirate Lafayette, soldiered for Terán, and married a Mexican woman. Bean left her and returned to Tennessee, where he married another woman. In the following years he traveled between his two wives until his health began to fail, and he chose to spend his last years with his wife in Mexico.

Fort Teran operated as a fort for a brief two years of continuous service. It was temporarily reactivated a couple of times—once to build boats to transport Santa Anna's troops across the river. Fortunately for the Texans, the boats were never needed.

It was the old fort's last military engagement that has so intrigued successive generations of Texans. The legends that have persisted since that scrape have excited men to bleed their sweat under broiling Texas suns in a quest for what the poet Robert Service described as "that muck called gold."

When the Mexicans of the Nacogdoches garrison were quitting the country, ahead of the revolution, they loaded their valuables into wagons and fled south with a band of Texas irregulars in hot pursuit. The Texans overtook the Mexicans at old Fort Teran, and a fierce fight ensued. Legend has it that before slipping away, the surviving Mexicans took all the gold and other things of value they had looted from the settlers and hid them in the cave. Another version of the legend has the Mexicans putting their loot into the barrel of a cannon, plugging the barrel, and rolling the cannon off a high bluff into the river. You may take your pick of whichever story you like, but the gold has never been found. Many have sweated and toiled in vain. Some have died in their quest for sudden riches. A young man was killed here in 1953 or 1954, the casualty of a premature dynamite explosion.

The climb from the river to the cave is hazardous. My old, wet sneakers are slick, and the pine straw that covers the steep trail is slippery. I am careful. I don't even want to think about a broken arm or leg out here, miles from anyone.

Finally, after laboring up the steep incline to the mouth of the Mexican soldiers' hand-dug cave, I stand and peer into the inky blackness that may be the repository of all that Mexican gold. Once upon a time a person could stand upright in the cave and walk in some forty feet to where the passageway forked into two rooms. The floor of one room was paved with handmade bricks. Today, after more than 160 years of punching, digging, and blasting by treasure seekers, the brick floor is gone; the rooms are filled, and all that is left is a hole in the cliff. And, of course, the gold. The downstream location of the fort itself has suffered much the same fate. A bulldozer was even used there to pillage the earth.

Gazing into the blackness, I fantasize about what I would do with all that wealth if I somehow found it. Maybe I would buy the entire Neches River and make it a public park. That sounds good!

I stir myself from these musings and complete the climb to the crest of the hill and see the large "Fort Teran" granite marker erected by the State of Texas. Vandals have removed the metal Texas seal emblem and have pocked the marker with numerous shots from high-powered rifles. Saddened and dismayed, I begin a cautious descent back to the river. The footing on the slippery pine straw is even more uncertain going down. Seven fresh Busch beer cans lying beside the trail are evidence that some rugged outdoorsmen have recently passed this way.

The flat rock to which the canoe is tied makes an excellent dock. I don't even get my feet wet getting back into the canoe.

About one quarter mile downstream a pipeline cuts a wide swath through the forest. Large signs on either side of the river warn against dredging or anchoring. It may be possible to strike oil here. Four rotting pilings, the last remains of another bridge that transported logs to the sawmill at Manning, stand at the edge of the water.

A luxurious carpet of yellow and brown leaves blankets the woodland floor in Big Slough Wilderness. (Mark Bush, Austin)

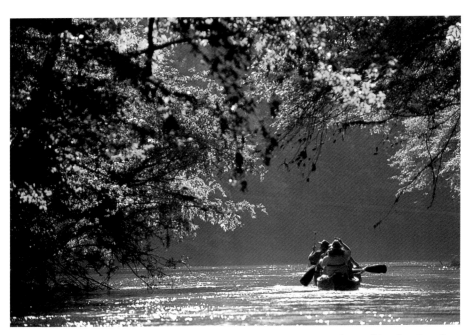

A canoe rides the current downstream from Anderson Crossing. Many canoeists and kayakers launch here for an easy four-hour paddle to Texas Highway 7. (Mark Bush, Austin)

A bobwhite quail picks among autumn sweetgum leaves for seeds and insects. (Connie Thompson, Pollok)

An opening between a tree root ball and the Trinity County riverbank provides a passageway for the canoe. (Author's collection)

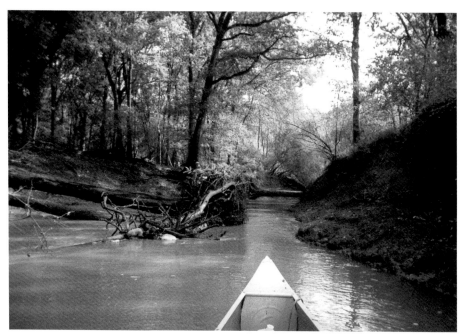

A log barricade piled against the abandoned Texas-Southeastern Railroad trestle completely blocks the river. (Author's collection)

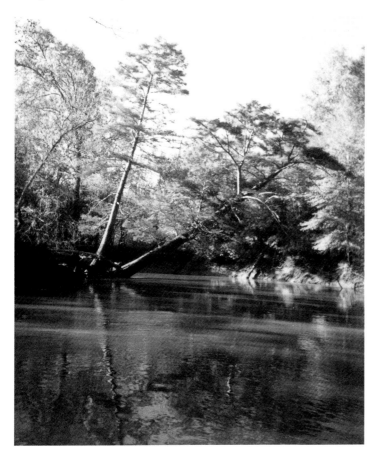

Autumn cypress in Polk County lean across the Neches downstream from the U.S. Highway 59 bridge. (Author's collection)

Maple leaves in hues of yellow and gold lead downslope to Biloxi Creek in Angelina County. (Author's collection)

Large boulders lie along the path from the river to the old Fort Teran cave in Tyler County. (Adrian Van Dellen, Woodville)

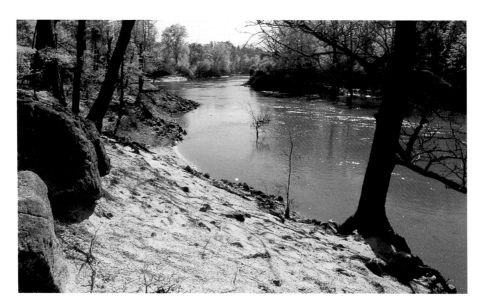

The Donovan farmhouse on Shawnee Creek is an old double-pen log home built about 1853—seven years before the Civil War. (Author's collection)

Note how expertly the logs of the Donovan house were fitted, using a crosscut saw and an axe. (Author's collection)

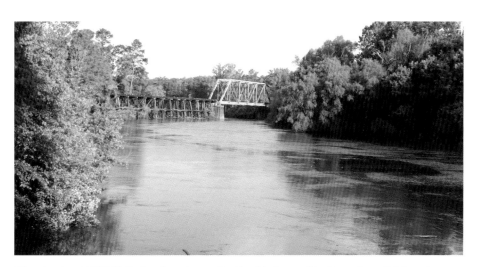

The abandoned T&NO Railroad trestle near Rockland looks capable of carrying a freight train even today. (Adrian Van Dellen, Woodville)

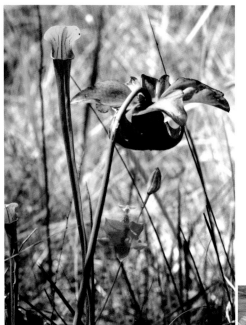

A tall and slender carnivorous pitcher plant shares the same sandy seep with a rare grass-pink orchid. The strange-looking flower above and left of the orchid is a pitcher plant bloom in Longleaf Ridge, Angelina National Forest. (Adrian Van Dellen, Woodville)

Rocky Shoals waterfall alongside Upland Island Wilderness was often a problem for riverboat captains. (Mark Bush, Austin)

A single stalk of switch cane grows near the door of the old International school bus at Rocky Shoals. Switch cane once covered wide expanses of the Neches bottomlands and provided valuable winter forage for wildlife and pioneer livestock. (Gina Donovan, Austin)

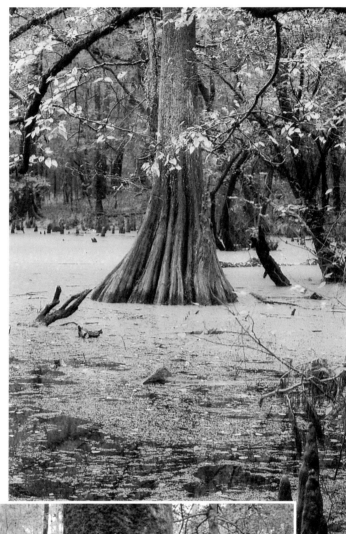

Green duckweed blankets the surface of the slough around a bald cypress tree, Upland Island Wilderness. (Gina Donovan, Austin)

Two people—in this case Bonnie and Richard Donovan—cannot reach around some of the trees that grow in Upland Island Wilderness, and there are a few that three cannot encircle. (Gina Donovan, Austin)

In springtime wild azaleas color the edges of several creeks and streams that furrow Longleaf Ridge, Angelina National Forest. (Gina Donovan, Austin)

A great egret takes flight at the approach of perceived danger. Shorebirds are plentiful along the Neches. (Connie Thompson, Pollok)

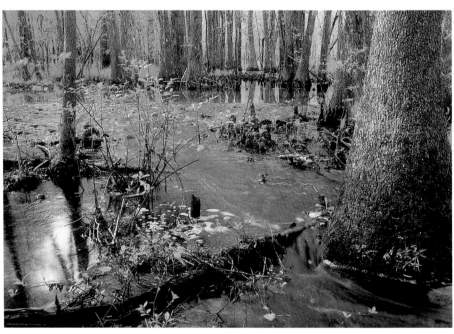

Floodwaters pulse and sojourn across the land, leaving loads of silt and rot in rich layers on the forest floor. (Adrian Van Dellen, Woodville)

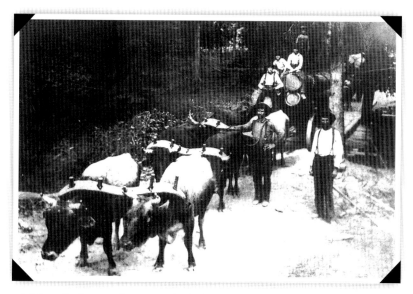

A "six-up" of oxen pulls a wagon load of logs to a small peckerwood sawmill at Old Manning, about 1875. At least one other wagon follows. The two men standing are thought to be Jeremiah and Thomas Harvard. The brothers came to Texas about 1853 and owned livestock in the area near Manning. Historians believe Dr. Manning took this photograph. (Lois Broussard, Buna)

There, on the Angelina County side, is Shawnee Creek. The mouth of the creek and as much of its course as I can see are graced by tall cypress trees. Trailing some fifty yards downstream from the creek's mouth is a high, steeply sloping sandbar laced with numerous vertical slide marks. Turtles create these impressions as they make their slow, laborious trek to the top to bask on the warm sand. It is amazing how fast these creatures can descend these bright slopes. They look like bobsleds as they slide down to enter the water with a big splash.

A couple of quick paddle strokes send the canoe gliding across the water until the prow slips between a protruding root and the hard, dry bank. I step ashore, one foot in Angelina County and one foot in Jasper County. The acute angle formed as the county line terminates at the mouth of the creek makes

this an easy task. The creek meanders almost due north for several miles, and trees growing along both banks reach across in a shady embrace.

Shawnee Creek: the mere sound of its name has me nostalgic and pensive. The words of a song run through my thoughts, "traveling down the back roads by the rivers of memories, flowing ever gentle on my mind." This stream is a thread that runs through my life and binds it together. Even today, my family and I cherish the hours we can share at our old log cabin snuggled on the edge of the Shawnee Creek bottom, some six miles north of where I am standing.

My first experience on the creek with the proud Indian name was in the late 1940s. James Allen Stanley and I, not yet in our teens, came to this creek with James's stepfather Monroe Bridges and Jack Haynes. Haynes drove the dump truck that was our transportation as far as possible down the old logging road; then we walked the remaining distance through a mixed hardwood forest of oaks, gums, hickories, and pines until we reached the cypress tree–lined creek.

We prepared numerous "set hooks" or "bank hooks" by cutting down small saplings, tying on hooks, sinkers, and lines, and baiting them with crawfish. The two adults embedded the fishing poles into the creek bank so that the baited hooks dangled about eighteen inches below the water's surface.

A forked, hoe-handle-sized ironwood tree caught my eye. I took a dull axe, whacked the tree down (no easy task), trimmed the small branches, tied a hook and line to each fork, and baited the hooks with two lively crawfish. As I prepared the set, Mr. Bridges and Mr. Haynes kidded me about the number and size of fish I was sure to catch on the forked pole. Oh, sweet victory! The next morning when we checked the lines, the forked pole would twist violently first one way, then the other. Two large catfish had securely attached themselves to the baited hooks. That silenced the kidding.

That fishing experience lingers in my memory more than any other except for the one, years later, when I was fishing in Sam

Rayburn Reservoir with Dr. Woody Ingram, Henry Holubec, and Joe Denman. That day I hung a seven-pound, one-ounce bass on a purple worm. A seven-pound bass was a respectable fish in the days before Texas Parks and Wildlife's "Share a Lunker" bass program. At the time, Woody wrote outdoor articles for the *Diboll Free Press* and enviously retaliated by jokingly saying some uncomplimentary things about the fish and me in his next article. (At least, I think he was joking.)

Denman Dunkin, his young son Len, and I followed Denman's squirrel dog Poochie up and down this creek and almost every other creek in this part of Texas during the formative years of my life. My father cared little for hunting. I began hunting and fishing with the Southern Pacific truck driver when I was about fifteen years old. Few weekends passed that we did not hunt or fish until I moved away to Waco in 1962. Once as we hunted along this creek, in a manifestation of wisdom uncommon for me, I prophesied: "The day is coming when we won't be able to enter the woods anywhere we like or be able to hunt and fish anywhere we want to." After contemplating this for a few seconds, Denman responded, "You think?" and then, "Nah, that's not going to happen." His response didn't alter my opinion. Somehow, I knew.

I feel a twinge at the thought of the number of squirrels that we brought out of these woods. Bessie, Denman's kind and gentle wife, prepared squirrel every way it could be cooked. We ate fried squirrel, squirrel stew, squirrel dumplings, squirrel gravy, and probably some recipes long forgotten.

Wild game meals like these are rare treats for us today, living only moments away from supermarkets and convenience stores. In the 1950s, when game still represented a significant part of some Neches families' diets, a good hunting dog was a valued possession.

Denman's dog Poochie was such a prize. He was without question the best trailing and treeing dog I ever saw. Like all good hunting dogs, he was born with the primeval predator instinct to trail prey until it either climbed a tree or went into a hollow log or

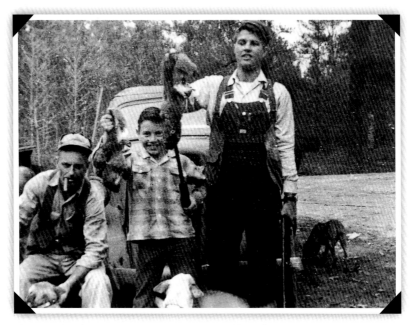

Denman Dunkin, with cigar, holds his incomparable squirrel dog Poochie, 1956. Denman, Poochie, Len Dunkin, and Richard Donovan display part of the morning's harvest of red fox squirrels in front of a 1936 Ford. (Author's collection)

hole in the ground. He would stop where the prey left the ground and would maintain a chorus of barking "treed" until we arrived.

Good dogs, like swift horses, tempt men into issuing challenges. Such was the occasion in Barge's General Store in Zavalla when a long-time friend, who possessed true river-bottom-strain credentials, let me know that his dog was better than the Dunkin's dog. Being a man of some modesty and humility, Denman was inclined to reject the contest, but I was not. A couple of weeks later, on a cool autumn morning, Denman, Poochie, and I loaded into my rattly 1936 Ford jalopy and headed out toward the Saron community. The fog was so thick you could cut it with a knife. Visibility was close to zero when we arrived where the challenger awaited us. A slim, sleek, reddish gyp (female dog) lay tethered with a rawhide string to a battered old pickup truck. You could tell at a glance that she carried a trace of redbone

hound in her veins and was sure to possess a keen nose for trailing the scent laid down by squirrels as they scampered over logs, treetops, and the ground.

"Let's turn 'em loose, boys," said the challenger from the Sulphur Springs community, as he slipped the rawhide from around his dog's neck. I quickly unsnapped the chain from Poochie's collar, and he sauntered into the woods.

The red gyp was already working in a fallen treetop, and I could clearly see she meant business. This contest was going to be close. Then, in less time than it takes me to relate the story, our dog barked a solid "treed." A few seconds later, the red gyp settled on the location of her quarry. I don't remember who shot the first squirrel out, but we allowed the challenger to take the one his dog had pinpointed. Before he could pick the squirrel up off the ground, Poochie was already rearing up on another giant red oak and was barking, "Come on. Here he is."

That was the way it was to be the rest of the morning. Sometimes Poochie would tree two, maybe three times before the red female could settle on one. Finally she abandoned trailing on her own altogether and hunted alongside the Dunkin dog. When he barked "treed," she ratified his good work by expectantly rearing up on the tree. Few bushy tails were ever able to elude the savvy Poochie by "timbering out," or jumping from tree to tree. He always seemed to keep an eye on the treetops and could visually follow the fleet animals until they stopped timbering. Then he would urgently summon us with vigorous barking.

About the middle of the day, Denzil Shives whistled his dog in, slipped the rawhide thong around her neck, and conceded defeat. Denman jovially agreed, but by that time his dog was already exhorting us to come to his aid. He had a big red fox squirrel up a huge shortleaf pine. The pine was growing on a long sandy hammock laid down by the Neches as it traveled back and forth across this valley centuries ago.

I had graduated from Stephen F. Austin State University and was living in Waco when Poochie died at a ripe old age. He was pitiful when I last saw him, mostly blind and feeble; but his

grit was intact. Even with all his ailments and almost no teeth, he dominated the yard. If one of the younger dogs invaded his space, the old hunter would send the upstart running with an outburst of vicious snarls and growls.

Denman and Poochie are both gone now, Poochie to a grave alongside the tea-colored waters of Graham Creek before it reaches the muddy Neches. Denman sleeps his eternal rest in the solitude of the remote Kitchens Cemetery, two miles from the Neches that he loved and that was so much a part of him. I will always remember him with love and affection. He and Bessie were surrogate parents to me during my teens; and when Bonnie and I were married, they adopted her as well. Denman was a practical man of solid Christian values, and some of the traits I learned from him as we stalked through the Neches bottomlands are, I hope, a part of the man I am today.

Upstream, where FM 1818 crosses Shawnee Creek, until recently there stood a beautiful hardwood forest of water oaks, white oaks, hickories, gums, cypress, and a multitude of other fruit- and mast-producing trees and shrubs. Sadly, it was clear-cut about five years ago. Nearby sits a 150-year-old log cabin nestled beneath an ancient pecan and several cedar trees. This is the cabin and acreage my family and I call "the farm." The farm has a rich history dating back to before the Civil War.

In 1975, Bonnie and I determined to learn all the history we could find about the old pioneer place before the few remaining old-timers died. In conversations with previous owner Suel Jones and taped interviews with his ninety-year-old relative Jim Jones of the Shawnee Prairie community, and from deed records, we pieced together a pretty reliable history of the old place.

In the years following statehood, Texas was offering free or low-cost land in "west" Texas to all who met claim requirements. A Miss Amanda Stevens, a woman of some means, left the Carolinas and headed her wagons west to take advantage of this attractive offer. The overland route from the Carolinas to Texas was long and difficult. The trek became even more arduous once the party crossed the Sabine. The State of Texas was

almost bankrupt. Its roads, where they existed, were nothing more than muddy trails that wound through an unending sea of forest. Almost daily, travelers had to ford rivers, bayous, creeks, and branches.

The farming community of Shawnee Prairie, located in a small, fertile, treeless plain, must have seemed an oasis to the Stevens party when they emerged from the woods and saw a broad expanse of blue sky for the first time in weeks. The community and creek took their name from the Shawnee Indian village that existed here when the Anglos began to arrive.

Miss Stevens and her entourage stayed in the Shawnee Prairie area for an extended period and made lasting friendships. The local homesteaders urged her to make her home among them, but she was determined to push on to her original destination in West Texas. In the 1850s civilized Texas stopped at Austin, extending northeastward to the Red River and southwestward to the Gulf of Mexico. West of this moving and bending invisible boundary, the wild Comanche and their fearsome allies, the Kiowa, were lords of the plains. Not even the feared Apache dared venture into the Comancheria.

This boundary land, where two vastly different cultures collided, was the environment that the Stevens party set out to homestead. Indian atrocities were occurring all along this frontier as the Native Americans attempted to hold the advancing tide of American and European settlers at bay. The settlers were taking the land, killing the animals the Indians needed for food and clothing, and spreading the silent killers of smallpox, cholera, and other diseases among the Indians. New arrivals along the frontier were being killed and scalped. Women and children were being taken away, some to be ransomed later, some to be adopted into the Indian bands, and others never to be seen or heard from again.

The desperate conditions of living on this savage frontier caused Miss Stevens to reconsider the warm invitations to remain in the fertile Shawnee Prairie farming community. She loaded her belongings into the wagons, hitched up the teams, and headed back east—away from savagery, toward peace and friendly neighbors.

Arriving back at Shawnee Prairie, she purchased the cabin and several hundred acres of land from a John W. Scott. The eligible Miss Stevens soon wed Wyatt Jones, raised a large family, and, as an old woman, died of diphtheria in the cabin.

In the first few years after Bonnie, Gina, and I purchased the cabin in 1974, numerous old-timers stopped in to relate stories of births, deaths, and good and bad times that had occurred at this homestead. Mrs. John Jones signed the guest book and added that seven of her eight children had been born in this double-pen log cabin. Others told stories of hunting turkeys and other game in the bottomland along the creek.

Once, in a moment of weakness, I allowed Bob Pittman to set a trapline on our property along Shoemake Branch before it empties into Shawnee Creek. We were heartbroken when he trapped two really big, beautiful bobcats the first week. We asked him to take up his traps.

There have been some eerie happenings along this creek, too. The towns of Marfa and Saratoga have their mysterious lights—old railroad men walking around with lanterns looking for their missing heads, that sort of thing—but no town I know of ever boasted a wild woman. I'm not talking about unchaste and wanton; that kind are almost everywhere. I mean really wild, like a pineywoods rooter hog.

There was such a wild woman in the 1940s who lived underneath or near the old Highway 69 bridge that crossed over Shawnee Creek. I never saw her, but plenty of people did—reliable folks like truck drivers saw her any number of times. Late at night, when they were driving that narrow, crooked road through the heavily forested creek bottom, this woman would come running out from under the bridge and scare them nearly to death. The *Lufkin Daily News* ran a front-page article and caricature of her, and I guess the sudden fame frightened her. She was never seen again after that. Some folks surmise she might have hitched onto one of those trucks and ridden down to Saratoga.

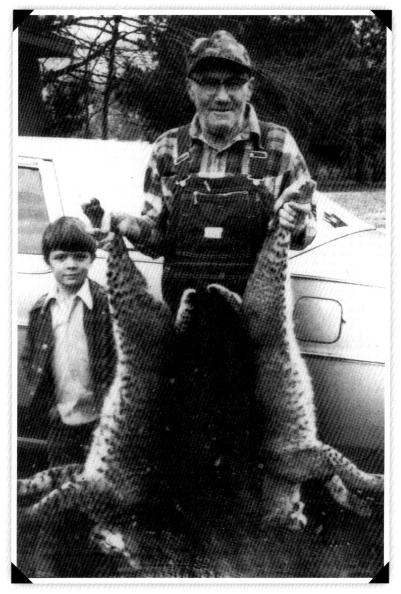

Old-time trapper Bob Pittman shows off two bobcats taken from his trapline along Shoemake Branch, 1974. (Richard Donovan, Lufkin)

The Neches begins to make another significant change on its journey south, especially on the Tyler County side. In many areas, the river has carved its channel through solid sandstone. The tops of these banks and the hills that soar up behind them are forested with a mixture of shortleaf and loblolly pine and mixed hardwoods.

Numerous rapids over beds of large gravel and rock outcrops keep me busy with the paddle. If one of these submerged rocks catches the keel ridge on the canoe bottom just right, all of my gear is going to get wet. The canoe turns the corner of another bend in the river showing one of the longest and most turbulent sections of rapids yet. Just past the rapids is a steep asphalt driveway leading from the water's edge up to a well-kept cabin perched atop eight-foot stilts. That would be George and Mary Cryer's cabin at the edge of the old saline.

Menyard Cryer, George's dad, was a peckerwood sawmiller and bought the old saline in the late 1950s, about 110 years after Peter Ellis Bean of Fort Teran notoriety claimed the saline and sold salt to settlers of the area. I don't know how the salt was mined, but my guess would be that salt-rich dirt was dumped into kettles of hot water to dissolve the salt. After the salt had melted and the dirt had settled to the bottom, the salty water would be poured into other vats, and the water evaporated off, leaving a layer of treasured salt lining the bottom of the container.

Delbert Jones of the Saron community remembers his wife Vicky's grandfather Hubert Cryer telling stories of the early settlers coming to dig sulphur and lead from the big rock outcrops between the saline and Shawnee Creek. There is at least one hand-dug cave remaining there today, bearing testimony to the difficult work required to put it there.

The biggest freshwater fish I ever saw came from a slough that slanted back into this saline. Robert Lee Dykes, Robert Smith, and Claude Hamilton caught the big fish here in the late 1950s. Each year when heavy spring rains swell the Neches out of its banks and across the bottomlands, fish leave the river to swim

out into the maze of sloughs and seasonal lakes and even into the flooded woods to forage for food. Fishermen like Dykes, Smith, and Hamilton would watch for this seasonal flooding and take the opportunity to stretch gill nets across the sloughs and lakes to snare fish as they swam through. Buffalo fish were the principal quarry, but other species, turtles, and even an occasional mammal would sometimes become entangled in the mesh.

That morning when the three men in a small wooden paddle boat reached one of their nets, they found it badly torn but still sufficiently intact to be holding a huge alligator gar. There was no thought of trying to get the fish into the boat. It was almost as big as the boat and still full of fight. A slug from a .38 caliber revolver stilled the big gar so that the carcass could be cut from the net and dragged to shore. When I saw the big predator, it was hanging from a thick tree limb.

An alligator gar is a bizarre-looking creature. The front part of its body looks like that of an alligator with no feet, and the rear half looks like a fish. This particular gar was at least six feet long; they estimated that it would have weighed one hundred pounds or more. It looked almost as big as the one the Sportsmen's Lodge at Dam B kept in a concrete minnow vat until it starved to death. The lodge, supposedly, weighed that one in at 135 pounds.

Numerous huge alligator gars were taken from the Neches in earlier years, and some have surely passed under this canoe these last three weeks. The size, jaws, and teeth of these big fish would allow them to inflict grave damage upon a person if they were inclined to do so. But for generations, men, women, and untold numbers of children have swum, bathed, done laundry, and grappled for fish in rivers inhabited by these great gars; and I have never heard one single story of anyone being attacked.

Rockland Dam

THE TYLER COUNTY SIDE of the river beckons with a small level spot to pitch the tent and make camp. I nudge the canoe alongside until it drags to a stop. The camp goes up quickly, and I hang the sleeping bag over a low bush to air out. The propane burner has the water boiling by the time the camp chores are finished, so I dump a packet of hot chocolate into the enamel cup and cover it with boiling water. The hot handle of the pan almost burns my hand. Then, cup in hand, I settle down on the soft leaves and sand to reflect and wait for the day to meld gradually into night.

Today was really a pleasant day for paddling; there were no obstacles that completely blocked the river. The only times I stepped from the canoe were when I wanted to stretch my legs or explore. The current passed swiftly and noisily over gravel beds and rock outcrops just often enough to break the monotony of dodging logs. Sometimes, it seemed there was a clean, glistening sandbar at every bend.

It is sobering to realize that this vibrant river and everything I saw today, yesterday, the day before yesterday, the day before that, and the two days prior to that, may someday be under water. This campsite will likely be under a million tons of concrete and steel if the ecological disaster they call Rockland Dam is built. The little spit of sand where I sit making notes cannot be more than a few hundred yards from the proposed dam site.

The Lower Neches Valley Authority, the dam's chief sponsor, contends that Rockland Dam and the 126,000 acres of water piled up behind it will be needed so that the Golden Triangle area of Beaumont, Port Arthur, and Orange can continue to grow. The LNVA also entertains the hope of selling water to metropolitan Houston sometime in the future. The agency is no stranger to the water "hustling," or water-selling scene. The mil-

lions of gallons of water it pumps from the lower Neches each year already affect the river adversely. LNVA sells water to rice growers, industry, and some municipalities for big bucks. This drawdown and the deepening of the Beaumont Ship Channel have made it necessary to begin construction of a multimillion-dollar saltwater barrier north of Beaumont to prevent saltwater from migrating farther upstream. Of course, the saltwater barrier is having its own ecological, monetary, and human costs.

According to statements from an LNVA spokesperson, the agency is looking at an optimistic construction startup date for Rockland Dam as early as 2010. True to the pattern of most pork barrel projects that enrich a few at a cost to many, the dam is being presented to the public behind the facade of growth and progress.

Now that *growth* and *progress* are among the key words in our vocabulary, I remember reading somewhere, we carry strontium 90 in our bones, DDT in our fatty tissues, and asbestos in our lungs; a little more progress and growth, and we'll all be dead. Things portrayed as growth and progress may benefit purveyors of said growth and progress, but the rest of us may be left holding the bag. A case in point: the waters of the mighty Rio Grande that once scoured Santa Elena, Mariscal, and Boquillas canyons through almost two thousand feet of solid rock no longer flow to the sea. The once proud Rio Grande, the international boundary between Texas and Mexico, dries to a trickle and disappears into the sand before it reaches the Gulf of Mexico. Thirsty cities, farms, and hayfields across Colorado and New Mexico gulp the river almost dry before it reaches El Paso.

The Mexican Rio Conchos replenishes the Rio Grande at Presidio and has provided the bulk of recreational waters for Big Bend rafters and canoeists for years. Now Mexican farmers, in violation of a treaty with the United States, are overpumping the Rio Conchos, and the Rio Grande no longer refreshes its estuary when it reaches the Gulf. What will be the price tag for citizens of Mexico and the United States for the growth and progress that are siphoning off the waters of this important river?

If the giant bulldozers are unloaded here on the banks of the Neches and begin pushing down acre after acre of hundred-year-old trees, what will happen to the tens of thousands of songbirds and their nests of eggs and chicks? What will happen to thousands of red and gray foxes and their pups? When the hollow trees and snags crash to the earth, what will happen to the owls, bobcats, raccoons, woodpeckers, opossums, squirrels, and their young that live in the great trees? The mature birds and animals that are able to escape the wrath of our machines—where will they go? What will they eat? We all know the answers to these redundant queries: wild creatures will die by the tens of thousands. The Rockland Dam and Reservoir project will be a wildlife holocaust with tentacles wreaking havoc on generations yet unborn.

Is this the way we define growth and progress? Is this ecological mayhem the price we must pay to keep a million water sprinklers spritzing on lawns of immaculate non-native St. Augustine grass? Most people think water is cheap. Well, no, it isn't. The days of cheap water left town the same day industry, modern irrigation agriculture, and increasing populations arrived. When all the real costs are factored in, we pay a dear price for every gallon that we carelessly allow to drip from our faucets or from the sprinklers that water our street curbs and sidewalks. Yet little is being done to make the monetary cost of water reflect the environmental, social, and human costs involved. Scant efforts are being made to encourage the wise use of our water resources.

In fact, quite the opposite is occurring. Many municipalities charge their water customers on a decreasing scale—the more water a household or an industry uses, the lower the cost per unit becomes. I don't profess to have the answers to our growth and water problems. I am the problem, or at least a part of it. We all are. It will require us all working together to develop a strategy that will provide the water needed for our comfort while leaving enough to allow ecosystems to function. As our water plans are developed, we will do well to remember the words of a wise Native American, Chief Seattle, who reminded those of his day:

"All things are connected like the blood that unites us all. Man did not weave the web of life; he is merely a strand in it. Whatever he does to the web, he does to himself." Texas faces big water problems, and only by working together can we successfully resolve these issues.

Temperature at 7:00 P.M. is 62 degrees.

Friday, October 22

A gang of noisy crows awakens me almost at the crack of dawn. The first rays of the morning sun are bathing the treetops in golden light. A blanket of silky fog floats delicately along the top of the river. A red-tailed hawk sweeps an open area across the way, barely skimming the tops of the grass and bushes as it silently searches for prey. The kingbird, flitting in the bare tree above my head, certainly does not miss sighting the graceful raptor.

Temperature at 7:00 A.M. is 40 degrees. The weather has been marvelous for this entire trip. Autumn and winter are the times to enjoy the Texas outdoors. Our ancestors knew this. After the crops were harvested in the fall, families would load into the wagon or truck and head for the river to camp and fish. Later in the year, the men from several families might return to the bottoms with their dogs to camp and hunt. Sometimes, these camps lasted for a month or longer with different people joining in and leaving as they chose.

Bonnie has packed some venison and pork sausage in my provisions at the Highway 59 crossing, so I start a fire with the propane burner and turn out a delicious breakfast of scrambled eggs and sausage. In spite of the time spent cooking, I fold the tent and still get on the water early.

Just below the campsite is a tall cypress with so many knotholes that I suspect the squirrels must become confused. A big crimson-crested pileated woodpecker is industriously scouring the tree for its next meal. It stops its work occasionally to utter its strange, piercing call.

There are giant boulders and great slabs of rock scattered

everywhere as if flung by a mighty hand. The river has become a noisy series of riffles and small waterfalls. A couple of times, I worry that the canoe might capsize.

Soon after breaking camp, I enter that great sweeping bend known locally as Best Bend. The river makes a long southern arc before looping back to the north, then east. The rock outcrops here probably are responsible for this dramatic deviation in the river's course. A lot of history went unrecorded here, times of plenty and hardship. As a young man, I often camped at a place known as the Lower Wire. I don't know the significance of that name, and probably no one living today does. The name was there long before fences were common along this river.

The river's turbulence for the previous couple of miles has diminished significantly. Rock outcrops and shallow rapids have temporarily disappeared. I know more rocks and rapids will occur downriver, but for now the river is gliding smoothly through a deeper channel. Suddenly, without warning, the silence is broken by the sound of splashing water and wingtips beating the air. A quick glance over my right shoulder reveals that a merganser hen has popped to the surface not three paddle lengths from the canoe. The duck does not hesitate but instantly takes to wing. Those rusty brown feathers, sticking out along the back of her head and neck, make her seem to be flying at forty miles per hour before she is ever airborne. As she skims the top of the water and disappears upstream, I wonder: Where did she come from? Had she seen my approach and dived in an attempt to remain undetected? Or had she not seen the canoe and simply dived in normal feeding activities? I don't know, but she startled me. One sees memorable sights quietly paddling the Neches in a canoe.

There are easily two dozen red-headed turkey vultures sitting in the tall cypress trees that line the riverbank. Some are spreading their long wings to let the early morning's rays remove the night's dew and moisture. Up close these creatures are ugly, almost grotesque. But let the sun warm the Earth and these homely scavengers will morph from ugly ducklings to graceful black shapes soaring high above on warm thermals and updrafts.

Yes, the Spanish had it right. This is truly the "Snowy River." The sparkling white sandy beaches would make the seashore envious. I lay the paddle down and let the current carry the canoe. As many times as I have seen this river and enjoyed the landscapes that surround it, I never really appreciated the beauty that it held. Earlier my thoughts had always been in terms of "What can it give me?" Today I can see it for what it really is.

My reflections are brief. Straight ahead is a long, wide delta of glistening white sand pushed into the river by Billams Creek. The creek is one of those spring-fed Tyler County treasures that gushes a stream of crystal water into the muddy river. I stop and walk on the long clean, white sandbar and relish the feel of soft sand on the bottoms of my feet and between my toes.

Two observations: Today there is much more vegetation growing on all the sandbars and beaches than there was in the 1950s. Also, there is a significant increase in the amount of algae growing on logs and rocks in the water, beginning south of Highway 94. There may be pollution entering the river somewhere along that stretch.

Reaching Billams Creek signifies that I have rounded the southernmost arc of Best Bend. The Bests were early settlers of Texas and, for generations, lived a good life, mostly off the fruits of the land. When Texas held its convention in Austin to withdraw from the Union and join the Confederacy, a Mr. Best was the delegate from Angelina County; his vote against secession gave Angelina County the distinction of being one of the few counties in East Texas that chose to remain part of the Union.

Billams Creek—the name is further testimony to the legacy of the Native American presence in Texas. Chief Billams' band of Cherokees lived and planted beans, corn, and squash along this stream. It was said that the chief and his braves helped construct the rafts that General Santa Anna never had the opportunity to use at Fort Teran. This rumor was all the excuse the Anglos needed to kill some of the Indians and drive the survivors across the Red River into Oklahoma.

Dunkin Ferry

THE U.S. HIGHWAY 69 bridge looms ahead. The flat, lifeless concrete structure that carries traffic across the river today, at speeds of seventy miles per hour and above, is a far cry from the tall steel truss bridge it replaced. The old 2,612-foot-long silver-painted steel bridge had personality. It creaked and rattled as you drove across and was so narrow that it seemed as if you might reach out and touch the driver of any passing vehicle.

The first bridge was completed in March of 1932, a Federal Aid Project to create jobs during the Great Depression. The bridge was part of Highway 40, which would later become Highway 69. Much of the material used for the construction of the 1932 bridge arrived by rail and was off-loaded in Rockland and hauled to the site by mule teams.

Charlie King, a friend of long ago, was a young man at the time and worked on the construction of Highway 40. Charlie was a better-than-average storyteller and used to regale us with stories of things that happened on that job. One of the more memorable was of the gasoline-powered concrete mixer that had to be hand cranked every morning. On its best days, this machine was difficult, but on cold mornings it sometimes took hours of laborious cranking to get the thing running. One particularly cold morning after several hours of arm- and back-wrenching cranking, one exhausted and enraged man jerked out his pocketknife and began uncontrollably cursing and stabbing the steel mixing barrel on the machine. Some wit present yelled, "Ooh, look-it the blood, look-it the blood." Everyone standing nearby ran, thinking the berserk man might turn on him, but old "Spood," the knife wielder, simply turned and slumped to the ground.

There is a crew of men working at the bridge when I arrive at 11:00 A.M. They are laying conduit for a fiber-optic cable that

will allow the transfer of so much information so much faster that soon everybody will know everything.

Bonnie arrives to pick me up at noon. I am mostly silent on the thirty-two mile drive into Lufkin. I am thinking of what an essential role she has played in this mission. It would have been impossible without her. There has been no adventure in it for her, only work. To keep me supplied with fresh water, food, and clothing, she has sometimes had to wait hours for me at river crossings. Never once has she complained. At the beginning of this expedition, Bonnie was somewhat apprehensive about pulling the little boat trailer hidden behind the pickup tailgate until I attached a three-foot dowel to the trailer and tied some survey ribbon at the top. Now she can look into the rearview mirror, see the ribbon flapping in the wind, and know the trailer is still following obediently behind her.

Monday, October 25

The old worn flannel shirt felt good at the 8:00 A.M. 38-degree temperature when I carefully slid down the steep riverbank, waved good-bye to Bonnie, and nudged the canoe into the water at the Highway 69 bridge. The usual morning steam was rising from the water, and two hawks were circling and screaming low overhead.

Around the first bend a clubhouse occupies the spot that was reportedly the site of last commercially operating ferry on the Neches. The Dunkin Ferry shuttled traffic back and forth across the river until the middle 1930s, when it was made obsolete by the new Highway 40 bridge. (Almost every map or historical article that includes this important river crossing incorrectly shows the name as "Duncan" ferry.) This ferry was capable of carrying one wagon and team of horses, mules, or oxen at a time. There was also a small skiff used for paddling one or two people across.

Mack Dunkin, the ferry owner, came to Texas about 1887 and found employment several miles upriver, operating a ferry for a Mr. Boone at old Fort Teran. Boone was a wealthy man for the time. He owned both the ferry and a trading post.

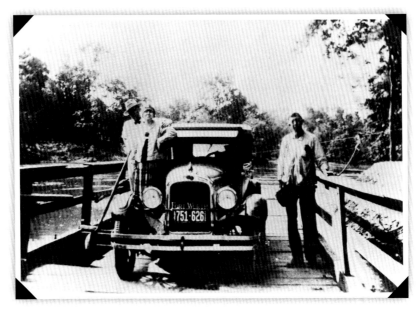

*Dunkin Ferry: Clyde Barrow and Bonnie Parker traveled the
road from Beaumont to East Texas in a 1929 Ford automobile,
crossing the Neches River on the Dunkin Ferry. The ferry attendant
is thought to be Dock Fann. (Kenneth B. Hill, Lufkin)*

One night a poker game including Boone and Dan Dykes
turned sour. A knife fight ensued, and both men were badly cut.
Dykes, it was said, was so bloody that his dogs did not recognize
him and would not let him approach his horse. Finally he was
able to get a stick of wood and keep the dogs beaten back until
he was mounted. Dykes survived the fight but had to leave the
county for fear of reprisal. Boone died from his wounds, leaving
behind a wealthy widow.

Mack Dunkin, a shrewd businessman, married the wealthy
Widow Boone even though he was fifteen years her junior. A
short time later the Dunkins sold the ferry, trading post, and
other holdings and relocated here, where the old road from East
Texas to Beaumont crossed the Neches. Rockland, less than a
mile away, was fast becoming a major shipping point. The
Sabine and East Texas Railroad had laid tracks to Rockland in
the 1890s.

In 1900 the Southern Pacific Railroad bought the East Texas line, renamed it the Texas and New Orleans (T&NO) Railroad, and extended tracks northward through Zavalla and Huntington to Nacogdoches and Shreveport. Rockland was a major railroad stop, and traffic on the Dunkin Ferry was profitable.

Vada Lee Rhodes McDonald of Zavalla, ninety-seven years old at the time of writing, remembers riding the ferry holding her grandfather's hand when she was three years old. Her grandfather, Dave Bellamy, had just been hired to operate the ferry for Dunkin and would continue to operate it until it shut down.

Oral tradition has it that when the Dunkins moved from their residence near the ferry into Rockland, it took three men to load a small trunk full of gold coins onto the horse-drawn wagon. Mrs. Dunkin was said to have ridden on top of the trunk during the move. Of course, rumors of this kind fuel mystery; for years after the couple's death, gold seekers almost dug the foundation from under their house.

One of the more notable passengers to use the Dunkin Ferry was old Dr. John Pickering of Angelina County. Dr. Pickering traveled southern Angelina County and northern Tyler County caring for the sick, injured, and dying until his own death in 1917 at the incredible age of ninety-nine. It was not uncommon to encounter the old doctor in his horse-drawn buggy at any place or any hour of the day or night.

Dr. Pickering was not your ordinary doctor. He was the last surviving veteran of the Battle of San Jacinto, the epic battle in which Sam Houston and eight hundred men gave birth to the Republic of Texas by defeating Mexican general and dictator Antonio Lopez de Santa Anna and his army of sixteen hundred regulars. This battle redefined the geographical shape of the United States and altered the world.

Still, Dr. Pickering was perhaps best known for the healing powers of his Koronkowa Linament. An advertisement for the medicine says it was concocted from the spirits of vinegar, tiribinth, phyto decandra, essence of xanthoxili, gum camphora, and other assorted ingredients. Those who took it said it tasted awful

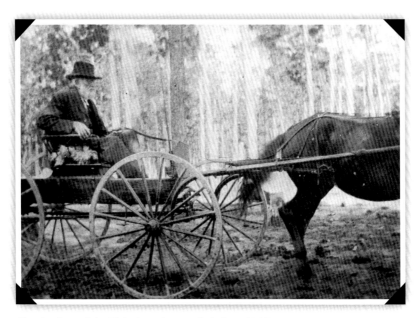

Frontier doctor John Pickering, photographed about 1910, crossed the Neches on the Dunkin Ferry many times as he traveled the dirt roads of Angelina and Tyler counties caring for the sick and hurting. Known for his Koronkawa Linament, Dr. Pickering was the last surviving veteran of the Battle of San Jacinto. (Sammy Crain, Huntington)

but that it sure did work. The elixir sold for fifty cents per bottle and drew testimonials to its curative powers from important public officials, including a Tyler County district judge, a former sheriff, and a Kirbyville doctor. The label, printed on the bottle, gave the patient a choice of either internal or external application for relief from sprains, bruises, neuralgia, rheumatism, and the bites of poisonous insects—among other things.

Dr. Pickering's dedication to his patients finally cost him his life one cold February day. He had traveled from the home he shared with the Pilot Williams family, on what is now FM 1270 in Angelina County, to the Concord community. The prolonged exposure to the cold was too much for his frail body. Today he lies buried in the Johnson Cemetery, a tiny, forgotten plot not far from the Neches. All the headstones in the little graveyard have

been knocked over, and some have been broken. Dewberry and sensitive briar vines cover them completely. You would never know the gravestones were there unless you kicked the briars back to uncover them. There probably are not two dozen people alive who know where the cemetery is, much less know who is buried there. In a few more years, no one will know; and no one will care—a sad ending for a man who gave so much to so many.

How dispassionately flows the river of time!

A few hundred yards below Dunkin Ferry, the abandoned T&NO Railroad trestle looms ahead. This trestle is longer than most and is quite tall. From my vantage point some fifty or sixty feet below, the structure appears capable of carrying a loaded freight train today.

In the days of steam locomotives, a man lived at the south end of the trestle, and it was his job to walk and inspect the trestle at least once a day. Fire was his main concern. Sparks from the wood- and coal-fired locomotives might set the small trees and grass growing around the wooden structure on fire and burn it down. The dunce cap–shaped water buckets hanging beside the water barrels, spaced along the bridge, evidenced the wisdom of the railroad people. Thieves had little use for a bucket that wouldn't sit on its bottom.

Upland Island Wilderness

IMMEDIATELY PAST THE OLD TRESTLE the river carries me into the crown jewel of Angelina and Jasper counties—Upland Island Wilderness. Within this wilderness are high, rolling hills of longleaf pines. Hardwoods of varieties almost too numerous to count grow in the bottomlands. Spring-fed streams of sparkling water as sweet and pure as any in the state flow from beneath the pines and tumble down the hills to join the water of the Neches.

American royalty reigns in Upland Island. At least three national champions live here: an American snowbell tree, a barberry hawthorn, and the largest Florida basswood ever reported. Alas, the king is dead; the national champion longleaf pine was here until a windstorm in 1989 snapped the top off the giant. Growth rings indicated that this Goliath was a growing tree when the Pilgrims landed at Plymouth Rock.

Among the Texas aristocracy that call this place home are the state champion shagbark hickory and parsley haw. The queen of the court is the state champion cherrybark oak. This magnificent tree anchors its roots in the rich wilderness soil and then pushes its crown a dizzying 155 feet toward the sky.

Adorning the feet of this nobility are a panoply of color and specimens of rare plants found in few other places: hoary azaleas, ten-angle pipewort, yellow sunnybell, sugarcane plumegrass, several species of orchids, and all four Texas species of carnivorous plants. Other marvels and botanical oddities make a visit to this wilderness a rewarding family outing.

Fifty minutes of leisurely paddling from Highway 69 brings me to the Rocky Shoals waterfall. As the canoe nears the falls, several large fish dart from underwater holes and crevices where they have been lurking in ambush for their next meal. The swirls and ripples the fish create in the calm, shallow eddies as they bolt

for deeper water reveal that three or four of them must be a foot or more in length. The current is shallow and swift where I step out of the canoe onto the slippery rock bottom.

I grasp the twenty-foot bow line and let the current turn the canoe around so that the line is taut and the bow is facing upstream. Then I walk gingerly forward and let the canoe drop over the falls, stern first. A couple of times the keel ridge catches on protruding rocks and almost flips the canoe, but the taut bow line keeps it upright. I walk carefully over the slick rocks to the bank and pull the canoe, gear intact, up onto the rock ledge. The falls are pretty and make quite a roar as the water cascades over the edge and falls some two or three feet. The noise of the rushing water drowns out all other sounds as I dawdle around picking up rocks and just enjoying the place. It is easy to imagine why riverboat captains were so fearful of being caught upstream of the rugged Rocky Shoals during times of even intermediate water flows.

Bonnie, Gina, and I have hiked in through the wilderness and camped several times on the bluff overlooking the falls. The roar of the falls lulls one to sleep at night. The south bank of the river is private property, but the north side is U.S. Forest Service land and is excellent for hiking and seeing extraordinarily beautiful trees, plants, mushrooms, wildlife, sloughs, and other natural wonders. Two people cannot reach around some of the trees growing here. There are a few that three cannot encircle.

This is a special place, but the river beckons; and the canoe takes me away. A few hundred feet downstream from the falls on the Jasper County side, another school bus–clubhouse sits atop a high bluff overlooking the river. I have long been familiar with this one. It is a 1952 model International. Rust, decay, and time have taken their toll on the old derelict. It has been close to forty-five years since the giggles and playful voices of school children reverberated within its rusty walls. "Boots" Morehead and Sam Burnaman of Huntington drove the bus to its present, and probably final, residence sometime during the late 1950s. They used it as a hunting and fishing camp for years. Rocky Shoals was an

excellent place to fish for white perch (crappie) in early spring. The logging road that brought the old vehicle here has all but disappeared.

A short distance below Rocky Shoals, the river piles into a thirty-foot Tyler County sandstone cliff and is temporarily deflected to a more northerly course. The bluff is an unusual pale gray, and the array of plants clinging to its almost vertical slope make it a pleasing spot. Blankets of soft sphagnum moss drape down in places like casually tossed throw rugs. Fastened to the face of the cliff and shading the moss are golden-leafed river birch, elm, American holly, sumac, maple, wax myrtle, and even a small magnolia. Large stones line the river's edge, and along the upper rim various hardwoods and the boughs of pine trees stand yellow, red, and green against a clear blue sky.

Around a bend from the cliff I carefully guide the canoe through the tricky gun sight rapids. Graham Creek appears on my left. Before it terminates at the river, its waters have coiled across a couple of miles of national forest and contributed significantly to the biological diversity of Upland Island Wilderness. The flat to gently undulating hardwood bottomland of the lower wilderness provides habitat for a profusion of wildlife. My friends and I regularly hunted deer and squirrels here in the 1950s. The little oxbow lakes a few hundred yards off the river sometimes provided a couple of wood ducks or mallards for a campfire skillet.

Many of this creek bottom's treasure house of food-bearing trees were later cut down and hauled away or poisoned with 2–4-D before the area was protected by the Wilderness Act in 1987. Corbit Pouland of Zavalla, a retired career employee of the U.S. Forest Service (and a true stockman), remembers one of the agency's Timber Stand Improvement operations here. "Thousands of some of the finest hickories I've ever seen were injected with poison and killed in there where Graham Creek crosses U.S. Forest Service Road 314," he recalls. "Why, it was fifty feet or better to the first limb on most of them hickories." Why would the Forest Service destroy those grand trees that were

so beneficial to wildlife? The answer: they did not fit the management plan. The plan was, and continues to be, tilted heavily in favor of growing pine trees. When someone speaks of managing the forest, it almost always means eliminating anything that impedes pine tree growth.

Immediately behind the mouth of the creek, the riverbank rises quickly to form a ridge that is seldom covered with water. This ridge supports a number of big, tall pines, and a small area underneath them is clean and covered with pine straw. I camped there many times in my youth. The last time I camped there, in the 1950s, we had fresh pork for supper.

Joshua Dykes and I had taken our rifles and walked downriver to kill a mess of squirrels. Shortly, a single blast from a 12-gauge shotgun reverberated through the woods. One shot, then silence. Josh and I were walking along the riverbank. Still some distance from camp, we saw two of our companions, Mickey Kitchens and Bud Widner, heave a good-sized shoat into the river. We stood and waited for the hog's carcass to float past, and as it did, I tried not to see any marks in the animal's ears. It was missing a ham. Some time later when we arrived back in camp, we were greeted by the delicious aroma of fresh pork frying in a skillet of hot grease. Supper that evening consisted of fried pork, pork and beans, "light" bread (the store-bought, sliced kind), and boiled river water coffee. All present lauded the cook for his culinary skills.

Of the many times I hunted, camped, and fished in these woods, my experience with a bobcat resides most fondly in my memory. Josh Dykes was one of my frequent hunting companions. He and I had parted before daylight and walked into the woods. The November morning air was cold and crisp as I slipped quietly over the soft wet leaves. Nothing moved; the world was still and quiet in the predawn half-light. I walked a short distance and selected a tree to lean against, the .22 rifle cradled comfortably in the crook of my arm. As I waited for squirrels to stir, the first yellow streaks of sunlight began to tint the eastern sky. My peripheral vision glimpsed movement. I slowly rotated my head to get a better look; nothing. I sat still and

I waited. Suddenly my eyes focused on something that stopped my breath. No more than a hundred feet away and twenty feet above the ground, a magnificent bobcat was standing in the fork of a steeply leaning oak.

Slowly I released my breath as the regal cat, with no sense of alarm, sauntered headfirst down the tree. Upon reaching the ground, the cat mimicked a ritual performed by every domestic cat that ever awoke from a nap. It planted its feet, arched its back, rotated backward on stiffened legs, and opened its mouth in a wide tongue-stretching yawn. Now wide awake and in a gait akin to a dandelion seed floating on a breeze, the bobcat trotted out of sight.

The acres upon acres of dense palmetto, water oaks, and willow oaks growing along the Graham Creek bottom are among the most confusing places I have ever been—a true wilderness. Every direction one turns, the country looks the same: palmetto, willow oaks, and water oaks. It is easy to get lost in here, especially on cloudy days.

Small gray cat squirrels thrive in abundance here on the plentiful acorns produced by the countless oaks. On rare occasions, the larger red fox squirrels can be found eating the seeds from pinecones growing along the hammocks that invariably curve through the river bottom.

The northern two-thirds of Upland Island Wilderness represent a dramatic ecological shift from the southern one-third, which is dominated by the bottomlands of Graham Creek and the Neches. The land to the north lifts abruptly from the low-lying bottomland to the crest of a ridge called High Point, 150 feet above the oak hardwood forest below. This high ridge begins a rolling terrain of sandy hills and valleys that extend to the northern limits of the wilderness and eastward across Longleaf Ridge. Creeks—Oil Well, Mill, Big, and Cypress creeks—flow out of these undulating hills. Each of these streams supports its own ecological zone of bottomland hardwoods, shortleaf, longleaf, and loblolly pines, and diverse wildlife populations.

This variable terrain provided the U.S. Army with an excellent infantry training ground during World War II; in the first three or four years of the 1940s, thousands of troops were bivouacked in these high woodlands. Mock war games would pit "armies" wearing red armbands against those wearing blue. When these forces were brought in for training and again when they were shipped out, it sometimes took the long convoys hours to pass through the tiny hamlet of Zavalla.

Those young "soldier boys" riding in jeeps and the trucks pulling cannons and all sorts of equipment were dramatic events in the lives of local people. Even in those days of stern discipline, there was no keeping schoolchildren from rushing to the windows as the army vehicles rolled by outside. The spit-and-polish Military Police drew the most attention. They were the vanguard of every convoy and would station themselves, with machine guns ever ready, at strategic locations in town, keeping the entire

The last open range cows were rounded up in what is now Upland Island Wilderness in the mid-1950s. The passage of stock laws ended the era of open range in Texas and began the "closing of the woods." This animal is believed to have belonged either to Lee Craven or to George Blake. (Author's collection)

convoy under strict surveillance. Most of the kids were awed by them, and I suppose the adults were, too.

An even more dramatic operation in what is now Upland Island Wilderness and Longleaf Ridge was the "bombing range" used to train flight crews during World War II. Airplanes—bombers—would come from I don't know where and drop bombs aimed at targets on the ground, one in the wilderness, one near Shearwood Creek, and another in McGee Bend. They practiced both day and night bombing. I cannot defend all the details of my memory, but I recall large bull's-eyes drawn on the ground with lime or rocks and sporting a large pyramid in the center, at least twenty feet square and made from wooden laths. I thought at the time that the pyramids resembled larger versions of the traps some people used to catch bobwhite quail.

For night training the army had strung strings of light around the targets and illuminated them with portable generators. Corbit Pouland recalls: "The first 'lectricity we ever had in our house came from some of that old number 10 wire they used for them lights. After they were gone I went and rolled up some of that old stiff wire and we got somebody to run it in our house so that we could have lights."

My connection to the military and the bombing range was a happy one. My dad, A. T. Donovan, had perhaps a greater knowledge of diesel engines than anyone within a day's drive. The army frequently came and got him to help them with some piece of equipment. As a result, I often enjoyed rides in green army jeeps and was lavished with Milky Ways, Hershey bars, and chewing gum when it was simply impossible to buy those things in stores. Neither were there sugar, shoes, tires, gasoline, ladies' nylon hose, and a long list of other items. All were diverted to the war effort. One night a four-engine B-17 bomber crashed in the forest. The military came and got my dad during the night and did not return with him until the next day. Dad often talked about the tight security employed around the downed plane because of the top secret Norden Bomb Sight it carried.

The targets are hardly visible today. One could walk through the middle of one and never recognize it for what it was. The U.S. Forest Service recently inventoried much of the area and found remnants of bomb fins and other debris. John Ippolito, forest archaeologist for the national forests in Texas, describes nature's benevolent healing touch, noting that he found a wild turkey's nest containing three brown eggs in one of the overgrown old bomb craters.

The river is almost continuously shallow now. It seems every stroke of the paddle scrapes the hard rock bottom. The deep holes are few and far between and are the hiding places of monstrous catfish.

Lone rattlebox bushes grow in sunlit openings along the steep riverbanks, and occasionally they colonize portions of sandbars. The rattly elongated bean pods of this interesting legume hang, dry and brown, waiting to drop into the current and be transported downriver, where new colonies of rattlebox can take root and grow. These plants often share sandbars with great clumps of the infamous cocklebur. This pesky weed is as much a part of early Texas history as are wild hogs, the cotton patch, woods cattle, and catfish. The spiny burs that give the plant its name would adhere to horses' manes and tails and would form a tangled mass. The tails of neglected, ungroomed horses would sometimes become unwieldy clubs as they attempted to swat gnawing gnats and flies from their itching backs and shoulders.

It seemed to me that the switch of a cow's tail, especially in milk cows, sought out the clinging burs. Believe me, there are not many things to compare with squatting down to squeeze milk from a Jersey cow and being slapped alongside the head with a wad of cow hair and cockleburs as big as two fists.

The river is perfect for recreation along this stretch. The many long, flat rock ledges and sandy beaches are ideal for picnics, inviting one to stop and explore.

Tree limbs, logs, and other debris are lodged against the rotting pilings of the old Burr's Ferry, Browndel and Chester

(BFB&C) Railroad trestle. Luckily, the opening between the Jasper County riverbank and the first piling is just wide enough to paddle the canoe through. These decaying remnants are all that remain of the tall BFB&C trestle that once spanned this river and carried trains loaded with logs to feed the insatiable appetites of the whirling steel saws at Aldridge, Browndell, and Chester.

There were numerous railroad trestles like this one crossing the Neches in the early 1900s. All were built for one purpose—to haul men and axes into the woods and to return with freight car after freight car loaded with saw logs. From these "mainlines," a spiderweb of spurs, or "tram lines," branched out into the forest in all directions. Tram lines extended out to the logging fronts where the virgin trees were being sawn down and loaded onto railcars for delivery to sawmills. Thriving mill towns—Manning, Aldridge, Browndell, and Ratcliff—sprang up almost overnight and disappeared almost as quickly when the trees were gone.

A short distance downriver, the mill at Aldridge sat smack in the middle of some of the most extraordinary timber east of the Rocky Mountains, the fabulous longleaf pine belt. Longleaf trees were a timber man's dream. To the lumberjack, or "flathead," they meant working in clean, open woods of big trees, virtually free of underbrush, with the tree limbs beginning fifty feet above the ground. To the investor or mill owner, the longleaf pines stood like long columns of figures that added up to sizable profits at the bottom of their income statements. Many of the older trees (some were over 350 years old) suffered from a malady called red heart. This disease significantly reduced the old trees' value for lumber, but who could determine by looking at a standing tree if its core was a texture of soft, red pith? The lumbermen took no chances. They cut them all. As the old giants fell, so did the red-cockaded woodpeckers in their nests, burrowed deep into the trees' soft red hearts. The destruction of the old-growth pines decimated the Texas population of this tiny woodpecker and pushed it to the brink of extinction. Were it not for a 1988 federal lawsuit by several environmental groups, the Texas red-cockaded woodpecker would almost certainly have disappeared.

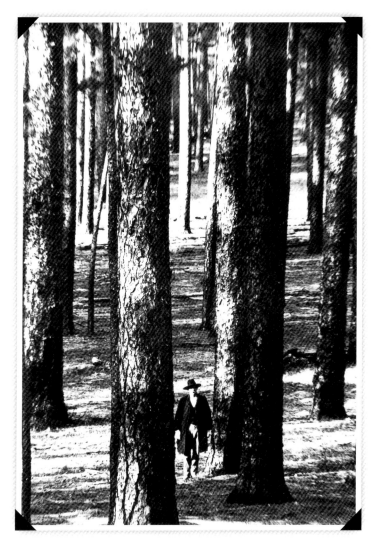

Virgin pine forest in northeast Tyler County, about 1907.
(Texas Forestry Museum, Lufkin)

As logging operations grew larger and larger and improved with technology, a new machine called the steam skidder began appearing on the tram rails that snaked back into the woods. The steam skidder was an awesome and terrifying piece of equipment. No one who ever saw one of these powerful machines at work ever forgot the sight.

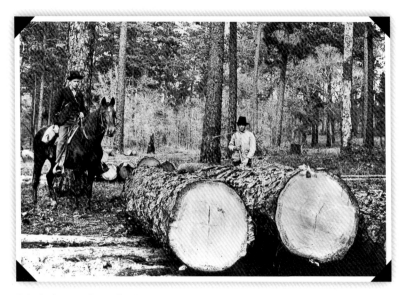

Woods foreman J. W. Getsinger, on horseback, and scaler J. T. Gillespie pose beside virgin pine logs, about 1907. The eighteen-inch diameter log scaled 882 board feet, and the sixteen-inch log scaled 784 board feet. (Texas Forestry Museum, Lufkin)

Reforestation pioneer W. Goodrich Jones likened the aftermath of the steam skidder to war-torn areas of Europe following World War I. As quoted in Thad Sitton's *Backwoodsmen: Stockmen and Hunters along a Big Thicket River Valley,* Jones described the steam skidder as "an octopus of steel, with grappling arms running out 300 or more feet. These grapple a tree of any size that has been felled, and drag it through the woods to the tram road. These become enormous battering rams and lay low everything in their way. The remains of the forest are like the shelled towns of France. Use of the re-haul skidder should never have been allowed by the state."

The skidder was really a big steam-powered winch. It did not work well in the river bottoms, but in the pine forests, especially the longleaf, it significantly reduced the time and cost of timber operations. Nothing exemplified the "cut out and get out" philosophy of the timber barons more than did the steam skidder. When the steel

grabs had been set into a log of any size, and the skidder operator pulled the lever to bring the log to the railcar, it came. It would come over, around, or through anything that stood in its path.

All pines less than twelve inches in diameter were considered too small for lumber production and were left standing. These trees and all hardwoods that stood in the path of the hurtling logs and humming cables were pulled over or snapped off like

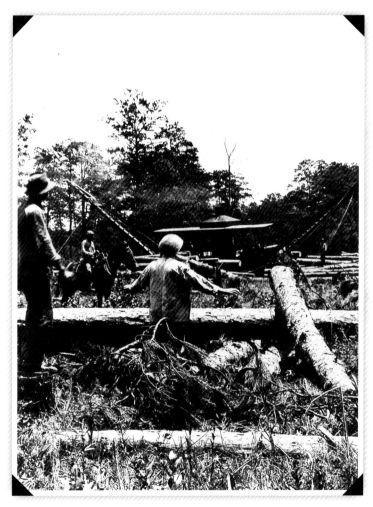

A Clyde four-line steam skidder drags logs to the tram line where they can be loaded onto railcars for delivery to the sawmill, about 1907. (Texas Forestry Museum, Lufkin)

twigs. In short, much of the land where pines grew was laid waste. The timber barons were not concerned; they knew they weren't coming back.

Many of the big sawmills were being forced to suspend operations as early as 1920. They had totally exhausted the supply of virgin timber. The flatheads and steam skidders cutting for the giant Four C mill in Ratcliff had to cut something like eight thousand acres of virgin pine timber annually just to satisfy that one mill's voracious appetite.

The tycoons who were not already gone were going. When they left, they took their trains, railroads, mills, and money with them. Many left nothing but devastated earth behind. From the laying of the first steel rail into the seemingly endless pine forest until the last of the big stands of pines were loaded onto railcars was only about thirty years—roughly equal to the best years in a working man's life.

A few seedlings and saplings are all that remain of the towering longleaf pine forest that once covered the rolling hills of what is now Upland Island Wilderness. This 1937 photograph was taken near an area once known as Craven Hill. (U.S. Forest Service)

I often wondered why they did it. Why would men willingly work long, toilsome hours under a blazing Texas sun for poverty wages to cut down, saw up, and haul away the treasure that had been their lives for generations? Years later, it dawned on me. We are still at it! We are no longer plundering virgin forests, and nor are the woods as essential to our livelihood as they were then, but we are still stripping away the hardwoods; later generations will resent us for it.

The twenty-sixth president of the United States witnessed much of the plundering of America's pristine virgin forest, and he left us this admonition, in a 1907 Arbor Day proclamation to the school children of the United States: "Any nation which in its youth lives only for the day, reaps without sowing, and consumes without husbandry, must expect the penalty. . . . Forests which are so used that they cannot renew themselves will soon vanish, and with them all their benefits." Theodore Roosevelt could see it.

The river's current has brought the canoe from the old BFB&C crossing to another of those clear, rushing streams that push snow-white Tyler County sand into the river. This must be Sugar Creek. My guess is that this creek takes its name from the gleaming white sand that graces its banks. There are not many creeks in the world more appealing then those feeding the river here in Jasper and Tyler counties.

Immediately below Sugar Creek the forest opens up for another pipeline crossing. Two pipes are visible on the left where they exit the water and disappear into the Jasper County riverbank. These pipelines probably carry natural gas to the great cities in the northeastern United States. People somewhere are burning gas from this pipeline right now to stay warm, as I sit here with wet feet, wearing a short-sleeved shirt.

Boykin Creek

THE U.S. FOREST SERVICE has thoughtfully tacked a sign reading "Bouton Lake" to a tree growing on the east bank. The riverbank here presents a steep climb from the water's edge to the top, where a well-beaten trail leads a hundred yards or so to the primitive campground at Bouton Lake. This tranquil nine-acre forest-surrounded lake is the southern terminus of the five-and-a-half-mile Sawmill Hiking Trail. Along its course leading east from Bouton Lake to Old Aldridge, the trail winds close alongside the Neches as the river makes one last northerly bulge before turning and striking almost due south for the Gulf of Mexico.

Near Old Aldridge the trail leaves the Neches and continues toward Boykin Springs Campground. Any time is a good time to hike this forested trail, but autumn, when the leaves are red, brown, yellow, purple, green, and golden, is my favorite. The trail intersects several creeks that must be crossed by footbridges, the most special being the swinging bridge that spans Big Creek's deep channel. The Boy Scouts of America, Troop 140, in cooperation with the U.S. Forest Service and Temple-Inland Forest Products Corporation, built most of the Sawmill Hiking Trail, and the Youth Conservation Corps girls did a large part of the work in building this unique footbridge. Another interesting feature of the trail is the high earthen embankment of a long-abandoned tramway, which it follows for some distance. The tram was once used to haul logs to Old Aldridge sawmill. It would be great to hike the trail. Walking would feel good; I have been sitting a lot lately. But hiking can wait for another time. The focus on this expedition is the river itself.

A little more than a mile north of Bouton Lake, on a private inholding within the national forest, is the ghost of what was once one of the most famous swimming holes in Texas: the Blue

Hole. In the 1930s, '40s, and '50s, couples and families often drove more than a hundred miles to enjoy the beauty of the abandoned rock quarry. The catastrophic Great Storm of 1900, which claimed between six and eight thousand lives in and near Galveston—the worst natural disaster in U.S. history—prompted the building of the seawall to protect the city from future storms. Some of the stone used in the foundations of the Galveston seawall and jetties was mined here in the Blue Hole. The pit was abandoned when it suddenly filled with water, presumably as a result of blasting and mining operations, and quarrying became economically unfeasible.

As the name implies, the water in Blue Hole was clean, clear, and a beautiful azure blue. Nature did not succeed in populating it with fish, frogs, or insects, but it was a paradise for swimmers and divers. Rock cliffs from five to thirty feet high rimmed the eastern bank, offering excellent places to leap into the cool blue water below. Tall pines gathered around the other three sides of the old quarry, providing comfortable shade for most of the day.

The old swimming hole would see quarrying resume briefly during the 1980s, when modern equipment and perhaps the drawing down of the aquifer allowed additional mining. Local legend had it that a steam locomotive lay in the depths of Blue Hole, but as far as I know, no such thing materialized as the quarry was drained for this second mining operation. Today, there is just a small pond of the blue water in the center of a bald clearing, with some rusty cables and other reminders of industrial activity. The beauty of the Blue Hole is a memory only, and in a few years no one will remember it was there.

Likewise almost forgotten is the once well-known whiskey maker and bootlegger "Ms. Gussie," who operated a thriving saloon and brothel nearby. In the early 1900s Ms. Gussie's enterprise was well attended by patrons from the stone quarry and logging crews and by mill hands from the Aldridge sawmill.

No more than a mile downstream from the Bouton Lake trail, a small clear brook enters from the east. This is probably Big

Creek, sometimes referred to as Falls Creek. Big Creek originates just in front of the old Concord Church and cemetery on Texas Highway 63. (The old pioneer church was relocated there from its historical site near the Angelina River to escape the rising waters of the Sam Rayburn Reservoir.) Move just a few feet north from this point of origin, and rainfall flows into Lake Sam Rayburn instead of the Neches. A short distance before emptying into the Neches, Big Creek is joined by Falls Creek, which collects its momentum from numerous springs in Upland Island Wilderness.

The sound of rushing water leads me to a gurgling three-foot waterfall entering the river from Jasper County. The water coming over the narrow falls is clear, cold, and a joy to hear. Some lucky folks have a green riverbank clubhouse nearby.

Sandbars and rock outcrops line the river beneath trees painted in ever-increasing autumn hues of red, brown, and gold. The extremely dry summer has diminished the exuberance of the colors; still, they are beautiful and portend a changing season.

The mouth of spring-fed Boykin Creek lies almost hidden beneath sprawling willows that are draped with grapevines and trumpet vines plaited together as if to shade the creek from the hot summer sun. Behind the willows stand numerous sycamores with their big brown leaves giving mute testimony to a long, hot, dry summer and an autumn slow in arriving.

Boykin Creek is another of those Neches streams rich in history as well as in natural beauty. I readily admit to possessing a mild bias, but I have always regarded the Boykin Springs/ Longleaf Ridge area as a place of special beauty. The towering longleaf pine trees, rolling hills, unusual plant communities, and cool, clear running streams make Longleaf Ridge's 32,000 acres unique in all of Texas.

If I were to beach the canoe and head north up the creek I would first step into the flat, alluvial plain of the Neches. This is wildlife's winter commissary. The autumn cornucopia of nuts, fruits, and berries growing there helps wild animals put on fat reserves for the winter as well as providing a continuing source of

food that will nurture them through the winter months. Before exiting the river bottom, I would cross a long, narrow sandy hummock laid down by the river centuries ago. The slight rise in elevation above the floodplain, one to two or three feet, allows growth of white oaks, hickories, and majestic shortleaf and loblolly pine trees that seem to touch the sky.

The bottomland is relatively narrow, and the eye-pleasing hills of Longleaf Ridge gain upward of 340 feet in elevation rather quickly. These hills give birth to numerous spring-fed creeks that pour into the Neches. Falls Creek, Shearwood Creek, and Trout Creek, just to name a few, gather their strength from springs and seeps that come to the surface beneath soaring longleaf pine trees. But not Boykin Creek. It fairly bursts out of the rocky Catahoula geologic formation in several torrents in the center of the U.S. Forest Service's Boykin Springs Campground. The water from these gushing fountains is joined quickly by that coming over the spillway from Boykin Lake, and then the creek begins its one-and-a-half-mile journey to deposit its sparkling waters into the muddy Neches.

The Boykin Springs Campground was once a place of great beauty. Constructed by the Civilian Conservation Corps in the early 1930s, it was a masterpiece of human skill at melding together nature's components of water, trees, and rocks to form a superb recreation area. Today it still possesses a ragged sylvan charm. The springs still spout out of the rocks; log footbridges still cross the gurgling streams, and there are picnic tables and campsites. But the waters coming over the lake's spillway no longer splash over the carefully constructed waterfalls; they go underneath. Because of constant prescribed burning of the forested hills and slopes surrounding the lake and erosion caused by churning wheels of all-terrain vehicles, the lake has silted up to a fraction of its original size. The log bathhouse that stood on a promontory overlooking the lake has been replaced with a cinderblock building, neglected and in need of repair. Still, in spite of the abuse and neglect it has endured, this remains one of my favorite places.

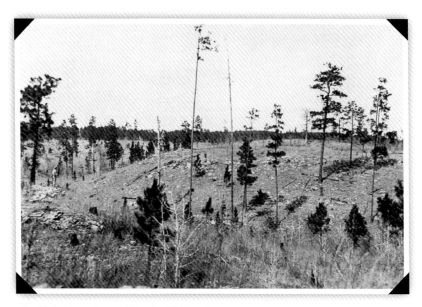

Boykin Springs about 1937: the Civilian Conservation Corps,
one of President Franklin D. Roosevelt's job creation programs
of the Great Depression era, transformed this cutover shallow
canyon and denuded hillside into Boykin Springs Lake and
Campground. The giant two- and three-hundred-year-old pines
that once protected these slopes from erosion had been cut down
and skidded to sawmills some twenty-five years earlier. (U.S.
Forest Service)

In the campground, where a high point juts in between the
confluence of two noisy streams, lies a small thirty by sixty-five-
foot moss-covered burial plot surrounded by a four-foot chain-
link fence. Inside the enclosure, bathed in the cool shade of
hickory, black gum, and dogwood trees, are three small head-
stones. The largest reads simply: "Sterling Boykin 1800–1871."

The simplicity of the name and dates chiseled into cold, hard
granite belies the legacy and complexity of the man buried there.
Sterling Boykin's life was nothing if not an enigma. Not much
is really known of him, yet he left a memorable legacy in Texas.
Sterling was bigger than life. This is the story as it was told to me
and as I remember it. Blonde, blue-eyed, 6 feet, 11 3/4 inches
tall and weighing 375 pounds, Sterling was a man people prob-

ably did not readily challenge. If he had cared to, and he probably wouldn't have, he could have traced his ancestry across the Atlantic to Huntingdon, England, and Brussels, Belgium. His ancestors immigrated to Surry, Virginia, sometime between 1650 and 1675.

Boykin lived in both North Carolina and Alabama before moving to Texas. His first wife bore him five sons and one daughter before her death. He then married an Indian girl and fathered a son by her before she died. After the death of his second wife, Boykin packed his white children and Indian son into a wagon and headed for Texas, the land of a new beginning.

How Sterling Boykin learned of the great springs gushing from the rocks amid millions of acres of giant trees is unknown. Did someone tell him? Could he have learned of them from the Indians? It is not likely that he was just riding along in the great virgin woods and happened upon the spot. However he came to be there, he chose land near the springs for his homestead. The area abounded in all manner of wild game. There was grass on the hills and hardwood mast along the creeks and in the river bottom for his semi-domestic livestock. And there was an unending supply of cool, clear water. For a Texas settler in the 1840s, this was truly a paradise. According to records of 1860, he laid claim to 3,500 acres that lay astride what is now the Angelina and Jasper county line.

Boykin made at least one trip back to Alabama. When he returned, a young mulatto girl (one-fourth black ancestry) was riding behind him as he made his way home. The girl's name was Lettie Neal, and it is said that she was a runaway slave. She was brought to Texas to raise Sterling's children and care for his house. For this, she would receive a payment of three dollars per week. Lettie later became Boykin's common-law wife and bore him two more children.

Sterling taught all his children to read and write, including his mulatto children, much to the displeasure of some of the area's whites. A gang of Red Caps, a vigilante group, burned his collection of books to make sure that no other blacks would be taught.

Thus Sterling Boykin left behind three families in three different races and two different worlds. His white children (two share his tiny burial plot) grew up and moved into the surrounding countryside. To the best of my knowledge, the Indian son Simon is buried in the neglected and forlorn Gilliland Cemetery overlooking the clear waters of Sam Rayburn Reservoir. The chain-link fence surrounding the old burial ground is bent and in need of repair. Large cedar and other trees grow among the headstones, and fallen branches lie in the ragged weeds. Many dates on the headstones hearken back to turbulent times largely unrecorded and forgotten. Simon Boykin's gravestone reads: "Born 1838—Died 1890." The Republic of Texas was two years old when Simon was born.

The black children and their descendents clustered around the family land and made a good life for themselves. Some remain here today. Others received college degrees and are doctors, merchants, and teachers as well as farmers, ranchers, and military personnel. Among the families that continued to farm and ranch in the Boykin Settlement, as the rural community came to be called, were the Fraziers. I have known this hardworking family most of my life. Harrison Frazier Sr. had the first mechanical hay baler in the area. He and his son Harrison Jr. ("Preacher," as I know him) did custom baling and baled hay for my dad and me more than once.

One of Harrison Sr.'s daughters (and great-niece of Mary Boykin Runnels) recently made a gift of twenty acres of the old pioneer land to the Natural Area Preservation Association. Dessor Ree Frazier, or "Miss Dessie," as she is affectionately called by family and friends, made the contribution in memory of her parents, Harrison Sr. and Mary Frazier, and grandparents, James R. and Emma Runnels; James was a freed slave. She stipulated that the entrustment be named the Frazier-Runnels Wildlife Preserve and that it be managed "so that future generations of Americans might come here and enjoy this wild place and the wildlife that lives here."

The Frazier-Runnels Wildlife Preserve is a twenty-acre tract

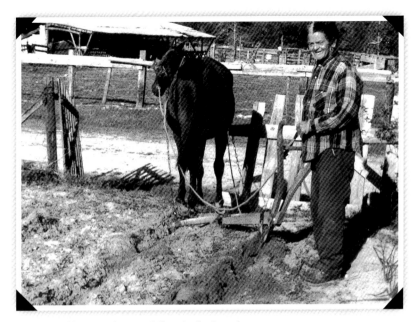

*Buddy Boykin uses a horse and Georgia Stock to plow
the garden at the Harrison Frazier farm. (Wilhelmenia
Hardy, Lufkin)*

about one and a quarter miles north of the Neches River and
completely surrounded by the Angelina National Forest. It is only
a stone's throw from Upland Island Wilderness Area and is in a
unique section of the national forest known as Longleaf Ridge.
The preserve is an old overgrown field now; but in a couple of
decades, it will be a forest of pines and hardwoods. Squirrels will
jump through the treetops, and birds will build their nests in the
boughs. Deer will eat acorns that fall to the forest floor, and owls
will rear their young in hollow cavities high above the ground.
Texas desperately needs more places where wildlife can breed
and raise their young. Expanding human populations are gob-
bling up rural land at an alarming rate; forestry practices that
favor pines continue to compromise hardwood regeneration; but
this tract will not be subdivided and sold off.

After passing Boykin Creek, the river makes an abrupt turn to
the southwest. If I wanted to visit the ghost town of Old Al-

dridge, or link up with the Sawmill Hiking Trail, I would pull the canoe to the Jasper County side, scamper up the bank, and intersect an old dim road that runs parallel to the river for some distance. Old Aldridge would be no more than a few hundred yards' walk north, and there I would intersect the Sawmill Trail.

The canoe is filthy again. My feet bring in mud and dirt every time I get in. Leaves and twigs fall into the canoe each time it brushes against a tree or limb. Another long, clean sandbar provides a good place to stop, wash the inside of the canoe, and stretch my legs. After the canoe is clean and the gear stowed in place, I slouch cross-legged on the warm sand to savor this wild place.

With a sudden flurry of leaves and sand, two sleek river otters come tumbling and sliding down the steep bank on the opposite side of the river not two hundred feet downstream. They frolic along the water's edge, then turn and proceed upriver toward me in their peculiar loping, humping gait. What a sight! I have witnessed similar events in Canada and Alaska, but this is a first in Texas. In my desire to record the experience, I foolishly attempt to crawl to the canoe three feet away to reach my little Quicksnap waterproof camera, but I have hardly moved a finger when the alert furry creatures slither into a huge pile of tree trunks and debris. Annoyed with myself for disturbing the wildlife show, I shove the canoe out into the southbound current and continue downstream.

Numerous rapids have been a treat today, and the canoe ran aground on rocks a couple of times, but I managed to keep it upright. The first three-fourths of the trip from Highway 69 to Highway 255 are scenic, with rocks and a waterfall, cypress trees, spectacular snow-white sandbars, clear creeks, and ferns of various kinds. For the most part the forests along the banks contain a pleasing mix of hardwoods and pine. In the last one-fourth of that stretch, the river grows wide, loses its current, and begins to show the appearance of becoming B. A. Steinhagen Lake.

Bottomland Forest

ONE OF MY INTERESTS from the beginning of the trip has been to watch the riverbanks for signs of wildlife. I have sighted many more birds and animals than expected, but the biggest reward has been the remarkable quantity and variety of animal signs I have seen. The moist sandbars and mud seeps have displayed an abundance of tracks, and the logs lodged in the river channel are littered with scat. Deer and beaver tracks have dominated my unscientific visual survey, perhaps for no reason other than that they leave the boldest and most recognizable tracks. The unmistakable signature of raccoons and opossums is everywhere imprinted into the river's mud and soft sand.

There has been no shortage of coyote tracks, and several times their fur-stuffed scat has dotted the game trails running along the edge of the river's outer bank.

The otters have been the surprise for me. I had never seen an otter in the Texas wild until this trip. There were none when I enjoyed my earlier time here. They had been trapped out. What a thrill to realize they have returned. It shows that given time, nature can heal itself from our environmental pummeling.

The biggest thrill was sighting the cougar tracks. Four or five prints were stamped into a thin veneer of slick mud and willow oak leaves at the edge of a low, flat sandbar. They were reasonably fresh and about the size of the mouth of a Mason jar. I photographed a couple of them for the record. Wouldn't it be the *crème de la crème* if I could spot a black bear strolling along the banks of the Neches?

It takes a strong, healthy ecosystem to support a viable wildlife population, and the Neches has it. The land and its flora are the wellspring of life here. The river in its southern meander flows through and alongside a significant amount of public land. The Davy Crockett National Forest counts more than fifteen miles

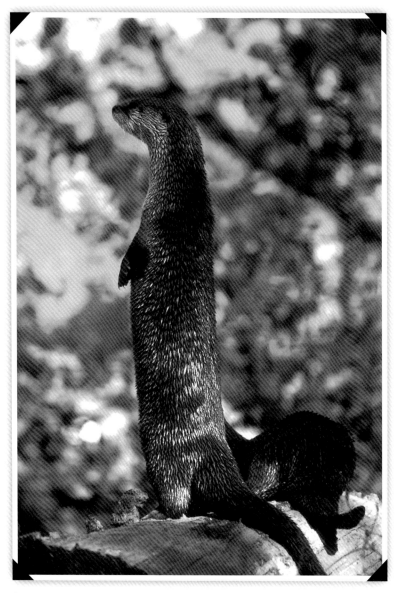

Otters are again present in significant numbers along the Neches
River. They were trapped almost to extinction fifty years ago.
These two are playing on a log beached along the water's edge.
(Connie Thompson, Pollok)

of frontage on the river. Farther south, the Angelina National Forest adds another 9.2 miles. But large timber companies, or forest products companies, as they prefer to be called, own by far the majority of the Neches' riparian margin. A scenic designation would allow these companies to keep their land for timber production rather than having it condemned to serve as a basin for a 126,000-acre lake that is not needed.

Much of the credit for the river's robust ecosystem rightfully resides with these forest products companies. Their vast land holdings provide many benefits to Texas and Texans, including outstanding scenery, open space, fisheries, wildlife habitat, carbon sinks, and water conservation. If these same lands were carved up into subdivisions, camp houses, and mini-ranchettes, the Texas environment would suffer irreparable loss. Do timber companies make mistakes? You bet they do, but they should be recognized for their good stewardship of this bottomland. True, big sawmills laid waste to the original magnificent Texas forest, but since that early mutilation, many of the companies' actions have benefited the river's woodlands and wildlife.

As painful as it was for my generation and the preceding generation, the closing of the woods into hunting clubs, mostly owned by timber companies, provided many benefits. Primarily, the clubs reduced both legal and illegal hunting pressure on fish and wildlife and gave them the opportunity to rebound. As previously mentioned, the companies played an important role in restocking deer and wild turkey. The closing of hundreds of old roads leading into the forests significantly reduced the disgusting practice of using the forest as a dumping ground for household garbage, old cars, dilapidated furniture, and other refuse.

Both the forest products companies and the U.S. Forest Service stress the important role of "management" in their stewardship of the land. However, some people have described the management practices applied here in the bottomlands as "benign neglect" or simply getting out of the way and letting nature take its course. Whatever has occurred over the past eighty years has shown that, given time, the land will restore

itself and sustain the wildlife that lives on it. However, there are worrisome signs that changes may be forthcoming. The small acreage clear-cuts, logging roads, and heavy thinning I have seen in the hardwoods along the river were a surprise and may portend a change in the way these bottomlands will be managed in the future. These woods may look vastly different at the end of the next eighty-year period.

Presently, the number of plant species growing along this river is truly astonishing. Scientists tell us there are at least 189 types of trees and shrubs, more than 800 herbaceous plants, 42 kinds of woody vines, and 75 grasses that draw their sustenance from the Neches watershed. All of these plants are important to the web of life, but the health, age, and quantity of oaks have been my chief concern. Oaks provide the most widely used source of food for North American wildlife. Long ago, someone penned the couplet: "Large streams from little fountains flow. Tall oaks from little acorns grow." I recently read an inspired sequel to it in *National Wildlife* magazine: "From tall oaks billions of acorns fall. And creatures wild will eat them all." In a good mast year with plenty of rainfall, the acorn crop in a healthy forest of oaks can approach seven hundred pounds per acre.

Birds and animals of an astonishing assortment are linked in some way to the generous oak and its rich bounty of acorns. Acorns are a significant staple for wild turkeys, wood ducks, mallards, and blue jays. Acorns typically make up at least 25 percent of the diet of squirrels and raccoons and would likewise do so for black bears if we are ever again fortunate enough to have bears in the region. White-tailed deer eat little other than acorns when they are available. For many animals, an ample supply of nuts can be the difference between living and starving to death in winter. It is easy to see that even a slight shift in the abundance of oaks would alter entire wildlife communities.

The Neches is supporting a healthy wildlife population today. We can only hope the oaks will be allowed to continue to grow so that billions of acorns will continue to fall, and creatures wild indeed will eat them all.

Forks of the River

LONG EVENING SHADOWS are slanting across the river as I settle into the canoe and begin to ply the paddle. It's time to look for a campsite for the night, so I angle for a sandbar visible downstream. As I pull close to shore and round the bend, I am within seventy-five feet of a six-foot alligator lying on the sandbar. Another fifty feet downstream, a five-foot 'gator lies on a log. They both splash into the water as the canoe approaches. I seek a campsite elsewhere.

The canoe parts a path through a sheen of golden-green algae blooms as I approach Route 255. The algae have been present on the surface of the water for a mile or more, but now they cover the entire river as far downstream as I can see. It is 4:30 P.M. when I paddle through the shadow as the bridge passes overhead.

A short distance below the bridge, I make camp at a little-known Texas Parks and Wildlife boat ramp and have a bowl of Fantastic Cajun Rice & Beans. It will probably be a long time before I have a desire for any more dehydrated foods. It seems strange that this boat ramp shows so few signs of use. One would think there would be a great demand for a ramp at the north end of the lake. After a little exploring and looking, I can guess the reason: the dirt road leading to the ramp is narrow and rough and appears to have the potential for being slick and muddy during rainy periods.

Temperature at 7:00 P.M. is 57 degrees. The cool night air settles around the tent as I zip the sleeping bag and position the small pillow. This is superb weather for camping. It is not cold—just cool enough to be comfortable.

Temperature at 7:00 A.M. is 37 degrees. Last night's sky was clear with a brilliant moon. Today begins with beautiful morning sunshine and a cool nip in the air. The sounds of roosters crowing and dogs barking echo through the woods from the riverfront clubhouses and residences that I passed yesterday near the Highway 255 bridge. A considerable amount of splashing in the water took place during the first couple of hours after dark. It could have been alligators, beaver, otters, or perhaps even gars fishing near the surface. Whatever it was, there was an extraordinary amount of activity.

The thin tent is again soaked with condensation inside and out. Water dribbles everywhere when I bump the canvas. After slipping my feet into the cold, wet sneakers, I light a fire and make coffee. The dark black brew tastes so good and feels good on my throat.

The soggy tent squishes as it is folded, and my sleeping bag and pillow are damp. Once everything is packed, it is easy to carry the gear down the narrow boat ramp to the canoe. It is always exhilarating to push away from the bank first thing every morning. This morning, however, I am pensive with the thought that I have just spent my last river night of this expedition. I'll be glad to be home in a day or two, but I will always treasure this special time on the Neches. There is not a ripple in the water as the canoe slices effortlessly through it with every stroke of the paddle. The hardwood trees growing along the reservoir-influenced water's edge continue to show their advancing autumn hues as they accept the approach of winter.

A great blue heron issues a *cronk, cronk* of irritation at the approach of my canoe, then, spreading its tremendous wings, gracefully lifts into the air.

Numerous clubhouses and residences line the riverbank. One frame house of early Texas architecture catches my attention. It is unpainted, and two stovepipes protrude through the roof. Blue

smoke curls gently upward from both pipes. It just looks cozy, nestled there by the river. Three large dogs come tearing out of nowhere and stand barking at the water's edge until I am out of sight.

They look a little like the dogs Boy Dykes had back in the Best Bend area. Dykes had a high wooden yard fence around his house deep in the Neches woodlands. Inside that yard were three or four of the toughest-looking, meanest-sounding dogs I ever saw. I would not have stuck my foot through that gate if a bear had been after me. I would have taken my chances with the bear. They were good dogs. When "Uncle Boy," as most folks called him, hunted, the dogs hunted. When he was after hogs or cows, they had their minds on hogs and cows. But a visitor had better not go into that yard unless someone from the family walked out to the gate and walked back to the house with the guest. It was the same when one left. Dykes and his Indian wife and daughter lived more from the bounty of the river and forest than anyone I ever knew.

Yellow signs begin appearing on either side of the river and tell me that I have entered a state wildlife management area. This is Forks of the River country. The federally owned area, managed by Texas Parks and Wildlife, is all that remains of the vast hardwood forests that stretched between and beyond the confluence of the Neches and Angelina rivers. Flanked on the west by the Neches and on the east by the Angelina, and bisected by Bee Tree Slough, this watery Eden may be the most wildlife-productive real estate remaining in the state.

The Forks of today are only a snippet of their once pristine grandeur. This wild place was the northern limit of an almost impenetrable area known as the Big Thicket. The 1936 Biological Survey noted that the thicket extended southward from near Lufkin to Beaumont and westward from the Sabine River to just beyond what is today Interstate 45. The Big Thicket also forms the western boundary of the great southern mixed forest that scrolls across the belly of the North American continent from Virginia to Texas.

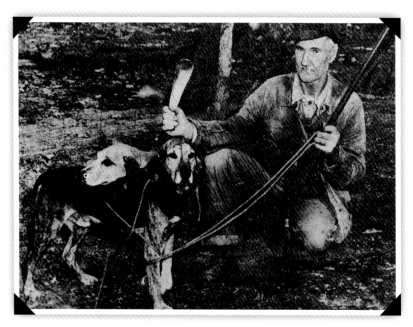

"Uncle Boy" Dykes of the Neches River Best Bend poses with his blowing horn and two of his acclaimed dogs. Dykes disdained tents and covers. When camping on wintry nights he would rake the campfire aside, pull his coat tightly around him, and lie down on the warmed earth. Once comfortably settled, he would call his dogs to snuggle up close to him. He would be asleep in minutes. (Beth Runnells, Zavalla)

Today's Forks still present a splendid glimpse of how millions of acres of Texas' virgin hardwood bottomland forests must have looked before farms, sawmills, towns, reservoirs, and loblolly pine plantations altered them over the past hundred years. Protected by swamps, sloughs, and the spillover from the exuberant joining of these two rivers, many of this forest's age-old cypress, hickories, gums, and water-loving oaks never felt the bite of the lumberman's axe.

Prior to the building of the two dams, Dam B in the early 1950s and Sam Rayburn in the mid-1960s, the rivers' waters ebbed and flooded in this region according to the rainfall upstream. Occasionally only one river would slosh out into the

woods and swales; but more often than not, both would wash over the land at the same time. As these silt-laden waters pulsed and sojourned across the flat landscape, their current diminished enough for their loads of silt and rot to be deposited in rich layers on the forest floor. These regularly occurring overflows are vital to the ecosystems that are the rivers' companions from their headwaters to the bays and estuaries along the Gulf of Mexico. When the floodwaters recede into the river channels, they bring with them crud and filth collected but diluted beyond harmfulness. No other natural system provides a more efficient or effective method for filtering and neutralizing pollutants. Any human action that interrupts the frequency and cycle of this flooding and withdrawal is fatal to bottomland ecosystems.

Now only the silt-laden Neches runs unfettered to the Forks. The clear, placid Angelina flows obediently in its channel for most of the year, its docile waters responding to the commands of the U.S. Army Corps of Engineers. Meanwhile, its cargo of rich nutrients and our pollutants gather in sheets of increasing toxicity below the surface of Sam Rayburn Reservoir.

The array of plant diversity here still makes it a forest buffet for many different kinds of birds and animals. Oaks—swamp chestnut oak, overcup, willow, laurel, cherry bark, and white oak, and of course water oak—are here in great numbers. Perhaps no other design in nature illustrates the relationship of wildlife to a particular food source better than does the attraction of wood ducks and mallards to acorns that fall from bottomland hardwoods. Wood ducks, among the most beautiful of all ducks, and mallards invade these watery woods by the thousands every year.

The ducks first brought me to the Forks of the River. The occasion was a high school boys' outing where a passion for forests, rivers, and things outside exceeded prudence and common sense. It was a cold January, and if my memory is correct, Tracy Armstrong's dad hauled several of us and our gear as close to the river as he dared drive his blue 1950 Plymouth sedan. We were to get back home any way we could.

Darkness comes early in a January river bottom. We selected a small opening and set up camp as quickly as possible. Tents and sleeping bags were beyond our economic reach, but we did have two tarpaulins and several homemade quilts. We stretched one tarp across a small sweetgum sapling ridgepole no more than three feet above the ground. The other tarp we used as a ground cloth to sleep on. For added insulation, we broke off green pine boughs and piled them on top of the tent.

A cold gray mist had begun to fill the air by the time our sleeping shelter was finished. There were enough dead limbs lying around on the ground to provide ample firewood, but they were wet and unsuitable for kindling. We quickly set about breaking twigs off the downed limbs and piling them in front of the tent until we had accumulated a pile about the size of a bushel basket. We then heaped the wet limbs on top of the pile of twigs. With what we thought was cutting-edge technology, Tracy snapped the top off a railroad emergency flare and shoved the spewing, crimson torch into the center of the pile. In seconds we had a roaring bonfire.

The mercury was down well into the twenties when daylight broke the next morning. We quickly donned our hunting clothes—basketball warm-ups and Converse athletic shoes—and fanned out into the surrounding woods of towering oak trees. Long fingers of backwater crisscrossed the landscape. Ducks! I have never seen so many ducks. It seemed that almost every backwater slough we approached unleashed swarms of these beautiful birds into the overreaching limbs of encircling trees. The noise they made as all at once they leaped from the water into the air, squealing and flapping their wings, was indescribable. Sometimes we would just stand astounded and behold the spectacle of the moment.

It was the acorns, of course, that brought the ducks to the Forks. The ground was covered with a carpet of acorns, and a floating mat of the shiny little nuts covered the surface of almost every body of water. Occasionally, in places where the backwater had risen and fallen, or at places of water current, piles of

acorns had drifted into long rows as if some mystical plow had furrowed them there.

We remained camped in that spot for three days before some other hunters ventured in, and we were able to hitch a ride out. The weather was bitter cold throughout. The mercury hovered below freezing most of the time. Every night, except for the first night, it dropped into the teens. Tracy and the others— Milton Hudspeth, Kenny Meyers, and Mickey Kitchens, I think they were—will remember how cold we were. More than that, each will have vivid pictures indelibly etched in his memory of the sights and sounds of those hordes of ducks taking wing through the cold, wet woods.

Today, the land of the Forks is much the same as it was then except for the lake's margin. Some of the trees around the edges of B. A. Steinhagen Lake have died from suffocation; they could not tolerate the long periods of saturation. Other trees succumbed, especially the ones closer to the Angelina, because their need for periodic flooding has not been met for years. Where the forest has been adversely affected by manipulated water regimes, understory invaders now block the view of what was an open hardwood forest. The watery channels, fingering inland from the reservoir, are today choked with water hyacinths and other aquatic weeds.

Move inland just a few yards from the reservoir's skirt, and little has changed in fifty years. Foresters and wildlife biologists would describe this as a mature hardwood forest with crown closure. The crown closure, or overstory of leaves and limbs, is so dense that little or no sunlight reaches the forest floor. Any light that does reach the ground is so cleansed and purified by its passage through countless leaves of green that almost no plants can generate enough energy to sprout. When an opening does appear in the forest crown, whether by lightning strike, windstorm, or perhaps a tree's death from old age, new life springs from the ground to drink in the sun's rays and quickly colonize the new opening. As time passes, only those sprouts that are strategically located and that can prevail over intense competition will mature to cast their progeny of acorns for future generations of ducks,

turkey, deer, squirrels, and black bears. These shifting mosaics keep the forest vibrant and productive.

The continuing abundance of mast, cover, and water and the absence of human intrusion make the Forks one of the primary wildlife breeding areas in the state. The best hope in the eastern half of Texas for seeing a black bear in the wild may begin right here in this plenteous land between the rivers.

A 1998 Texas Parks and Wildlife study, "Suitability of Habitats in East Texas for Black Bear," identified the middle Neches corridor as possessing the highest "Habitat Suitability Index" of any area in the entire eastern part of the state. From the Forks, ideal bear habitat follows the Neches Valley northwestward through Longleaf Ridge, Upland Island Wilderness, and up-river as far as U.S. Highway 59. There is little doubt that tourists would flock to the region hoping for a momentary glimpse of one of the black bruins.

But this wild place, like several other locations up and down the river, is at great risk. The Lower Neches Valley Authority, with its seemingly insatiable appetite for water to sell, has the Forks dead center in its crosshairs. The agency is already developing plans and marshaling its political muscle to increase the height of Dam B, which creates B. A. Steinhagen Reservoir. The present 13,700-acre reservoir has a top-of-dam elevation of ninety-five feet above sea level. The two options LNVA is pursuing call for raising the height of the dam seven feet to achieve a 21,860-acre reservoir or twelve feet to achieve 31,105 acres.

Either of these options, if executed, would effectively destroy the Forks of the River, Martin Dies Jr. State Park, three Corps of Engineers' parks and campgrounds, and thousands of acres of bottomland hardwood habitat.

The damage to people, wildlife, and forest by any of the proposed dams and reservoir projects is not confined to the harm imposed on the upstream landscapes. There is a harsh price to be paid downstream, too. The altered water flows imposed by dams would adversely impact the Big Thicket National Preserve and the eighty-five-mile Big Thicket Neches River Corridor. The

ecosystem of Big Thicket National Preserve's botanical wonders is dependent on the ebb and flow of the river. Altered water regimes would affect the nutrient-rich overflows necessary to flush and refresh the sloughs, oxbow lakes, and forest floor. Water temperatures would rise, and the floodplains would contract as water-dependent plant species succumbed and were replaced by more drought-tolerant plants. This upheaval, in turn, would deprive water creatures, birds, and animals of their essential habitat.

Farther downstream, at the river's mouth where it empties into Sabine Lake and the Gulf of Mexico, commercial fishing and shrimping industries depend on freshwater inflows into coastal estuaries to reduce salinity and to feed nutrients into the spawning areas of marine species. The multimillion-dollar recreational fishing industry would be irreparably harmed by the degradation of the river and its water environments.

If we have learned anything from the exploitation of our world over the past hundred years, it is that the remaining places like the Neches must be managed for the mutual benefit of all, not for the enrichment of the few. An observation I saw in *American Rivers* magazine has bearing here: "Once the last tree is cut and the last river poisoned, you will find you cannot eat your money."

Journey's End

THE RIVER HAS BECOME the lake. The paddle is my sole means of propulsion since there now is little, if any, current. A dozen mallards lift off the water as I approach the mouth of Bee Tree Slough.

Chinese tallow trees grow on almost all of the available land in and around this part of the lake. Every bit of land one inch above the water seems to be covered with them. Some of their leaves are beginning to turn flaming red, purple, and orange. The cypress trees are adding their autumn hues to the bouquet as well. In a couple of weeks, a boat ride on Steinhagen Lake will be a cool and colorful fall outing.

Alligators were the show today, twenty-three of them. I saw almost all sizes: small, medium, and large. Large, as in very big. One lying on a sandbar had to be seven feet long. Another I saw swimming could easily have been ten feet long. Alligators are cold-blooded animals and seek warm, sunny spots when not hunting for food. As I approach such spots, I hug the shore closely enough for them not to see the canoe until it is within a few hundred feet. They can move with unbelievable speed and make a terrific splash when they hit the water, thrashing their great tails.

These scaly reptiles do not realize their good fortune in never having crossed trails with Denzil Shives. Denzil—"Dinky" to those who knew him well—was one of the old ones; not at the time old in years but just of the old ways. He was a true river bottom stockman, and a good one. His hogs and cattle roamed the bottomlands along Shawnee Creek down to the river.

The year was about 1952, and Dinky had slung a saddle on his horse and had ridden down the creek to check on his livestock. He probably had a few ears of dried corn that he would dribble out to his animals to keep them at least semi-domesticated.

Suddenly, he heard hogs woofing and squealing in the distance. Dinky touched the rowels of his spurs to his horse and rode to investigate. He arrived at the creek to find hogs bunched together, facing a big alligator with a hog in its jaws. As soon as the big reptile saw the man on horseback, it disappeared beneath the waters in a deep hole in Shawnee Creek. Denzil waited for the big alligator to resurface, but it somehow evaded him. Well, there are more ways than one to neutralize a hog-eating alligator.

He remounted, returned to his barn, and picked up a stick of dynamite, a fuse, and a detonating cap. The explosive probably came from the crew of stump blasters who were in the area blowing rich lighter, or fat pine, stumps out of the ground. The stumps were hauled to DeRidder, Louisiana, where they were processed to extract a whole array of chemicals. Armed with the explosive and with his young son Doug, two nephews, and a neighbor in tow, Denzil returned to the 'gator hole. A quick survey of the creek revealed nothing; so the fuse was lit and the dynamite was tossed into the creek. The dynamite disappeared into the dark water and emitted a stream of bubbles for what seemed a long time. When it blew, the water boiled and leaves and muck that had been lying on the bottom for ages roiled to the top. But no alligator. Then, as they stood there and talked, the nostrils of the 'gator broke the surface as it slowly made its way to the bank. The men stood and watched in amazement as the animal, barely alive, crawled slowly out of the water and died.

Someone in the group threw a noose around the leathery snout and dragged the animal out to a place where it could be tied to the top of Kerlon Shives's 1939 Ford sedan. I happened to be present at Frank and Louise Mott's service station when the group brought the eight- or nine-foot alligator into Zavalla.

As I ply the paddle back and forth through the water, the river increasingly takes on the appearance of a large lake. Ducks jump up and fly overhead. A couple of times men zoom by in powerful boats; their wakes slap ominously against the sides of the canoe. The cresting waves lift the craft high before dropping it into a

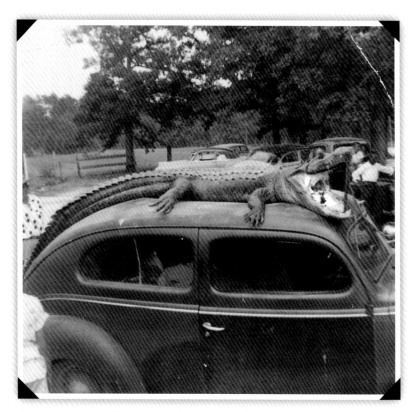

*The big hog-eating alligator stretched along the top of Kerlon
Shives's 1939 Ford was killed by Denzil Shives with a stick
of dynamite, about 1952. Those present for the photograph
were Douglas Shives, Preston Grimes, and Melvin, Kerlon, and
Denzil Shives. (Kerlon Shives, Zavalla)*

trough, almost capsizing it. Then, far to the south, I glimpse the
old Highway 190 bridge. With each stroke of the paddle, the
rusty bridge grows closer.

The entrance to the Highway 190 bar ditch where I learned
to water-ski forty-six years ago is hard to find. Paddling against
the wind and trying to locate the bar ditch and campground that
adjoins it exhausts what little strength I have left. The plan is to
spend one night at Martin Dies Jr. State Park, just west of the
boat ramp. Imagine my surprise when I beach the canoe and see

the sign: "For Day Use Only." What a blow! Where is the campground? It had better not be far; I am exhausted. Poor planning can sometimes lead to unpleasant consequences. More fool me for not scouting the park in advance of the expedition.

A Texas Parks and Wildlife truck is parked near the washrooms. A man is loading his tools, preparing to leave. I hurriedly approach and ask if I may camp there for a night. I don't know that I have the strength to paddle into the wind coming across the lake, even if he can tell me how to reach the campground. The man is Jerry Morrison, who patiently listens to my story and then suggests a pickup ride to the camping area for me and my gear. What a friendly thing to do!

Martin Dies Jr. State Park is one of the top state parks in Texas. The scenery is spectacular. The panorama of the smooth waters of the lake dotted with cypress trees is special, but my even greater pleasure is the remarkable trees that fill the campground and surround the lakeshore. The campground is a microcosm of East Texas trees. Great swamp chestnut oaks, magnolias, white oaks, black gums, and towering pines are visible from all campsites. Many trees are dripping with Spanish moss. Cypress trees grow in and along the inlets that finger back into the camping area.

The facility is clean and well tended. Lakeside campsite number 44 on the water's edge and near the boat ramp is where they put me. Jerry kindly helps me unload the canoe onto the carpet of green grass that borders my campsite. I thank him again for his generous help before he gets into his truck and drives away. The first task is set up the tent to let it dry.

After the damp sleeping bag is spread over the picnic table, I survey the canoe and its contents. The inside of the craft is cleaner than at the end of any other day of the trip. There have been no portages around muddy root balls and no overhanging limbs dislodging showers of leaves and debris into my face and onto the gear as I push through. Every time I have stepped from the canoe in the last two days, my feet have been planted on either sand or rock, not slippery mud. The five one-gallon

milk jugs that have held my tepid water supply for the past three weeks are stuffed into a garbage bag for the trip to Lufkin's recycling center. The two buckets that hold the few remaining cups of dry noodles, granola bars, eating utensils, and propane burner are lifted onto the picnic table. Grasping with both hands Ed Furman's bent-shaft paddle that has served me so well, I make several long pulls through the air. I must remember to return the paddle to Ed soon.

The exhilaration I have felt since first seeing the rusty bridge on Highway 190 seems to evaporate, and a strange sense of melancholy settles over me. My eyes sweep the wide, placid waters of B. A. Steinhagen Lake. The river is nowhere to be seen. The finality of the moment sinks in; the journey of a lifetime has ended. There will be no more feelings of keen anticipation of new discoveries that wait just around the next bend. It is a surprise to realize that I am really sorry it's over. But then a cheerful thought brings a smile to my heart. We have succeeded in our mission of calling attention to the treasure that is the Neches River. If I had the opportunity, I would do it all over again. Filled with the warm glow of renewed satisfaction, I light the burner and start a pan of water to boil.

"Red sky in the morning, sailors take warning; red sky at night, sailors' delight." I grew up hearing one form or another of this old adage. Its origin goes back to before Christ. Sailors must be delighted tonight. The western sky is a big splash of red. Several more days of fine weather lie ahead.

The hot chocolate tastes good as I sit and slowly sip it and watch night fall. The sun moves quickly. One doesn't realize it during the day, but from the time the bottom of that big orange orb first touches the horizon, it takes only five minutes before it disappears and another day is gone.

An armadillo appears from nowhere. It ambles here and there, rooting up the neatly mown grass along the water's edge. Suddenly, as if it has someplace important to go, it scurries off into the gathering dusk.

Conclusion

My conception of liberty does not permit an individual
citizen or a group of citizens to commit acts of
depredation against nature in such a way as to harm the
future generations of Americans.

—Franklin D. Roosevelt

EACH OF US HAS A SPECIAL PLACE that frequents
our thoughts. It may be a cooling river in the Hill Country, a
wide beach on the Gulf shore, a favored birding spot, or a place
high in the mountains. Perhaps it is a jogging trail in the shadow
of downtown skyscrapers or just a shady nook in the backyard.
Wherever they are, these places rescue our frayed spirits and give
us strength to continue to be strong, happy, and productive in
this busy world.

I have just revisited my special place after years of self-exile. The
Neches River, home of the largest contiguous wildlife habitat
corridor remaining in Texas, is even more serene than I remem-
bered. Few of us have time to spend three weeks doing nothing
but canoeing, camping, and reveling in nature's treasures. I know
that I am truly blessed to have had this experience.

The Neches belonged to me for most of the trip. I saw fewer
than half a dozen hunters along the entire route and encountered
only seven people fishing until I reached B. A. Steinhagen Lake.
I would have had it no other way. Wildlife provided a pleasant
reminder that the woods, water, and air were filled with wild
creatures. Hawks and crows usually ushered in the first rays of
morning light. The whistling chatter of squirrels and the snorts of
startled deer accompanied me as I paddled, pushed, and pulled
the canoe downstream. Sometimes it seemed that the squeals
of flushed wood ducks awaited behind every bend in the river.

Egrets, herons, and kingfishers were commonplace. Periscope eyes and snorkel nostrils, barely visible above the surface of the water, were frequently all that betrayed the presence of an alligator.

As I camped under skies studded with a billion twinkling stars and a gleaming moon, the nocturnal creatures gave a voice to the night. The hoots and shrieks of the barred and great horned owls regularly mixed with the yips and mournful howls of coyotes. At times, it seemed there must be a million frogs and katydids singing in chorus. But it was the times of silent solitude that stirred my soul. Mornings, just before dawn, were almost always quiet; but on several occasions, for which I have no explanation, the entire night would be eerily devoid of sound. The usually cheerfully murmuring river seemed to sense these moods and would glide silently between muffled banks.

This great river, by the providence of admirable stewardship by most of those who own the land adjoining it, is in the same league of wild beauty as far places profiled in *National Geographic*. Ironically, the Neches is forgotten terrain although within easy reach of the major population centers of Texas. It is nothing short of miraculous that this narrow ribbon of life has escaped the machines of economic growth and has survived virtually intact into the twenty-first century.

If I learned anything on the trip, it is that water is the very essence of life. If a magic elixir is ever found on this earth, it will be found in water. Texas faces a host of economic, ecological, and environmental issues in the twenty-first century. But no single issue will be more important than the sensible allocation of the state's underground and surface water resources. The capture and distribution of water supplies will be the ecologically defining issue for much of the next century. We are told, and readily understand, that water is essential for human health, economic growth, and quality of life. We need to remember also that our well-being is intricately linked to the well-being of the plants and wildlife around us. The ecosystem that supports us is the same ecosystem that sustains the plants and wild things we love, enjoy, and require.

Over the past half century, soaring population growth and the water demands arising from that growth have produced a building boom in dams, reservoirs, and other water-related projects. These water projects come with a huge financial, social, and ecological price tag. Many of the state's once bountiful springs no longer flow; their underground aquifers have been pumped too low. Dams and diversions have altered rivers and deprived wetlands of seasonal flooding. Some rivers no longer transport their age-old cargo of minerals and decaying vegetative matter to coastal estuaries, and loss of these contributes to the decline in the commercial fish and shrimp industries. Equally critical, the diminished water flows are insufficient to provide the delicate balance of fresh and salt water so essential for the reproduction and early development of hundreds of species of fish and shellfish.

In addition to the Sam Rayburn Dam and Reservoir on its tributary, the Angelina River, the Neches River is already held hostage behind two dams, Blackburn Crossing Dam at Lake Palestine and Dam B at B. A. Steinhagen Lake. Between these two dams flow the 235 miles of virtually untrammeled river I have just traversed. If the water sellers have their way, this last wild stretch of river will eventually disappear beneath at least three new impoundments: Fastrill, Rockland, and the Dam B expansion.

Not all costs associated with these water projects are environmental. In addition to the huge monetary costs to taxpayers, such projects entail loss of jobs and raw materials, and entire industries suffer financial loss. The multimillion-dollar coastal fishery, both commercial and recreational, faces potentially devastating financial impact if freshwater flows continue to be reduced. The timber industry has already been hard hit. New dams mean thousands of additional acres of timberland that afford jobs for loggers, truckers, paper mills, and sawmills will be submerged under giant reservoirs. Farmers and cattle growers will see their pastures and hay meadows disappear beneath the drowning waters. Operating in reverse, so to speak, the multiplier

effect spreads the damage to an almost unending list of economic victims. People will also have their homes, cemeteries, and heritage stripped from them, costs that cannot be measured in dollars and cents.

"Why are you concerned with what happens to that river? Why do you want to save it?" some ask. "You don't fish or hunt," others say. In a 1986 conversation, old man Dudley Denmon, once a stockman, trapper, hunter, and fisherman of the Jasper County open range bottomlands, answered a similar question with the following response.

"I'm gonna tell you something. Anything that's an interest and a benefit to the children of this earth, the ones that's here, the ones that's growing up—it's a dirty shame for people to disregard and disrespect the creation of all these beautiful things that have been made, that people have privilege and opportunity to use, during their trip on this planet. They should think about them little fellows that is coming up and allow them the same privilege. If we don't respect this stuff and defend it, they won't never know. They'll just say: 'There ain't no more of that. That's just an old story told by some of the old generation.'"

Dudley Denmon was not well educated as we measure learning. His wisdom derived from the natural world in which he lived. He accepted that the human species has an obligation to leave at least a fragment of created things for the future generations inhabiting this planet. He understood that our environmental problems are of our own making and that we can stop making them if only we will exert the political will. We must become the change we want to see.

My canoe expedition down the Neches was an incredible experience. A couple of times during the first week, I thought I might not make it, but the trip was worth every bit of effort. I canoed through some of the wildest country left in the state and floated past many ghosts along the way. The Caddos, Cherokees, and Shawnees solemnly raised their hands as the canoe slipped by. The stooped and bent Spanish friars made the sign of the cross. I heard the baying of dogs, the shouts of men, and the crack of rawhide whips as hogs and cattle were brought out

of the thickets for slaughtering or marking. Finally, there was the *swish, swish* of hard metal against soft wood, followed by the crashing thud of breaking limbs and three-hundred-year-old trees striking the ground. Amidst this din came the lowing of oxen, the cursing of men, and the familiar crack of the bullwhip. The shrill whistle of a steam locomotive could be heard as the engineer blew it to clear the tracks.

It was all there. I saw it and heard it. I shall never forget the sights, sounds, and scents of the Neches. They are part of me.

Epilogue

THE VIEW FROM THE WINDOW of my loft office is a brilliant splash of color. The autumn slant of the morning sun accentuates the array of color that shortening days and cool temperatures have produced on trees and native shrubs surrounding our home. Red maples, awash in warm solar rays, shower their fuchsia leaves airborne with every waft of breeze. Multicolored sweetgums vary from pale yellow to vermilion, and the leaves of white oaks, always among the last to change, cling to their branches in blends of green and crimson. The temperature outside is no more than 60 degrees. In almost every way, today is a replica of those days spent on the Neches River Canoe Expeditions of 1999 and 2001.

The public response to the 1999 trip was so positive that we thought there should be a second expedition to capitalize on the momentum of the first. The objective continued to be to get the river's story to as many people as possible. The experience of the first journey made us comfortable in issuing an invitation for the public to join us as we paddled downriver. In the fall of 2001, we arranged a schedule of estimated times we would reach highway crossings to allow river protection enthusiasts to link up with us. The schedule also enabled our publicity coordinator to plan media events that were more successful than we could ever have dreamed.

The metropolitan Golden Triangle region of Beaumont, Port Arthur, and Orange, with tens of thousands in population, is an important constituency of the river we are trying to save. Much of the area's industry and commerce is clustered near the mouth of the Neches. To reach that audience, we decided to extend the 2001 expedition an additional eighty miles to a terminus at Collier's Ferry Park in Beaumont.

As time-sensitive plans were developed, it became apparent that a publicist-coordinator would be essential. Janice Bezanson, executive director of the Texas Committee on Natural Resources and a voluntary member of our communications team, persuaded my daughter Gina to assume this task. She was a wonderful choice and did an excellent job.

In spite of the problems presented by low water flow in October of 1999, we again chose early autumn to begin the second trip. Cool evenings, few bugs, ideal campsites, and—unless a hurricane came prowling into the Gulf—lots of sunshine made the harvest season a time to enjoy the great Texas outdoors.

The weather for the October 22 launch beneath the U.S. Highway 175 bridge north of Jacksonville was superb. Gina chatted with KTRE-TV producer James Doughty and others before stepping into her Dagger Sojourn canoe to join me for the first five days. She would need to leave the river at U.S. Highway 294 to prepare news releases and finalize arrangements for a number of canoeists to join the expedition at Anderson Crossing in Houston County.

Karen Loke, video news director for the Texas Parks and Wildlife Department, was waiting for us as we approached the U.S. Highway 79 bridge. She spent two days and a night with us. We carefully stowed her gear, including an expensive video camera, into my canoe and pushed out into the softly flowing current. Karen was a good sport and did her share of paddling, besides shooting numerous rolls of film. The thing I most appreciated was that she did not hesitate to help drag the heavily loaded canoe over logs or to slosh through shoe-top mud.

Our camp that evening was at the picturesque concrete weir and waterfall at Rocky Point in Anderson County. After we ate, Karen set up her camera and a couple of small floodlamps. Gina and I sat in front of the whirring camera, sipping hot chocolate and talking about the river for what seemed an hour before we crawled into our sleeping bags and were lulled to sleep by the sound of water tumbling over the weir.

The following day Karen used the last of her film and record-ed some for me on my little 8 mm Sony Handycam. About the middle of the afternoon we rounded a bend in the river and saw the U.S. Highway 84 bridge and, beside it, the white Texas Parks and Wildlife Department van with the huge red, white, and blue Chevy logo emblazoned on its side. Karen's driver was waiting to pick her up for their return to Austin.

The next two days passed quickly. Gina stayed about a hun-dred yards ahead of me so that she could enjoy the experiences of happening upon wildlife. She was thrilled to come upon a doe deer and her spotted fawn standing on a slope by the river. Gina grasped a limb in the middle of the river to avoid floating too close and frightening the animals. She waited for me to join her, and we both watched the doe and her fawn leap into the water and swim across to the other side.

Jim Lemon from Nacogdoches, waiting to join me at the U.S. Highway 294 bridge with his canoe, was a pleasant surprise. Gina drove his truck to her home, where she e-mailed progress reports and made media plans. Jim was welcome company and camped two nights, leaving me at the Old King's Highway (Texas 21).

I arrived at Anderson Crossing two days after Jim's departure, popped my tent on a little straw-covered hill, and waited there for the canoeists and kayakers who were to join me the following day. I did not have to wait long. My tent was no sooner up than a Lufkin father-and-son team who had launched at Highway 21, unbeknownst to me but just minutes behind, beached their canoe on a sandbar across the river.

By 8:00 A.M. on October 31, the crowd began arriving in pairs and groups until we numbered fifteen or twenty. Among those present were Lufkin's mayor, city manager, and the director of the city's convention and visitors' bureau; camera crews from Beaumont's KTRM (Channel 6) and KBMT (Channel 4); and Christine Diamond, staff writer for the *Lufkin Daily News*.

Now I really had something to worry about. The camera equipment carried by the TV reporters was huge and looked expensive, causing me no little concern. I could all too easily

envision one of those cameras being dunked in the Neches. The floating press conference and water caravan that began at Anderson Crossing and concluded at the Texas Highway 7 boat ramp was more than I had anticipated, showing just how enthusiastic Texans are for protecting the Neches. In addition to the press already noted, the Lufkin-Nacogdoches KTRE-TV cameras were filming as we slid the canoes onto the grass beside the boat ramp at Highway 7. The three camera crews interviewed several of those who had made the trip from Anderson Crossing, including several teenagers and preteens in kayaks decorated with "Save the Neches" signs.

I was totally unprepared for what happened next. Two men stepped forward, one wearing a wet suit, and introduced themselves as Tony Freemantle, environmental reporter, and Kevin Fujii, press photographer for the *Houston Chronicle*. They announced that they would be accompanying Gina and me for the next four days and nights until we reached the boat ramp at U.S. Highway 59. It was exhilarating to learn that the *Houston Chronicle*, with a circulation of 745,000, was going to help us get out the message from the Neches.

Soon it was evident why Kevin was wearing the wet suit. He stepped over and snuggled down into a short bright yellow kayak not much longer than my paddle. He gave a couple of lurches with his body, and the craft skipped down the grass into the brown water. Then with a few quick paddle strokes, the cigar-shaped craft skittered across the top of the water rather like a whirligig. Before the trip ended, I was to see him do an effortless 360-degree roll with the kayak.

Tony's canoe, a seventeen-foot Grumman loaded with gear and food, was ready to catch the river's downstream current. Tony and Kevin studied the Neches and shared with Gina and me stories of their exciting lives. (My dubious contribution was to introduce them to the grainy taste of wild huckleberries.) Our last night together was spent at the southern boundary of the Davy Crockett National Forest. They built a nice bonfire while I prepared venison sausage and eggs for supper. We sat up late,

telling stories and talking about the extraordinarily beautiful things we had seen on the Neches River.

I was sorry to see them depart at the Highway 59 boat ramp. Gina left also, to prepare for the upcoming media event at Martin Dies Jr. State Park. Gina had given me a message that Park Ranger Terry Lamon, whom I had never met, had called and extended me an invitation to camp on the sandbar beside his riverfront home. I gratefully accepted, and after a delicious meal of fresh collard greens, pinto beans, cornbread, and a meat entree of fried swamp rabbit prepared by Terry's neighbor Glen Hutto, I unrolled my sleeping bag on Terry's screened porch.

In the morning, by the time we finished a delicious breakfast of bacon, eggs, and hot homemade biscuits, again courtesy of Glen Hutto, supporters of the scenic Neches were arriving and unloading their canoes and kayaks into the river. At this point the river had become the north end of B. A. Steinhagen Lake. My companions for the short trip to the state park were from Nacogdoches, Lufkin, and Sour Lake. Maxine Johnston, president of the Big Thicket Association, paddled the canoe with me.

The U.S. Army Corps of Engineers had kept the Dam B gates open for several months, and the lake was almost dry. There were only a few scattered sloughs and ponds of water outside the river channel. Maxine wanted to see an alligator, but the reptiles were not showing themselves. We had almost given up on seeing one when we noticed a three-foot wide opening in the riverbank that led to a small two- or three-acre pond. The opening was just wide and deep enough to permit the canoe to squeeze through. As the canoe broke into open water on the other side, two big alligators were lounging in the shallows. We each snapped several photographs before rejoining our group.

As our small group bumped onto the beach at Martin Dies Jr. State Park, one canoe or kayak at a time, we were pleased to find a crowd gathering beneath a large banner tied between two pine trees. The bold letters on the banner read: "Neches River Canoe Expedition." There was considerable evidence the Big Thicket Association was participating in this media event, too; signs,

maps, and photos were positioned in strategic places, displaying the beauties of the Big Thicket and describing the damage that would befall its flora and fauna if the Neches is dammed or altered.

The assembled crowd was larger than we expected. Numerous residents from Jasper and Woodville, as well as the state park staff, were present to greet us. Newspaper reporters from both the *Tyler County Booster* and the *Jasper Newsboy* were on hand to cover the event for their readers.

Several local members of conservation groups made brief speeches concerning the Big Thicket National Preserve and the procedure necessary for maintaining the Neches River in its free-flowing state. The speakers answered questions from the audience. A few residents took the opportunity to criticize the Corps of Engineers for their mismanagement of B. A. Steinhagen Lake.

When the meeting was concluded and good-byes were said, my family and I loaded our canoe and gear onto the boat trailer for travel to the nearby campground. We were fortunate to secure familiar campsite 44 for another cool, crisp night of camping in the beautiful Martin Dies Jr. State Park.

The following day, after portaging around Steinhagen Lake, I resumed the journey to Beaumont. Each side of the river now bore signs designating the river channel as the Big Thicket Neches River Corridor. The river flows through the Neches Bottom and Jack Gore Baygall units and alongside the Beaumont unit of the Big Thicket before reaching Collier's Ferry Park.

We had plotted the trip's upriver time schedule with amazing accuracy. Downstream from the dam was a different story. By the time I reached the Lakeview community in Orange County, I was two days ahead of schedule. A small National Park Service picnic area and beach provided an excellent place to loaf and wait for two days to pass.

During my two-day layover, the kind and generous spirit of the people who inhabit the entire trace of this river continued to be evident. J. B. Bailey insisted on taking me downriver to his comfortable stilt-legged home set in this low flat land alongside a

river that can stay out of banks and inundate the land for days. I used his telephone and met his family. The next morning he again pulled his motorboat up to my camp, this time with a bag of ice that he suspected I might need. That day Leslie Rhodes and Louis Sheffield were making repairs to park facilities; when lunch time arrived, they invited me to be their guest at the little country café in Lakeview. I readily accepted.

By 8:00 A.M. on Friday, November 16, my companions for the last few river miles of the 2001 Neches River Canoe Expedition had begun arriving to unload their craft and join me. They were a diverse group, drawn here to support a cause they cared about—to preserve the Neches in its free-flowing state. They were from a variety of backgrounds and locations, including Beaumont, Orange, Kirbyville, Nacogdoches, Lufkin, Austin, and Houston.

The huge $61 million saltwater barrier under construction downriver from Lakeview is larger and more environmentally threatening than I had imagined. John Muir's words in *My First Summer in the Sierra* came to mind as we drew close to the barrier: "When we try to pick out something by itself, we find it hitched to everything else in the universe." The three upstream dams that presently hold back the river's flow, the pumping, and the continual dredging of the ship channel are steadily pushing salt water farther and farther inland, destroying native plant, animal, and marine life that depends on fresh water or conditions of low salinity. Now the barrier that will hold the advancing sea at bay will exact its retribution from the land and the things that live there. Where will it stop?

Robert Sloan, outdoor editor for the *Beaumont Enterprise*, met our little armada while we were still several miles upriver from Beaumont. He thoughtfully stopped his outboard short of our group to ensure that his wake would not swamp any canoes or kayaks. We discussed the features of the river, wildlife, and the calamitous effects additional dams would bring to the river and its environs. He snapped several photos. Then, as quickly as he had appeared, he was gone.

As our flotilla approached the boat ramp at Collier's Ferry Park, other canoes and kayaks joined us and extended warm congratulations for our having completed the trip. Our canoes bumped into the boat ramp right on schedule, at 11:00 A.M. *Houston Chronicle* reporter and former river companion Tony Freemantle, a Beaumont KBMT-TV cameraman, and a *Beaumont Enterprise* news reporter were there to greet us as we stepped ashore. James Doughty with KTRE-TV of Lufkin-Nacogdoches was on hand to film the last of a five-part series, "To Save a River." Broadcast weekly, these segments covered the entire expedition from launch to takeout.

Doughty began the series with an evening news preview spot prior to launch and aired in-depth segments each Friday for the next four weeks. The news commentary began with a brief historical introduction to the Neches, then moved to discussing dams, wildlife habitat, population, the need for water conservation, and congressional involvement.

It was a relief to have the canoe strapped to the trailer and to be traveling north on Highway 69 toward home. The weather had been perfect, and I was not as tired as I had feared I might be at the conclusion of the trek. Only twice during the previous twenty-seven days had I slept between sheets. My nights had been spent in the small tent under the stars except for the night I slept on the Lamons' screened porch and two Saturday nights at home.

The success of the 2001 Neches River Canoe Expedition still awes us. News reports continued to appear in the various media for several days after the canoe trailer was parked beneath the big pines at our home. The story "Reservoir Reservations" ran beneath a photo in the November 17 issue of the *Beaumont Enterprise*. Five days later another fine piece, "Canoeing Neches for a Cause," appeared on the front page of the *Enterprise*'s outdoor section. The news photo accompanying that article now adorns my personal memo stationery.

The Sunday, November 18, edition of the *Houston Chronicle* was more than we could have imagined. Freemantle's front-page article headlined "Blazing Paddles" wrapped around Kevin

Fujii's stunning photo of a lone individual in a canoe. The canoe was set in the rippling waters of the Neches, reflecting the orange radiance of a setting sun. The shoreline, trees, blue sky, and clouds above were bathed in hues of red, white, and amber. The photo looked almost like a painting. Tony's article spoke to the issues—damage to the natural world, the state water plan, population, dams, conservation, and the prospects for having the Neches River protected under the federal Wild and Scenic Rivers Act. The article was clear and concise. It put the issues squarely before the people. That was all we had hoped for. The Associated Press picked up the *Houston Chronicle* story and it ran in newspapers over a broad section of Texas and as far away as the state of Maine.

The National Wildlife Federation honored the hard work and dedication of all involved by naming me a "Conservation Hero" for our efforts to protect the Neches River from costly, unneeded dams; our cause was publicized in *National Wildlife* magazine in October–November, 2002. The Lone Star Chapter of the Sierra Club presented me their Evelyn R. Edens Award, for protecting Texas rivers, at their 2002 Annual Awards dinner in Austin on July 19, 2003.

The Texas Committee on Natural Resources contracted with Gina to lead their Neches River Protection Initiative. Promoting designation of the Neches as a Scenic River, she has traveled to Washington, D.C., to meet with U.S. senators and congressmen and representatives of the National Park Service, National Wildlife Federation, and American Rivers. Gina has also met with numerous landowners, forest products companies, the environmental staff of the Alabama-Coushatta Tribe of Texas, Texas state senators and representatives, and numerous others, seeking their support for protecting the Neches. Letters of endorsement for the Scenic River designation have been received from the National Wildlife Federation, American Rivers, Texas Parks and Wildlife Department, Nature Conservancy, Conservation Fund of Texas, Audubon Texas, Big Thicket Association, Sierra Club, and Pineywoods Chapter of the National Wild Turkey Federation.

The fate of the Neches River and the ecosystem that surrounds it rests squarely in the hands of the U.S. Congress. A Scenic River designation would save the river and its wildlife from extinction, not to mention saving thousands of acres of valuable timberland and other private properties. The process for securing Scenic River status begins with a congressional bill, usually introduced by the local congressman and passed by both houses of Congress, authorizing the National Park Service to conduct a study to determine the river's eligibility for federal protection under the Wild and Scenic Rivers Act. If the study supports designation of the Neches to Scenic River status, a second bill must be introduced into the House and Senate for final approval. If that were approved, the Neches would then be removed from harm's way. If not, future generations of Americans will mourn its loss.

The Neches River Canoe Expedition and its accompanying publicity have created an awareness of the Neches River's ecological contributions to the state and its important role in early Texas history. Additionally, government agencies and environmental groups are formulating positive preservation plans that will keep much of the river intact.

A private partnership involving Renewable Resources and the Conservation Fund was formed to purchase approximately 33,000 acres of bottomland along the middle Neches between U.S. Highways 59 and 69, with the intent that the property be used as a mitigation bank to provide environmental credits to entities such as the Texas Department of Transportation. If the mitigation bank is established, the 33,000 acres will be turned over to the Texas Parks and Wildlife Department, which will maintain the land as a wildlife management area and will possibly establish a state park and visitor center where Highway 59 crosses the river.

The U.S. Fish and Wildlife Service is in the exploratory phase of establishing the Neches River National Wildlife Refuge along the northern reaches of the Neches. In addition to providing food, cover, and water for fish and wildlife, the refuge will ensure wintering habitat for migratory birds of the Central Flyway; will protect the bottomland forest for its diverse biological values

and wetlands functions of water quality improvement and flood control assistance; and will provide for compatible wildlife-dependent recreation opportunities for great numbers of people.

Formed in 2001, the Neches River Protection Initiative (NRPI)—a coalition of environmental organizations, business people, landowners, and concerned citizens—has made great strides in educating the public about the threats to the river. As a result of NRPI's informative programs, slide presentations, and canoe trips, area citizens are beginning to see the value and economic potential of this historical natural resource.

Among the NRPI's objectives is to promote the Neches Valley as an eco-tourism destination. The valley offers many opportunities for birding, canoeing, hiking, camping, hunting, and photography. Communities along the Neches are embracing the eco-tourism plan and are supporting projects such as the Neches River National Wildlife Refuge, creation of the Neches River State Park and Wildlife Management Area, and the annual Neches River Rendezvous (a ten-mile canoe trip).

An ominous cloud is now gathering over the Neches River near the cities of Jacksonville and Palestine. The City of Dallas and the Upper Neches River Municipal Water Authority have initiated studies that could lead to the construction of the proposed 32,000-acre Fastrill Reservoir. Dallas currently uses more municipal water per capita than any other major city in the state and would retain 80 percent of the water rights. Yet Texas leads the forty-eight contiguous states in surface water, with 204 major reservoirs. Existing surface and groundwater supplies are available to meet the needs of Dallas beyond the year 2060. This proposed reservoir simply is not needed for water supply. To make matters worse, the reservoir would destroy the Neches River National Wildlife Refuge presently being considered for establishment by the U.S. Fish and Wildlife Service.

Since congressional redistricting and the 2004 elections, new federal and state legislators have taken office and are currently learning of the Neches River Protection Initiative's goal of having the river designated as Scenic under the Wild and Scenic Rivers Act.

The future of the Neches River is uncertain, but with a little bit of luck and a lot of hard work, we can protect the river for future generations of humans and wildlife alike. We must unite as supporters of this unique resource and rally our elected officials to have the Neches designated a national Scenic River.

The Neches, our river, is more than a river. It is a special realm, almost out of place in our urbanized world. So much of the landscape and environment that have made the words *Texas* and *Texan* two of the most recognized words around the world have been obliterated. Almost all the state's rivers have been pumped dangerously low or made into a long series of lakes and ponds. Many of the other places that fostered the mystique and awe of Texas have been crisscrossed with roads, clear-cut, cross-fenced, and polluted. Yet the Neches, an anomaly in the midst of all this upheaval and alteration, still flows for a 235-mile stretch much as it did in the early 1820s when Stephen F. Austin planted his colony a few miles to the west.

All those who have ever known the Neches and its wildness will carry the song of its waters forever in their hearts. Its rhythms beat with the pulse of life and its melody sings of the bond that has always existed between people and the natural world. Will we allow this song to be forever silenced and this incredible river consigned to future heavy-handed exploitation? Or will Texans and Americans see it for the rare treasure it is and rescue it? This river can be saved from the degraded and exhausted fate experienced by so many of our other natural resources—like the Everglades, for instance. Everything seen, heard, and learned on the Neches River Canoe Expedition leads to only one conclusion: the beautiful and wild Neches should be preserved for future generations of humans and the wildlife we enjoy. If it is lost, not for one trillion dollars from the U.S. Treasury could it be re-created.

Further Reading

Most of the incidents and events recorded on these pages came from the dusty recesses of my memory. They are told as I saw them and lived them and, in some instances, as they were related to me. I was fortunate to have caught an ephemeral glimpse of Texas frontier life before the door of that era slammed shut forever. I am grateful also for the writings of others, which made this effort much easier.

The following list of books is suggested for readers wishing to explore the region and related topics:

Abernethy, Francis E. *Tales from the Big Thicket*. Austin: University of Texas Press, 1974.

Ajilvsgi, Geyata. *Wildflowers of the Big Thicket, East Texas and Western Louisiana*. College Station: Texas A&M University Press, 1979.

Fritz, Edward C. *Realms of Beauty: A Guide to the Wilderness Areas of East Texas*. Austin: University of Texas Press, 1986.

Graves, John. *Goodbye to a River*. New York: Curtis Publishing Company, 1959.

Gunter, Pete. *The Big Thicket: An Ecological Reevaluation*. Denton: University of North Texas Press, 1993.

Loughmiller, Campbell, and Lynn Loughmiller. *Big Thicket Legacy*. Austin: University of Texas Press, 1977.

Seale, William. *Texas Riverman: The Life and Times of Captain Andrew Smyth*. Austin: University of Texas Press, 1966.

Sitton, Thad. *Backwoodsmen: Stockmen and Hunters along a Big Thicket River Valley*. Norman: University of Oklahoma Press, 1995.

Sitton, Thad, and James H. Conrad. *Nameless Towns: Texas Sawmill Communities, 1880–1942*. Austin: University of Texas Press, 1998.

Stahl, Carmine, and Ria McElvaney. *Trees of Texas*. College Station: Texas A&M University Press, 2003.

Truett, Joe C., and Daniel W. Lay. *Land of Bears and Honey: A Natural History of East Texas*. Austin: University of Texas Press, 1984.

Index

mergansers, 160

Mexican period, 74, 138, 142–44

Mier y Terán, Manuel de, 142

military training activities, U.S., 173–75

mills: chip, 118–19; paper, 2; pecker-wood, 21–22; sawmills, 21–22, 77, 176, 180, 182

money cave, 142–44

Morehead, "Boots," 169–70

Morrison, Jerry, 207

mosquitoes, 18–19, 42

Mott family and home, *19*

Muench, Roy, 68

Muir, John, 221

mussels, 33–34, *after 48*

My First Summer in the Sierra (Muir), 221

Nacogdoches, 17, 138

National Park Service, 7–8, 9–10

National Wild and Scenic Rivers System (National Park Service), 8

National Wildlife Federation, 6

Native Americans: Alabama-Coush-atta, 17–18; Billams, Chief, 161; Caddo Tejas, 15, 17; central/west Texas mid 1800s, 151; Cherokee, 17, 74–76, 161; Fredonia Rebel-lion, 138–39; immigrant tribes, 17; Killough Massacre, 75; and medici-nal plants, 39, 130; Seattle, Chief, 158–59; Shawnee tribe, 138, 139

native/folk medicine, 39, 56, 130, 165–66

Neal, Lettie, 187

Neches Belle (steamboat), 125–26

Neches Bluff, 76–77

Neches River Canoe Expedition of 2001, 215–23

Neches River corridor: Anglo explora-tion/settlement, 15, 17–20; Big Thicket Neches River Corridor, 202–203, 220–22; eco-geological profiles, 15, 18, 61, 168–69, 172, 184–85; future outlook, 209–13, 224–26; middle river, **72, 120–21**;

naming of river, 17; river course, **16**; upper river, **24**. *See also* channel characteristics

Neches River National Wildlife Refuge (proposed), 224–25

Neches River Protection Initiative (NRPI), 223, 225

Nerren, George, 100

night hunting, 64, 66–67, 132–33

nutria, 37

oak trees, 79, 194, 200–201

obstacles. *See* canoe piloting issues

Old Aldridge, 21, 182, 190

Old Concord community, 19, 20

Old Fort Teran, 142–44, *after 144*

Old River Club, 115

Old San Antonio Road (El Camino Real), 74, 76

open-range livestock. *See* free-range livestock

ospreys, 69

otters, 137, 190, 191, *192*

owls, 86, 134

paddle wheelers, 124–26

paper industry, 2, 119

Parker, Bonnie, *164*

parsley haw tree, 168

peckerwood mills, 21–22

Perkins family, 108

persimmons, wild, 27

Pickering, Dr. John, 165–67

pileated woodpeckers, 93, 159

pine cultivation, 4, 44–48, 119, 170–71

pine forests, longleaf, 168, 176–81, 184

pitcher plant, *after 144*

Pittman, Bob, 152, *153*

plant life: carnivorous plants, 168, *after 144;* cockleburs, 175; Forks of the River, 199; grapes, wild, 39; huckle-berry bushes, 129–30; Martin Dies Jr. State Park, 207; overviews, 18, 60, 79–80, 93, 194; pitcher plant, *after 144;* 'possum grapes, 39, *after*

"To Save a River" (TV mini-series), 222

"tram lines," 176

trapping, 58–59

tree falls, 36, 38–39, 118, 137, *after 48, after 144*

trees: American hornbeam, 71; black gum, 41, 77; bois d'arc (bodark), 17; champions, 168; Chinese tallow, 134, 204; cypress, 22, 129, 137, *after 144;* decaying and role in ecosystem, 4, 115, *after 48;* girdling of, 45–46; hickory, 170–71; ironwood, 71; longleaf pine forests, 168, 176–81, 184; mayhaw, 103; oaks/acorns, 79, 194, 200–201; poisoning of, 46, 170; red heart disease, 176

trestles. *See* railroad trestles

TSE (Texas Southeastern Railroad), 71, 73, 110–12, *after 144*

turkeys, 84

turtles, 27–28, 145

Twain, Mark, 23

2001 Neches River Canoe Expedition, 215–23

Upland Island Wilderness, 168–81, *after 144*

Upper Neches River Municipal Water Authority, 5, 225

vultures, 160

water, characteristics of. *See* channel characteristics

water as commodity, 5, 73, 156–59, 202, 207–10, 225

waterfalls, 48–49, 168–69, 184

wax myrtle shrub, 78

whirligig beetles, 38

Whist on, Constance, 13

Winder, Bud, 171

Wild and Scenic Rivers Act, 7–10, 224

wildlife, overviews, 18, 50, 79, 191, 194. *See also* aquatic life; bird life, wild; mammals, wild

wild woman of Shawnee Creek, 152

Williams, Pilot and family, 114

wolves, 59–60

women's roles in rural life, 98–101, 113–15

wood ducks, 26

woodpeckers, 93, 115, 159, 176

woodsmen, 47–48, 63

World War II, 21, 173–75

Wright, W. T. (Bill), 84

Y'Barbo, Antonio Gil, 17

Zavalla, 30, 53, 108